The Spiritual Image
in Modern Art

The Spiritual Image in Modern Art

Compiled by Kathleen J. Regier

*This publication made possible with
the assistance of the Kern Foundation*

The Theosophical Publishing House
Wheaton, Ill. U.S.A.
Madras, India/London, England

The Theosophical Publishing House
306 West Geneva Road
Wheaton, IL 60187

A publication of the Theosophical Publishing House, a department of the Theosophical Society in America.

Library of Congress Cataloging in Publication Data

The spiritual image in modern art.

"A Quest book."
"A Quest original"—T.p. verso.
Includes bibliographies.
1. Mysticism and art. 2. Art, Modern—20th century—Themes, motives. 3. Theosophy. I. Regier, Kathleen J.
N72.M85S6 1987 750'.1 87-40127
ISBN 0-8356-0621-X (pbk.)

Printed in the United States of America

For my husband, Tim

Contents

Preface

Spiritual influences have now been established in nearly every major modern art movement. However, it has taken many years for the spiritual nature of modern art to emerge and become recognized.

By the 1960s and 1970s many scholars had found that traditional interpretations for a significant number of works of art did not lead to a satisfactory or convincing analysis. While many images (representational and abstract) seemed "translatable," many scholars concluded that the inspiration for a number of modern images (representational and abstract) seemed "translatable," art historians concluded that the inspiration for a number of modern images had yet to be fully explored. Scholars turned to the availability and significance of mystical and occult traditions as a possible source of influence for artists in the nineteenth and twentieth centuries.

Little by little, the spiritual thread that was wound around modern artistic inspiration in European and American art became unraveled. In the late 1960s and early 1970s, publications began to appear which clearly demonstrated the influence of such beliefs on modern artistic endeavors. Specifically, Sixten Ringbom in a landmark study identified the tie between occult ideas and abstract painting, and Robert P. Welsh established the influence of Theosophy on Mondrian.[1] In 1971 Robert Galbreath called for an interdisciplinary journal on the occult in which all types of scholarly analysis would appear. Research on the tie between occultism and art, which had remained in the background for many years, revealed that mysticism was indeed a viable source of inspiration for a significant number of artists.

Artists set their sights on finding a universal language. Researchers found that there was "a class of art which speaks a particularly

sophisticated language, for it seeks to encapsulate a secret sym-
bolism of forms and structures which are intended to be understood
only by the initiated, or by those who have in one way or another
developed the sensitivity of the soul to occult truths. This is the
hidden art, which speaks a very special language of the spirit."[2]
This language spoke initially to only a select few. However, the per-
vasiveness of esoteric influence on modern visual phenomena
soon became apparent.

Many modern artists steeped in spiritual ideas found that
representing the real world was not sufficient. A significant change
in perception occurred for them, from the actual to the spiritual,
from the immediate to the cosmic. Many of these artists sought to
depict the spiritual forces in nature, forces that were far removed
from modern materialistic society. They soon found that repre-
senting the real world was not a sufficient means to express spiritual
enlightenment, and they turned to abstraction. The empirical
world was rejected, and abstraction became the vehicle to reveal the
triumph of spirit over matter.

While the influence of occultism on various styles of modern
art may still be held in question by some scholars, its existence
can no longer be doubted. In addition to the artists mentioned in
the following essays, a partial list of those who proved to be
spiritually inclined includes: Fernand Khnopff, Paul Sérusier,
Gustave Moreau, Pablo Picasso, Georges Braque, Juan Gris, Charles
Burchfield, Marsden Hartley, Marcel Duchamp, Frantisek Kupka,
Hilma af Klint, Barnett Newman, Joseph Beuys, Arthur Dove, and
Kazimir Malevich.[3] We know now that artists such as these made a
"pilgrimage," a "pilgrimage . . . that each of us must make alone,
into the realm of the stars and galaxies, to the limits of the universe,
to that boundary of space and time where the mind and heart
encounter the ultimate mystery, the known unknowable."[4]

Each of the following essays demonstrates the influence spiritual
beliefs have had on the creative imagination. The purpose of this
book is to present to the reader ten different essays that show
spiritual influences in modern art. The book is not intended to be a
comprehensive anthology, but a selection of essays that demonstrate
mystical or occult influences on a few nineteenth and twentieth
century artists. While the number of pieces included is limited
by consideration of space, I am aware of the wealth of research, both
published and unpublished, which could also have appeared in
this volume.

Some of the essays are abridged or revised. In the case of reprinted articles, the number of illustrations has often been reduced, and when necessary authors' footnotes renumbered.

I am grateful to Robert P. Welsh for writing the introduction, to the authors who kindly consented to having their essays in the book, and to the publishers who approved the reprinting of the articles. I would also like to thank the many authors with whom I have had contact regarding possible essays for this publication. I am grateful to my students who offered support during this project, my secretary Rita Claypool, and Webster University for providing funding for the book.

Notes

1. Sixten Ringbom, "Art in the 'Epoch of the Great Spiritual': Occult Elements in the Early Theory of Abstract Painting," *Journal of the Warburg and Courtauid Institutes* 29 (1966), pp. 386-418; Robert Welsh, "Mondrian and Theosophy," *Piet Mondrian 1872-1944, Centennial Exhibition* (New York: The Solomon R. Guggenheim Museum, 1971), pp. 35-52.

2. Fred Gettings, *The Hidden Art: A Study of Occult Symbolism in Art* (London: Studio Vista, 1978), p. 7.

3. For a discussion of many of these artists, see *The Spiritual in Art: Abstract Painting 1890-1985*, exh. cat. (Los Angeles: Los Angeles County Museum of Art, 1986).

4. Chet Raymo, *The Soul of the Night: An Astronomical Pilgrimage* (Englewood Cliffs, NJ: Prentice-Hall, 1985), p. x.

Acknowledgments

Thanks to the following publishers for permission to reprint their articles:

Ruth L. Bohan, "Katherine Dreier and the Spiritual in Art," published as "Dreier's Artistic Philosophy," excerpt, revised from *The Société Anonyme's Brooklyn Exhibition: Katherine Dreier and Modernism in America*, pp. 15-25, copyright ©1982, 1980 by Ruth L. Bohan, is reprinted courtesy of UMI Research Press, Ann Arbor, Michigan.

Thomas Buser, "Gauguin's Religion," reprinted from *Art Journal*, XXVII/4, Summer 1968, pp. 375-380, published by the College Art Association of America.

Robert Knott, "Paul Klee and the Mystic Center," reprinted from *Art Journal*, XXXVIII/2, Winter 1978/79, pp. 114-118, published by the College Art Association of America.

Patricia Mathews, "Aurier and Van Gogh: Criticism and Response," reprinted from *The Art Bulletin*, LXVIII, Number 1, March 1986, pp. 94-104, published by the College Art Association of America.

John F. Moffitt, "The Theosophical Origins of Franz Marc's Color-Theory," published as "Fighting Forms: The Fate of the Animals. The Occultist Origins of Franz Marc's 'Farbentheorie,' " reprinted from *Artibus et Historiae*, #12 (V), 1985, pp. 107-126 (abridged, revised). Reprinted permission *Artibus et Historiae*.

Jonathan Welch, "Jackson Pollock's 'White Angel' and the Origins of Alchemy," reprinted from *Arts Magazine*, Vol. 53, Part 7, March 1979, pp. 138-141. Reprinted permission *Arts Magazine*.

Robert P. Welsh, "Mondrian and Theosophy," excerpt, abridged from *Piet Mondrian 1872-1944, Centennial Exhibition*, exh. cat. (New York: The Solomon R. Guggenheim Museum, 1971), pp. 35-52. By permission of The Solomon R. Guggenheim Museum, New York.

Acknowledgments

Thanks to the following for permission to reprint paintings:

Wassily Kandinsky, *The Woman in Moscow*. Artists Rights Society, Inc. ©ARS, NY/ADAGP 1987.

Piet Mondrian, *Passion Flower, Devotion,* and *Evolution*. Visual Artists and Galleries Association. ©Beeldrecht/V.A.G.A., New York.

Paul Klee, *Omphalo-Centric Lecture*. Cosmopress. 1987 ©by Cosmopress, Geneva.

Contributing Authors

Ruth L. Bohan is Associate Professor in the Art Department at the University of Missouri-St. Louis. She is the author of *The Société Anonyme's Brooklyn Exhibition: Katherine Dreier and Modernism in America* (1982). She also served as contributing editor for *The Société Anonyme Collection and the Dreier Bequest at Yale University: A Catalogue Raisonné* (ed. Robert L. Herbert, Eleanor S. Apter and Elise K. Kenney; 1984). Professor Bohan is currently at work on a book examining Walt Whitman's influence on early twentieth century American painters.

Thomas Buser, Associate Professor of Art History, has taught at the Allen R. Hite Art Institute of the University of Louisville since 1972. He studied the history of art at New York University's Institute of Fine Arts. He also studied theology for two years at the Jesuits' Woodstock College in Maryland. He has written about religious art in Early Christian times ("Early Catacomb Iconography and Apocalyptic," *Studies in Iconography*, 1980) and during the Counter-Reformation ("Jerome Nadal and Early Jesuit Art in Rome," *The Art Bulletin*, 1976 and "The Supernatural in Baroque Religious Art," *Gazette des Beaux-Arts*, 1986). He is currently writing a book about the iconography of religious art in the nineteenth century.

Robert Knott is Associate Professor of Art History and former chairman of the Art Department at Wake Forest University. He has also taught at the University of Massachusetts-Boston and at the University of North Carolina at Chapel Hill. He was educated at Stanford University (A.B.), the University of Illinois (M.A.), and the University of Pennsylvania (Ph.D.). In addition to publishing articles and professional papers on Monet, Braque, Klee and other nineteenth and twentieth

century artists, he is an actively exhibiting sculptor and photographer.

Patricia Mathews is Assistant Professor of Art History at Oberlin College. Her major research interests include art theory and criticism, especially of the French Symbolist and Postmodern periods, as well as Feminist art theory. She has published articles in *The Art Bulletin* and *Apollo Magazine* and a book entitled *Aurier: Symbolist Art Criticism and Theory*, as well as criticism in a number of journals including *Art Criticism, Dialogue,* and *Women Artists News.*

John F. Moffitt received his doctoral degree from the University of Madrid in 1966. An exhibited painter, he has published widely in scholarly journals in this country and in Europe, including *The Art Bulletin, Burlington Magazine, Il Paragone, Oud Holland, Gazette des Beaux-Arts, Konsthistorisk Tidskrift, Archivo Español de Arte, Pantheon, Artibus et Historiae,* and many others. He is presently Professor of the History of Art at New Mexico State University.

Melinda Boyd Parsons holds a B.A. and M.A. in studio art and in 1984 received her Ph.D. in Art History at the University of Delaware, with areas of interest in modern art, the history of photography, and botanical symbolism in art. She taught art history for five years in the Honors Program at the University of Delaware and is now Assistant Professor in the Art Department at Memphis State University, where she is researching visual artists in the Yeats circle and the nature of religious expression in modern British art. Recent and forthcoming publications include a book on Pamela Colman Smith; a contribution to *British Photography in the Nineteenth Century: the Fine Art Tradition* (New York: Cambridge UP, 1989); and articles in *Nineteenth Century Studies* and *ESQ, A Journal of the American Renaissance.*

Celia Rabinovitch, an artist and art historian, holds an interdisciplinary Ph.D. in the History of Art and the History of Religions from McGill University, Montreal and an M.F.A. in painting from the University of Wisconsin, Madison. Her large illusionistic paintings have been shown in numerous exhibitions including "Occurrences: Four Manitoba Painters" (1981) and "Woman as Viewer" (1975) (the first

national juried show of women artists in Canada), both at the
Winnipeg Art Gallery. Her work is represented in various col-
lections in Toronto, Montreal, Winnipeg, San Francisco,
and Wisconsin. Her research interests include a theory and
method for the study of art and religion, with a special
focus on modern art history and the archaic, occult, and
oriental influences that inform the modern creative imagina-
tion. Currently she teaches art history and fine arts in
the Department of Fine Arts at the University of Colorado in
Denver, where she also directs the art history program.

Kathleen J. Regier is Associate Professor of Art History and
Chairperson of the Art Department at Webster University.
Her areas of interest are Modern, Ancient, and American Art
History. She has also taught at the University of Kentucky,
Washington University, California State University, San
Bernadino, and Western Illinois University. She was
educated at Ohio University (A.B.), Indiana University
(M.A.), and Washington University (Ph.D.). She has pub-
lished articles in *The American Theosophist, Art Voices South,*
and the *Research and Information Bulletin of the National
Council of Art Administrators.*

Jonathan Welch received the M.A. in Art History (1977) and B.A. in
Art (1971) from the University of California, Santa Barbara.
He also served as Assistant Gallery Director in Santa Barbara.

Robert P. Welsh was educated at Princeton University, from which
he received a B.A. degree in International Affairs in 1954 and
a Ph.D. degree in the History of Art in 1966. His doctoral dis-
sertation was devoted to the early career of the Dutch artist
Piet Mondrian, as were many of his subsequent publications.
Recently he has published on the art of Paul Gauguin, the
French Nabi group, and the Canadian contemporary abstract
artist Guido Molinari. At present he is working as co-author
of a *catalogue raisonné* of the oeuvre of Mondrian. His current
position is Professor in the Department of Fine Art at the
University of Toronto, where he has taught since 1962.

Introduction

ROBERT P. WELSH

It was scarcely in order to affect the development of modern
art that while in New York Mme H.P. Blavatsky in 1875 joined in
founding the Theosophical Society and two years later pub-
lished her monumental two volume *Isis Unveiled*. Instead, as she
stated in the title page of Volume II: Theology, she intended to
present to mankind "A Master-Key to the Mysteries of Ancient and
Modern Science and Theology," thus interrelating and recon-
ciling these latter two spheres of knowledge. Yet by the time of her
death in 1891, the teachings of the Theosophical Society and related
movements had become so widespread and influential that artistic
circles (especially the Nabi in Paris) were beginning to reinstate
spiritual enlightenment as a valid function of art. This came in
reaction to what was seen by many as the dominant but unfulfilling
materialism of the age.

Nor was this impetus to prove transitory. In recent years art
historians have become increasingly aware of how pervasive has
been the dedication of numerous artists and movements in
twentieth century art to mystical or occult preoccupations. The
highest concentration of this involvement has been found within
so-called Abstract Art, as documented both in the exhibition
catalogue *The Spiritual in Art: Abstract Painting 1890 - 1985* and in the
present anthology of writings on the subject. Nonetheless, similar
involvements have been posited for a number of representa-
tional Symbolists, Marcel Duchamp, and certain Surrealists, so that
the verdict is still out as to whether or not abstraction in art is the only
necessary or logical consequence of mystical artistic exercises.

What then were the historical circumstances in which an
alliance between art and occultism emerged in late nineteenth

1

century European culture? It was surely not that occult writings had been unavailable, since, for example, those of Paracelsus, Jakob Boehme, Swedenborg, and Novalis, along with more ancient mystical texts, could be found by those who sought. Moreover, the major treatises of Eliphas Lévi (pseudonym for Abbé Adolphe-Louis Constant) were published between 1856 and 1861 without having an appreciable effect upon art within or outside France, despite the numerous mystical diagrams and insignia which they contain. Only during the 1880s, after the Theosophical Society and Rosicrucianism had proven popular within Parisian intellectual circles, were the contributions of Lévi to occult science widely recognized. This was due largely to the popularizing efforts of Papus (pseudonym for Dr. Gérard Encausse), who during the late 1880s was both a member of the Theosophical Society and involved with Freemasonry-Martinist and Rosicrucian organizations. (For further details on French nineteenth century occultism, see articles by G. Imanse and R. Welsh in *The Spiritual in Art*.)

A major reason why the Theosophical Society could be accepted in largely Catholic France as well as in predominantly Protestant parts of Europe and North America was Mme Blavatsky's insistence that membership was entirely compatible with adherence to traditional religious sects. Herself a declared "Esoteric Buddhist," she did not consider this the only faith which could allow for the higher understanding of religious truth which she advocated. Hence artists who evinced a deep and lasting interest in the Theosophical Movement included persons who were raised as Protestants (Mondrian and the Nabi artist Paul Ranson), Catholics (Paul Sérusier, Emile Schuffenecker), and the Russian Orthodox Kandinsky. It must be remembered, however, that to date only Mondrian among major painters is known to have been an actual member of the Theosophical Society (beginning in 1909) and that many other artists seem to have limited their association to the reading of books and attendance at lectures sponsored by the Society.

The problem for art history in all this is how to define an artist or his work as "theosophically" inspired or informed. One answer has been to distinguish between big "T" and small "t" definitions of the movement, restricting the former category to members of the Society and those who have declared their art to be Theosophically inspired and the latter to those with only a casual

or no knowledge of the Society and its literature. By this standard, Mondrian would qualify as a Theosophical artist, at least during the period in which he produced the *Evolution Triptych* (see below pp. 163-184), while Gauguin, who may never have read the writings of Mme Blavatsky or her followers, is seen as a theosophical artist only in the broadest sense of the term. His theosophical inspiration came merely from the Swedenborgian novels of Balzac, *Louis Lambert, Seraphita* and *La Recherche de l'absolu,* that he is known to have admired (see T. Buser, "Gauguin's Religion," pp. 40-54, below).

Quite likely Mme Blavatsky would have accepted the broader category of "theosophy" and art derived therefrom, since she always maintained that the occult tradition has survived in one form or another from ancient times. Mondrian, too, would not have limited the production of spiritually elevated art to members of the Theosophical Society. Hence among some sketchbook annotations of circa 1912-14, possibly written for inclusion in a never published article for a Dutch Theosophical journal, is found the following: "Even without knowing it, the artist is forced by the spirit of the times towards abstraction—exactly along the course of evolution (Picasso)." Doubtless Mondrian was aware that Picasso was not inclined towards spiritual pursuits in either his life or his art, but this did not prevent the Dutch artist from designating the Spaniard as a force for progress in the evolution of man's spiritual condition, which in a nearby sketchbook passage he linked with the "Doctrine of Evolution" and "Theosophy" (*Two Mondrian Sketchbooks 1912-1914*; Amsterdam: 1969, pp. 62, 64, 66). Significantly, during the first decade of the twentieth century, articles appeared in the Dutch periodical *Theosophia* which imputed Theosophic content to certain paintings by Leonardo and Rembrandt, which if known to Mondrian could only have encouraged a belief that the force of spiritual evolution as defined by Theosophy had been as active in the art of earlier centuries as it was proving to be in the present.

It is also to be noted that inspiration identified as Theosophic in the art of the late nineteenth and early twentieth centuries manifests in extremely diverse times and places. This is explained by several considerations. First, there are the fortuitous translations of standard Theosophic texts into languages other than the original English. It was not until fairly well along into the twentieth century,

after these translations appeared, that the impact of Theosophy on art was seriously felt. Ironically, this was due in part to the lack of flourishing avant garde traditions in late nineteenth century England, the United States and English-speaking Canada, and in part to lukewarm enthusiasm in these places for religiously informed art in general. In the case of Arthur Dove, Marsden Hartley and Georgia O'Keeffe in the United States (see C. Eldredge, "Nature Symbolized: American Painting from Ryder to Hartley" in *The Spiritual in Art*) and Lawren Harris in Canada, this involvement was first manifest during the 1920s, while an interest in a variety of esoteric religious philosophies resurfaced within the so-called Abstract Expressionist movement of the 1940s (see essay on Jackson Pollock below, pp. 193-201).

In contrast, in France, where one might have expected fairly fierce resistance to what was often termed the Anglo-Indian orientation of the Theosophical Society, due to the primacy there of the orthodox Catholic faith, the reception was virtually open-armed. This held true at least during the 1880s before polarization between the universalist outlook of the Theosophical Society and the basically Christian orientation of the Rosicrucian movement had developed. Even afterwards distinctions of emphasis were blurred, and as in the writings of Lévi, a study of the Jewish Kabbala was an integral part of both Theosophic and Rosicrucian examinations of occult phenomena. It was thus no accident that a group of Christian-raised and theosophically inclined young French artists chose to call themselves the "Nabi," a Hebrew word meaning "prophet" but also implying a brotherhood of initiates. This particular brotherhood was in fact so close and so economically self-sufficient that there was little incentive to produce art for either economic gain or artistic reputation. The Nabi group may therefore be considered a rare occurrence in Western art since the Middle Ages—talented persons who felt themselves open to influences from the East while wishing to maintain an essential allegiance to the Christianity of the West.

As regards this ambience, it is no surprise that Patricia Mathews has discovered in the art criticism of Albert Aurier an inclination to esoteric convictions (pp. 12-39 below), especially as these concern his own development, so tragically cut short by an early death. Vincent van Gogh is another artist who, like Gauguin, has been linked with theosophical precepts in recent art historical

literature. However, his familiarity with Theosophic or other occult texts is rendered doubtful by the absence of their mention in Vincent's voluminous correspondence. Although his repeated use of solar, lunar and stellar images, like his metaphorical comparison of a trip by train with taking "death to reach a star" (Letter 506), clearly betoken his deeply religious nature, such usages have yet to be successfully paired with specific occult texts or doctrines.

In European countries other than England and France, direct familiarity with the major publications of the Theosophical Society was hampered by a lack of translation into native languages, except in the form of often abbreviated versions which appeared in native-language Theosophical journals. By the beginning of the twentieth century the situation had begun to change markedly, especially in The Netherlands and Germany, where by circa 1914 the fundamental writings of Mme Blavatsky and other important Theosophical texts were available in translation. Equally important, just following the year 1900 two other fountainheads for a knowledge of Theosophy produced publications which now seem to have had at least as profound an effect upon esoterically inclined artists as those of Mme Blavatsky. The first of these books was *Thought-Forms* (1901) by Annie Besant and C.W. Leadbeater, and the following year Leadbeater published his *Man Visible and Invisible* (both available in Dutch and German translations by 1908, as were also Blavatsky's *The Secret Doctrine* and *The Key to Theosophy*). While being indebted to ideas found in the writings of Blavatsky, the books by Besant and Leadbeater included concentrated discussions of auras or ovoids of colored light which were said to envelop people and other life forms and even minerals, and which were said to be visible to those with clairvoyant vision. The color illustrations accompanying the texts in these volumes were both numerous and fully explained. Suffice it to say that the two volumes over the years have provided the standard exegesis for the Theosophical Society of color as a supersensory experience, and as such complement the various meanings attached to numbers, lines and geometric shapes by earlier occult authors. Strangely, until approximately fifteen years ago the possibility of associating esoteric meaning to both linear and color configurations in works of modern art was largely ignored. However, in the years since, more and more credence has been accorded the assertion of such spiritual content in otherwise "abstract" forms of painting, as

discussed in several of the essays contained in the present volume. And while exceptions surely exist, it is striking how many of the artists who have been examined in these terms have been Dutch, German, Russian or American in origin rather than French.

Another influential catalyst for artists to consider painting and an interest in the occult as mutually reinforcing was Rudolf Steiner, best known as the founder of the Anthroposophical Society (in 1913). During the previous decade he had served as the leading figure and author within the German branch of the Theosophical Society, though later he denigrated Mme Blavatsky and her followers as overly Anglo-Indian in orientation, as opposed to his own more Christian outlook. Subsequent denials notwithstanding, his circa 1904 original German editions of *Theosophy* and *Knowledge of the Higher Worlds and its Attainment* deal with some of the same phenomena found in the above-mentioned books by Besant and Leadbeater. Steiner's books may well have been derived from Besant and Leadbeater's models in format as well, since Steiner's volumes are similarly intended as handbooks to guide esoterically inclined acolytes into progressively higher states of spiritual enlightenment and awareness.

Kandinsky and Mondrian, among other artists, are known to have read the writings of Steiner, and there is evidence to suggest that in 1908, probably before either artist knew of the other's existence, each attended one or more lectures delivered by Steiner. However, there is little evidence to suggest that this had any serious effect upon the allegiance of these painters, who had previously established contacts with Theosophy. It can be surmised, instead, that artists, who by definition must establish a personal style in order to be recognized, would have accepted divisions of approach among their source authorities with equanimity.

By way of summary, it may be asserted that the influence of the various occult societies which were founded during the late nineteenth and early twentieth centuries was not directed to artistic production. There is little evidence of a concerted attempt on the part of the Theosophical Society to promulgate its doctrines via artistic expression. Instead it is reasonable to presume that artists were themselves persuaded of the validity of the world-view as expostulated in Theosophic texts. Within this context, it is only reasonable to assume that artists of the rank of Mondrian, Kandinsky, Kupka and Malevich felt themselves free to interpret

and thus integrate their own experiences of the occult with established occult dogma. Clearly these interpretations were posited on an individual basis, which explains the considerable diversity of style within so-called Abstract Art.

One factor which helped foster this diversity was that the goal of the Theosophical Society was not to establish itself as an independent religious body, and it would have been inappropriate for it to adopt or invent a specific style of architecture and building decoration as have most historical religions (and also Steiner in his successive Goethenaeum buildings at Dornach). Apparently, the leading figures in the Theosophical Society did not believe it desirable, or perhaps even possible, to render clairvoyant visionary experiences by means of pictorial representation. Despite the color illustration and fairly detailed verbal description of various "astral" forms which occur in *Thought-Forms*, an early chapter is devoted to an explanation as to why representation of these forms created by thought provides only a pale reflection of actual perception of them. Or, as Besant put it in her foreword after thanking the three friends who had provided the illustrations of thought forms observed by herself or Leadbeater: "To paint in earth's dull colors the forms clothed in the living light of other worlds is a hard and thankless task; so much the more gratitude is due those who have attempted it. They needed colored fire, and had only ground earths." As a consequence of this view, only rarely does one find mention in theosophical journals of attempts to translate a clairvoyant experience of color into a work of art. Fortunately, a surprising number of both major and minor artists were not inhibited by Besant's warning and attempted both to develop their own powers of occult or supersensory vision and to depict their personal visionary experiences by means of brightly colored pigments imposed upon some material surface.

It must be noted at this point that precious little written testimony has been provided about the specific methods by which artists cultivated clairvoyant powers of perception. On occasion, as with the Dutch artist Janus de Winter, who indicated his esoteric intentions with such titles as *Aura of an Egotist*, the public is informed that realms of vision transcending the natural world are being invoked. More commonly, artists have chosen titles which only obliquely evoke "the higher realms" by reference to some myth or cosmic event, or else have provided labels in analogy with

music—widely considered an inherently transcendental art form—as did Kandinsky in his three categories of Impressions, Improvisations and Compositions. This is understandable. Given the general public's indifference or antipathy to most forms of modern art and the widespread skepticism as to the reality of supersensory experience, why should painters provide an unsympathetic or hostile world with additional ammunition to prove themselves either fraudulent or unbalanced and their creations inexplicable and thus unworthy of admiration? As a result of this reticence, one is left wondering, for instance, whether individual paintings were executed from memory of an extraordinary psychic experience or during one. Did the artist come by his pictorial imagery by observing some person or object in nature in a clairvoyant manner or through some self-induced imaginative process? If visionary in origin, were the images reproduced after some form of visual projection upon the canvas surface, or did they come about during some form of trance which left the artist only partially conscious of his physical actions? All such possibilities may be hypothesized, but unless a manuscript is found giving an individual artist's account of his own psychic state while in the act of creation, our knowledge of such matters remains speculative.

If we turn now to the modes of representation in which spiritually inclined artists of the late nineteenth and early twentieth centuries sought to realize their conceptions, it is apparent that a full gambit of styles ranging from naturalism to abstraction was employed. On one side of the scale could be found such academic Symbolist painters as Jean Delville and Carlos Schwabe, adherents respectively of Theosophy and Rosicrucianism, who depicted scenes of spiritual ascent or discovery with minutely realistic styles derived from a selection of Renaissance, Mannerist or Neoclassical painters. Much of the early work of the Czech painter Kupka—who apart from his painting practiced as a medium, worshipped the sun and was widely versed in esoterica—was executed in a similarly detailed realism, as when he treated such themes as *Soul of the Lotus* or *An Avenue of Sphinxes*. This mode survived well into the twentieth century and appeared in the work of certain female Surrealist artists known to have had an interest in alchemy such as Remedios Varo and Leonore Carrington.

More important historically were those Symbolist artists such as Gauguin and the Nabi who eschewed naturalism and

allegory in favor of flattened, more decorative modes of style and imagery, which defy easy understanding for lack of narrative content and the use of unorthodox iconographies. Two classic examples are the *Vision after the Sermon* and *The Yellow Christ* by Gauguin, in which biblical events seem to be reenacted within the context of contemporary peasant life in Brittany. Thomas Buser's case for attributing an interest in Theosophy to Gauguin is strengthened by the inclusion of a Tau cross in *The Yellow Christ*. However, the conflation of sacred history with mundane rural French settings militates against any clear understanding of the artist's intended theme, in terms of either theosophic or traditional Christian concepts. According to the literary Symbolist Manifesto, the aim of the movement was "to clothe the Idea in perceptible Form," but in practice both idea and form are difficult to define because of the blending of one with the other.

The Nabi were more overt in their acknowledgment of mystical and theosophic impulses through their art. Their leader Paul Sérusier was an avid reader of esoteric literature, especially of *Les Grands Initiés* by Edouard Schuré, an author who, while not writing as a member of the French chapter of the Theosophical Society, received critical praise from that source when the book appeared in 1889. The pictorial language of Sérusier varied from more or less naturalistic landscapes modeled after the example of Gauguin to figural depictions replete with insignia derived from traditional signs of the zodiac and other standard emblems. In the work of other Nabi artists, references to Theosophy are even more apparent. Thus the Nabi sculptor George Lacombe devoted wood reliefs to the theme of Isis as matrix of the world. He also represented the cycle of procreation-death-reincarnation, and this theme is epitomized in the decorations of a "bed" in which the standard theosophic emblem of the snake biting its tail summarizes the processes of recurrent creation. Yet in typical Nabi fashion he manages to mix the worlds of the sacred and the profane. The paintings and drawings of Paul Ranson, perhaps the most assiduous student of arcane knowledge among the Nabi, are interspersed with reference to astrology, alchemy and other mystical realms. Yet all usages remain subject to unraveling according to standard esoteric texts and diagrams and as such remain in the class of traditional iconography and not abstractionism.

It becomes progressively less easy to discover intended esoteric meaning in the course of modern art, as it employs ever

less representational or more abstract modes of style. One example of this development is the use of what Rose-Carol Washton Long has termed "hidden images" in the art of Kandinsky (*Kandinsky, The Development of an Abstract Style*; Oxford: 1980). She has demonstrated convincingly that within the paintings of circa 1910-14, formerly thought to be virtually pure abstractions, can be found linear and planar configurations deriving from figural, landscape and architectural forms, and these have distinct spiritual significance within the context of the artist's overall iconography. Although the writings of Steiner comprised one influence on the imagery chosen by Kandinsky, the artist himself produced a rich assortment of iconographic motifs, from which he could produce a seemingly endless variety of richly coloristic compositions. His gradual adoption of ever more abstract modes of style, as made clear in his published art theory, was undertaken in the service of an anti-materialist outlook on life and a belief in a spiritually enlightened society, which it was the purpose of art to help bring about. In his immediately pre-World War I work areas of color, while often deriving from or substituting for physical objects, also are frequently suggestive of brightly colored auras. In contrast in his immediate post-World War I style, more strictly geometric lines and planes replace the former expressionistically laid on bursts of line and color. Although sometimes seen as a consequence of his contact with the geometric abstraction of Malevich during the war years spent in his native Russia, it seems more likely to the present writer that he was merely moving from still vague to more precisely defined spiritual essences, a path advocated and predicted for adepts or initiates of most mystical societies, in particular the Theosophical Society.

Other major artists of the twentieth century followed this path from vague to geometrically conceived compositional components. Often, as in Kandinsky and Klee, upward pointing triangles were first associated with the outline of mountains, a usage perhaps traceable to the Romantic period landscapes of Caspar David Friedrich. Other artists, such as Mondrian, Kupka and Robert Delaunay, all on occasion discovered an analogy between cathedral towers, spires or arches and the ascending vertical line, as associated in occult tradition with the masculine realm of spirit, in opposition to the horizontal line connotative of feminine matter. It was Mondrian who reduced compositional formats to this one essential linear opposition. Still, for most if not all spiritually inclined

10

artists born in the nineteenth century, raised in an intellectual milieu where anti-materialism was a driving force, and converted to an abstract or at least anti-naturalistic style, there can be little doubt that all basic geometric forms were felt to stand for some exalted spiritual truth.

In sum, it can no longer be doubted that the interest in mystical literature and theory shown by numerous avant garde artists during the past 100 years was often manifested in their works of art and not just in their published art theories, as previously thought. Whether leading to a relative or pure form of abstraction or to a more representational mode of style, this interest in making art serve some truth higher than mere accurate representation of nature also may be considered part of a widespread historical phenomenon. It thus coincides with the late nineteenth century reaction against what were thought to be the limitations of a rationalist and materialist world-view. This reaction pervaded the realms of art, literature and philosophy, and also religion, especially as manifested in the several occult societies which were then founded and have continued to flourish. The fact that so many artists have been attracted to these societies or their teachings (incidentally, without any effort of proselytizing or offer of patronage) further indicates the breadth with which this anti-materialist intellectual outlook has been dispersed throughout modern culture.

In the realm of art, this outlook has been maintained or rediscovered throughout a succession of generations, typically more as an individual or small group involvement than as an all-embracing commitment to any particular movement or period; hence the multiplicity of stylistic and iconographic innovations which have been produced by modern artists under the influence of their esoteric or occult pursuits. Nor should it be thought—as it has been by some art critics and historians in the past—that involvement in such pursuits necessarily leads to a diminution in artistic quality. This is of course possible, if dedication to problems of artistic form and expression is forsaken in favor of simply illustrating a particular esoteric doctrine or experience. This, fortunately, has not been the case for the many serious artists who, since the late nineteenth century, have sought a knowledge of the occult in conjunction with a search for a personally innovative style. The magnitude of the success of such quests can be judged by the stature of the artists discussed in the present anthology.

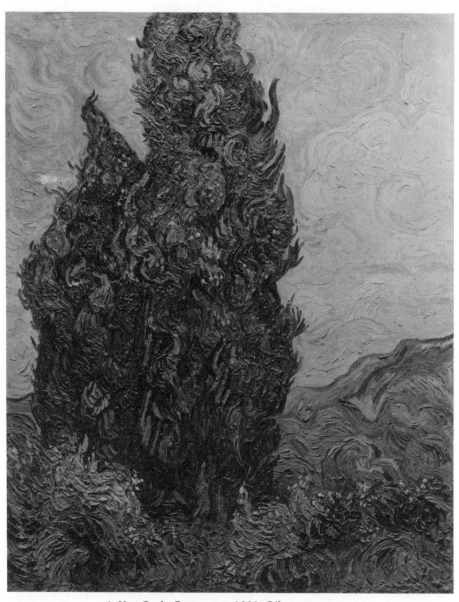

1 Van Gogh, Cypresses, *1889. Oil on canvas,
36¾ x 29½''. The Metropolitan Museum of Art,
New York. Rogers Fund, 1949*

1

Aurier and Van Gogh: Criticism and Response

PATRICIA MATHEWS

*G.-Albert Aurier, the Symbolist writer and art critic,
wrote the first interpretative article on the art of Vincent
van Gogh, published in January, 1890. The artist responded
with a long and telling letter to the critic. The first part
of this article outlines Aurier's analysis of Van Gogh's
works, based on the critic's comprehensive theory of ex-
pression and the creative process, the aesthetic experience,
and the role of the critic. The second part considers Van
Gogh's reaction to this interpretation of himself and his art.
He agrees with Aurier's concept of what art should be,
including his own, but does not like being referred to as an
"isolé."*

Shortly after Vincent van Gogh's death in July of 1890, his brother
Theo wrote a warm letter to the critic he felt could do most justice to
his brother's genius.

You were the first to appreciate him, not only on account of his greater
or smaller capacity to paint pictures, but you have *read* these pictures, and by
doing so you very clearly saw *the man.*
 Many men of letters have evinced a desire to write something about
him, but I have requested them to wait, . . . I wanted to leave you time to be
the first to speak, and, if you should like to do so, to write a biography,
for which I could furnish all the material. . . .[1]

This letter was addressed to the French Symbolist poet, art critic,
and theorist, G.-Albert Aurier, celebrated as the art critic *par
excellence* of his own era,[2] and known today for his formulation of a
Symbolist aesthetic theory in art, subscribed to by Gauguin and
other Synthetists.[3]

13

Theo had good reason to call on the young critic in his search for supporters to honor his late brother. Aurier had earlier that year made Vincent a figure to be reckoned with in Parisian intellectual circles through his penetrating article on Van Gogh's art.[4] Prior to that time, Vincent was known only to a select group of painters and friends. The comprehensive Symbolist art theory contained in the article brought the young Aurier recognition as well. Yet Aurier's article caused Van Gogh no small degree of agitation. The artist not only wrote to Aurier but to several friends and relatives about it. While his letters occasionally betray a defensive tone, they also exude eagerness and excitement about the ideas of this bright young critic. In this essay, I shall first examine Aurier's critique of Van Gogh's art, and then briefly consider Van Gogh's intentions and attitudes expressed through his response to it.

Aurier's Critical Interpretation of Vincent's Art

Aurier's article on Van Gogh is one in a series of essays in which he developed his theories of the creative process, the aesthetic experience, and criticism. The structure of this article is determined by two aspects of his theory of criticism: first, the critic should be a poet[5] who translates the work of art into his own more familiar language, since education has suppressed the public's intuitive ability to read the once universal, formal language of art.[6] Second, the critic must go beyond this poetic interpretation to illuminate the "ensemble of ideas"[7] that all true works of art contain.[8]

In accordance with his theory, Aurier began his article by evoking Van Gogh's works with a series of poetic metaphors derived from his subjective response to them. The intensity of his experience of the paintings is conveyed through extraordinary images of nature in metamorphosis. "[F]orms are seen as in nightmare, color has turned into flame," and "light sets fire to itself" (cf. Figs. 1 and 2). The light of the paintings is further described as an "incessant and awesome shimmering" (cf. Fig. 3). Skies are "cut into dazzling fragments of sapphire and turquoise," or resemble "molten outpourings of metal and crystal." Trees are "twisted like battling giants" (cf. Figs. 1, 2, and 3), and mountains "rear their backs like mammoths or rhinoceroses" (cf. Fig. 4).[9] In its ecstatic nature, this imagery is more than just exaggerated Symbolist prose, however. Ecstasy is the very essence of the aesthetic experience

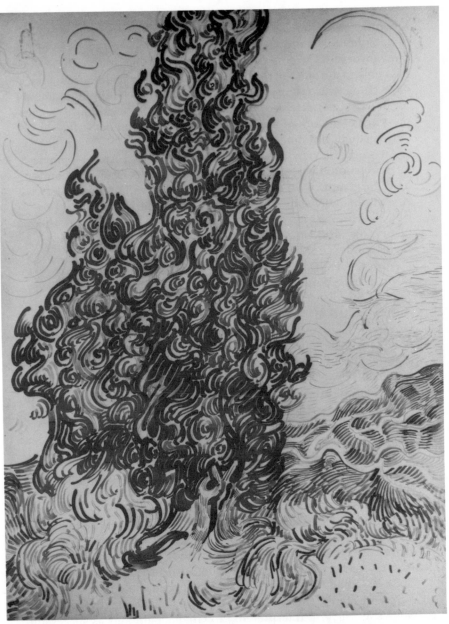

*2 Van Gogh, Cypresses, 1889. Reed pen and ink over
preparatory pencil, 24¾ x 32¼''. The Brooklyn Museum.
Frank L. Babbott and A. Augustus Healy Funds*

according to Aurier. He considered the aim of aesthetic experience to be an intimate and mystical communion between the soul of the viewer and the soul of the work of art.[10] One must submit passively to the work in order to receive the "sympathetic radiance" of its being, emanating from the ideas, emotions, and sentiments it contains. Aurier referred to the experience of this radiance in the presence of a work of art as "the sentiment of the beautiful" or "the aesthetic emotion."[11]

An animistic view of nature is also revealed in Aurier's poetic interpretation. Everything, "being and appearance, shadow and light, form and color, rises and rears up in a willful rage to howl its own essential song—at full pitch and as fiercely shrill as possible."[12] This passage discloses the foundation of Aurier's aesthetic theory, his Idealism—that is, his belief in absolutes and their correspondence in appearances.

Aurier's Idealism is in part derived from the theory of correspondences formulated by Baudelaire and the seventeenth-century Swedish mystic Emmanuel Swedenborg, both of whom Aurier quoted in support of his own theory of correspondences.[13] However, Plato and the third-century Greek Neo-Platonic philosopher Plotinus are more important for Aurier's ideas. For example, he conceived of absolutes as Ideas in a purely Platonic sense: *"In nature, the object is, in sum, only the signifier of an Idea . . .* this ideistic substratum is everywhere in the universe and, according to Plato, is the only true reality—the rest is only appearance and shadow. . . ."[14] He considered Ideas to be mystical essences or beings, manifested as symbols in this world, and brought to life through art. ". . . Symbols—that is, Ideas—surge from the darkness, become animated, begin to live with a life that is no longer our contingent and relative life, but a resplendent life that is the essential life, the life of Art, the being of Being."[15]

Aurier believed that Ideas are recognized and comprehended by only a select few, the artists.[16] The role of art is to reveal and express this realm of universal significance, through the individual artist's response to it. Therefore, when Aurier claimed that Van Gogh searched for the "essential sign of each thing,"[17] he not only communicated to the reader what we sense to be a truth about Van Gogh's art; he also interpreted Van Gogh's paintings as successful expressions of his own mystical Idealism.

In his poetic evocation of Van Gogh's works, Aurier also employed several literary techniques with which the Symbolists were

experimenting at the time. For example, through incantatory rhythmic repetition, Aurier hoped to achieve a hypnotic effect, common to much Symbolist poetry: "Under skies at times cut into dazzling fragments of sapphire and turquoise . . . ; under skies resembling molten outpourings of metal and crystal . . . ; under an incessant and awesome shimmering. . . ."[18] Aurier's description of the atmosphere in the paintings as one of red-hot liquid metal, crystals, and jewels reflects another concern of the Symbolist milieu and of Aurier in particular: alchemy.

The rising interest in alchemy during the Symbolist period resulted from concurrent occult and mystical revivals. Its significance for that generation of poets and writers lay not in the procedure of this ancient "science," which claims to transmute base metals through fire into gold, but rather in the symbolic nature of such a quest. From its origins through the nineteenth century, alchemy was commonly understood to have metaphoric import.[19]

The spiritual as well as material symbolism attached to the alchemical quest for gold is well known. Goethe's *Faust* integrally incorporates alchemy as a metaphor not only for worldly accomplishment, but also for spiritual realization through initiation into the alchemical process. Poet-seers such as Rimbaud also related their inner quest to the alchemical tradition.[20]

Seen in such metaphysical garb, alchemy was as pervasive in the thought of the Symbolist period as Darwinism and the idea of progress or Marxism and Freudianism are today. Whether or not one had read or understood the theory, one at least superficially referred to it and grasped allusions to it.

The implications of purity through reduction inherent in the alchemical process were not lost on Symbolist theorists such as Aurier, who searched for a vocabulary in which to speak of exactly such issues as simplification, purity, and reductionism in art. These ideas are indeed central to Aurier's expressive theory.[21]

More importantly, however, the process of alchemy symbolizes the absolute unity of the universe distilled from the flux and relativity of the material world.[22] Alchemy therefore was seen as a tool, for some a practical one, for most a theoretical one, to reveal the absolutes beneath appearances. Finally, the idea of various steps culminating in an ultimate revelation was also understood analogously by the Symbolists as the stages that lead to the ecstatic mystical experience of art and of the world.[23]

17

Aurier's interest in alchemy is documented in several places.[24] He often used alchemical symbolism to allude to the imagery of creation, especially artistic creation. He referred to the young artists working outside the Salon and its academic milieu as "obscure alchemists" creating what would perhaps be "le Grand-Oeuvre" of tomorrow.[25] Monticelli is described as "le grand alchimiste," whose "magic crucible full of gems, enamels, and metals melting together and merging" brings forth "glowing apparitions."[26] Aurier's articles on Monet, Renoir, and Pissarro all contain references to art as alchemy.[27]

One of the most subtle yet extensive uses of alchemical imagery is found in Aurier's article on Van Gogh. He used such imagery to create a sense of the intoxicating transmutation that nature undergoes in Van Gogh's art. Before citing specific examples, it must be noted that nowhere did Aurier imply that Van Gogh's art symbolizes the alchemical process. Aurier neither explicitly reconstructed alchemical processes, nor supported alchemical doctrines. Rather, he used alchemical language as an analogue or tool of expression to suggest rather than describe the nature of Vincent's art, and likened his creative process to that of the alchemist. Through Aurier's symbolic description, then, we enter the hot furnace that is the artist's "moi," where the transmutation of the motif into art takes place.

Aurier began by referring to Van Gogh's skies as cut sapphires and turquoises, kneaded with "some unknown kind of infernal sulphur, so warm, poisonous, and blinding."[28] Sapphires are an alchemical symbol and sulphur the combustible element in its process. Since sulphur must be extracted so that the alchemical transmutation can take place, its nature could be described as "poisonous" or "deleterious."[29] Van Gogh's skies are also characterized as "molten outpourings of metal and crystal [in fusion],"[30] reminiscent of the alchemical crucible where all melts together and fuses. Such fusion of metals is directly related to alchemy in the reference to Monticelli quoted above.[31]

The imagery of a furnace is intensified in the next passage: "... heavy, flaming, pungent mixtures of air, seemingly exhaled by fantastic furnaces in which gold, diamonds, and [other] singular gems are volatized. ..."[32] It is exactly such jewels as diamonds, "the most brilliant and most valuable of precious stones," that represent gold in alchemy.[33]

After a long passage in which Aurier depicted a nature come to ferocious life in Vincent's paintings; another follows that relates Van Gogh's creative process to the alchemical process. The landscapes of the artist are described as created in a crucible filled with precious stones, enamels, and metals, in a simulation of the alchemical process of the creation of alloys such as gold and silver were thought to be.[34] Many of the stones and metals mentioned are alchemically significant.

Flaming landscapes appear as the effervescence of multicolored [enamels] emerging from some diabolical crucible of an alchemist; frondescences like the patinas of ancient bronze, new copper and spun glass; gardens of flowers which appear less like flowers than the most luxurious jewelry made from rubies, agates, onyxes, emeralds, corundums, chrysoberyls, amethysts, and chalcedonies.[35]

Because, in the passage on Monticelli quoted above, Aurier spoke of the "magic crucible full of gems and enamels," it is clear that the alchemical significance of this concept was familiar to him. In the last passage of this poetic description, Aurier intermingled animistic imagery with alchemical symbolism, to suggest a transformation of all nature: "It is the universal, frantic, and blinding coruscation of objects; it is material reality or nature frenetically distorted into a paroxysm of extreme exacerbation; . . . color . . . , once purified, becomes jewel-like, . . . and life is lived at a fever pitch."[36]

As shown in these passages, Aurier relied on alchemical imagery to express a correspondence between the metaphoric implications of alchemy and the feverishly intoxicating art of Van Gogh. Many of his contemporaries no doubt would have empathetically recognized the atmosphere of alchemical, magical transmutation through the creative process implicit in Aurier's account.

After his visionary description of Vincent's art, the critic proceeded to interpret it critically. In a consciously abrupt contrast to the preceding poetic passage, Aurier proposed that the art of Van Gogh had affinities with the bourgeois and mundane "little masters" of seventeenth-century Holland. He described Vincent soberly as a realist in a long line of Dutch realists.[37] In so doing, Aurier set up the polarities, in style as well as content, that he believed to exist in Vincent's art: a strong bond with reality expressed through an excessively intense and sensitive personality. His art is "simultaneously true to life, yet quasi-supernatural."[38] In the second part of his article, Aurier clarified the duality inherent in Van Gogh's

19

art by critically applying his theory of the creative process.

According to this theory, the critic must first establish the artist's sincerity to sensations before nature or before his motif as evidence of his originality.[39] Sincerity in art was valued for the same reason that awkwardness was valued by Symbolist critics. It was proof that the artist was not blindly following academic rules but was attempting to translate his own subjective response to the motif.[40]

Aurier contended that Vincent's work exhaled sincerity like a perfume. In the critic's mind, Van Gogh's "profound and almost childlike sincerity"[41] resulted from his naïveté. This quality is indeed a necessity, for it allows an artist to see and "read" the universal significance of nature, unencumbered by the constriction of educated knowledge. To Aurier, "être savant" meant to be too learned, to know too well the lessons and formulas of the academies, and to have thereby lost any sense of individuality and originality.[42] Aurier's belief in the superiority of naïveté over knowledge played a role in his concept of the primitive. The "savages," he said, have an "intimate communion with the immanent thought [Ideas] of nature, with the soul of things," which civilized man has lost.[43]

Simplicity is another virtue inherent in this distinction between knowledge and naïveté. It was one of Van Gogh's greatest assets as far as Aurier was concerned. As a result of his desire to begin again in art, Vincent wanted to create a very simple type of painting that would be understood and would move even "humble folk who don't understand refinements and . . . the simplest of the poor in spirit."[44]

Because Aurier considered subjectivity to determine reality, and even doubted the existence of an objective, immutable reality,[45] he believed that the artist must rely totally on himself. Therefore, the development and focusing of one's natural abilities through an interior synthesis represents the first step in his theory of the creative process, *la synthèse du moi*. A more sophisticated and subtle artistic temperament than the less developed native temperament results from this synthesis.[46] In Vincent's case, his native and his artistic temperaments, his artistic soul and his human soul, are identical. The principle in both is excess.[47]

Aurier characterized Vincent's artistic temperament as neurotic, "hyperaesthetic,"[48] and "sublimely unbalanced."[49] His very illness placed him among the initiates who considered suffering a

necessary condition to free one to create. His excessive tempera-
ment was seen as a sign of his superior ability to experience and
to reveal.

This concept of the beneficial effects of suffering pervaded
nineteenth-century thought. Early in the century, the philosopher
Ballanche stated that "le Malheur," especially in the "great man,"
renders "the sensibility more profound and more refined."[50] The
stereotype of the artist suffering to attain nobility makes its debut
through ideas such as these. Rimbaud, for example, believed that the
poet must "deprave himself and degrade himself in order to break
down all the normal restraints." He must "experience all forms
of love and madness so that he may keep only their quintessence."[51]
"The poet becomes a *seer* by a tedious, immense and reasoned
derangement of all the senses."[52] For Baudelaire, too, pain was sweet.
It was a necessary initiation for individual perfection. It fortified
as well as purified:

> . . . my God, who givest suffering
> As the only divine remedy for our folly,
> As the highest and purest essence preparing
> The strong in spirit for ecstasies most holy.[53]

Hyperaestheticism, defined as the ability to see mystically
what healthy eyes cannot, was also linked directly to pathology in
the psychological and physiological literature of the period. When
Aurier called Van Gogh a hyperaesthetic "with clear symptoms"
who perceived with "abnormal intensity," he may have been
referring not only to sensitivity, but to a real illness. "Hyperesthésie"
is defined, just as Aurier defined it, as "hypersensibility": "an
abnormal sensitivity of . . . some sense organ."[54]

The term "névrosé" that Aurier used to describe Van Gogh's
temperament was another medical term in vogue at the time. It was
one of many medical expressions appropriated and popularized by
writers from the work of such pioneers in psychopathology as
Pierre Janet. When Aurier referred to Vincent's *Sowers* (several
extant versions) as an "obsession that haunts him,"[55] he was again
using a term for another disorder identified by Janet, "l'idée fixe."[56]

Among doctors, psychologists, and philosophers, as well as
artists, there was also a general belief that mental illness could reveal
the inner workings of the mind,[57] and therefore the mentally ill
were believed to have a profundity that healthy minds could not

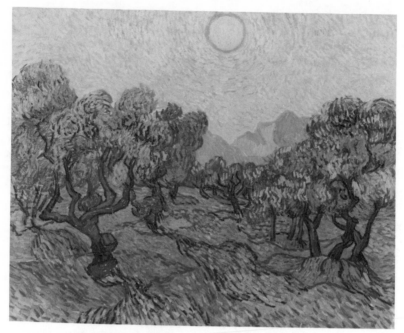

3 Van Gogh, Olive Trees, *1889. Oil on canvas,*
29 x 36½". Minneapolis Institute of Arts

attain. For this reason, Aurier connected Vincent's genius directly to madness as well as to pain and suffering. He called him "a terrible, maddened genius, often sublime, sometimes grotesque, always near the brink of the pathological."[58] Césare Lombroso's treatise *L'homme de génie* (Paris, 1889; Italian ed. 1882) was notorious for associating genius and madness. The literature of the period abounds in denials of this thesis,[59] but the ideas of suffering as sensitivity and madness as genius continued to pervade the Symbolist milieu. Even the well-respected philosopher Ravaisson concluded in his study of nineteenth-century French philosophy (1868) that genius and madness are not totally incompatible.[60]

In light of the prevailing attitude on the subject, it is not so surprising to find Van Gogh, too, emphasizing the positive side of neuroses. In his letter to his sister in which he discusses Aurier's recent characterization of him as neurotic, he connected neurosis with sensitivity.

The ideas he speaks of are not my property, for in general all the impressionists are like that, are under the same influence, and we are all of us more or less neurotic. This renders us very sensitive to colors and their particular language, the effects of complementary colors, of their contrasts and harmony.[61]

The second phase of the creative process, *la rêverie philosophique*, represents the interaction between artist and motif, in which Ideas (absolutes or "universals") reveal themselves to the artist, and a mutual deformation takes place between the subjective "idea" of the artist and the objective "idea" contained in the object. In the case of Van Gogh, nature revealed its essence to him through the filter of his hyperaesthetic personality. The reverberation between artist and object results in an interior *haute synthèse* of his vision of nature, which Aurier referred to as the "ideal."[62] This process defines Van Gogh's intention as well, to express his own soul through the soul of nature.

In the last step of the creative process, *la traduction*, the artist translates his ideal into a work of art.[63] The means by which this step is effected constitute Aurier's expressive theory, based on a reductive and purist aesthetic. "One must obtain the greatest possible effect with the least possible means."[64] The means of expression are themselves "direct signifiers" because they, too, contain Ideas.[65] It is, in fact, through the perception of the formal configuration of the motif that the artist grasps its universal content,[66] since essences (absolutes) are revealed as "undulating abstractions."[67] The formal configuration that represents the work will be different from that of the motif because the artist selects only those formal elements that clearly and distinctly express its universal content, and because he can and should exaggerate or deform those elements according to his subjective response to them.[68] The painter then "kneads with colors" his meaning and "translates his dream" through formal elements.[69] The result of this process is an art that is ideally synthetic, symbolic, and decorative.[70] Van Gogh's *traduction* followed this pattern, according to Aurier. He saw the "secret character" of things through lines and colors; in other words, he saw the significance of an object in its formal configuration. He translated his ideal in the same manner: his lines and colors are expressive *means*, simple *methods* of configuration."[71]

In Van Gogh's *traduction*, his realism comes to the fore. According to Aurier, his feeling for the materiality and tangibility of matter,

part of his Dutch heritage, led him to translate his ideal through material forms, rather than distorting forms into an abstract synthesis as Gauguin and Bernard did, for example. But his realism is very different from his earlier Dutch ancestors, because it was translated through an excessive, neurotic temperament, so different from their healthy, bourgeois ones. More important, he considered material reality to be only a "marvelous language destined to translate the Idea," rather than as an end in itself.[72]

Beneath this morphic envelope, beneath this very fleshly flesh, this very material matter, there lies, in almost all his canvases, for those who know how to find it, a thought, an Idea, and this Idea, the essential substratum of the work, is, at the same time, its efficient and final cause.[73]

Van Gogh attained this "affirmation of the character of things" through "his often daring simplification of forms."[74] He therefore arrived at the two "fundamental dogmas" of Symbolism as Aurier understood them: the creation of *symbols* through *synthesis*. Aurier defined the symbol as the expression of ideas, and synthesis as the means to attain it, through "the aesthetic and logical simplification of forms," in a "mode of general comprehension."[75] Van Gogh achieved "a masterly synthesis" through his drawing ("dessin") by deformations that "exaggerate the character" of the motif, and by simplification "over and above" detail.[76]

The result is what Aurier referred to in a later article on Gauguin as "decorative," by which he meant an art that "sympathetically radiates"[77] its meaning through a literal and direct presentation of the formal elements.[78] The physical vibration of such a work, resulting from its emphasis on formal means to create a decorative unity, resonates in a spiritual vibration. Such a presentational art, in which meaning is created through the simplified and emphatic presentation of formal elements, characterizes the particular effect and the revolution of Van Gogh's art.

In his analysis of that art, Aurier applied the five axioms of his aesthetic and expressive theory, which was definitively set out only later in his article on Gauguin.[79] Van Gogh's art is ideistic, symbolist, synthetist, subjective, and decorative.

Finally, Van Gogh conformed to the most important element in Aurier's concept of the artist. He communicated with his motif on the level of "transcendental emotivity."[80] The "vehement passion"[81] of his work shows that he was among those who are "moved body and soul by the sublime spectacle of Being and of pure Ideas!"[82]

Aurier characterized Van Gogh's relation to society as that of an "isolé," an isolated one. His work is "so original and so apart from the milieu of our pitiable art today."[83] This is again a qualitative statement. *"The value of a work of art is inversely proportional to the influence of the milieu on it."*[84] The more an artist is able to isolate himself from his decadent milieu, the greater his art will be.

In summary, in his study of Van Gogh, Aurier applied his theory of the creative process, his critical theory, and his aesthetic and expressive theory of Symbolist art. He did not try to claim that Van Gogh held these beliefs. "His poetic soul takes the place of an aesthetic."[85]

Van Gogh's general reaction to Aurier's article was favorable, even though the personal characterization in it frightened him. As Mark Roskill points out, Van Gogh's response represents his "psychological withdrawal at this point from the acclaim that Aurier's article represented."[86] This withdrawal did not occur immediately, however, and can be traced through his letters. As will be shown, his opinion about the article and critical acclaim ebbed and flowed on the waves of his illness.

The Artist's Response

Van Gogh's first reaction to Aurier's article was dismayed surprise.[87] He wrote his mother toward the end of April, 1890, from St. Rémy: "When I learned that my work was being recognized in an article, I immediately feared that this might completely un-nerve me. It is almost always like that in an artist's life that success is one of the worst things."[88] When Isaacson had wanted to do an article on him earlier, Vincent had asked him not to,[89] because he did not yet feel ready for a critique. Theo had not told his brother that Aurier had approached him about his article,[90] probably fearing that Vincent would refuse him, too. The artist, constantly unsure of his work,[91] feared ridicule and was anxious about publicity.

Yet, surprisingly, Van Gogh confirmed Aurier's image of him as the hypersensitive artist. In his letter to the critic, he told him that "the emotions that grip me in front of nature can cause me to lose consciousness," resulting in a fortnight during which he was incapable of working.[92]

He was in fact flattered that an article with such an "artistic value of its own" had been written about him.[93] He mentioned it in most of the letters of this period before his next and intensive

25

attack.[94] On the day he received it he said that it, along with other things, made him feel better.[95] He claimed that he did not feel worthy of it, however, and said his role should be considered only secondary.[96] But he recognized its economic value and suggested to Theo that it would be worthwhile to send copies of the article to dealer friends.[97] He truly appreciated what Aurier had done for him, and sent the critic a study of cypresses to show his appreciation.[98]

At the same time Vincent felt hostile towards the article. He expressed this in harsh words to his mother: "I was disturbed when I read it, it is so exaggerated; things are not like that. . . ."[99] This is, in part, a response to the hyperbole of Symbolist language that Aurier used.[100] However, what really disturbed Vincent was Aurier's characterization of him as an "isolé." Vincent consistently shrugged off the yoke of singularity: ". . . what sustains me in my work is the very feeling that there are several others doing the same thing I am, so why an article on me and not on those six or seven others, etc.?"[101] Such an image conflicted with his dream of a community of artists working together in harmony,[102] and made him feel afraid and alone.

Van Gogh further remarked that Aurier's article might have tempted him to move toward abstraction if only he did not so need the reassurance of nature.[103]

Aurier's article would encourage me if I dared to let myself go, and venture even further, dropping reality and making a kind of music of tones with color, like some Monticellis. But it is so dear to me, this truth, *trying to make it true*, after all I think, I think, that I would still rather be a shoemaker than a musician in colors.[104]

This passage shows that Van Gogh was conversant with the tenets of Aurier's expressive theory.

In an earlier letter to his friend the artist Emile Bernard, Van Gogh had also spoken of his need for the model and his attachment to nature, but he admitted that he was not totally opposed to abstraction: "I don't mean I won't do it myself after another 10 years of painting studies."[105] However, as his illness developed, abstraction became a fearful thing to him. Reality provided a bulwark against loss of control: "In any case, trying to remain true is perhaps a remedy in fighting the disease which still continues to disquiet me."[106]

Toward the end of February, 1890, Vincent suffered another

attack, which lasted two months. He wrote to his brother, April 29, 1890, from St. Rémy: "I am sadder and more wretched than I can say, and I do not know at all where I have got to."[107] Only then did he ask Aurier through Theo not to write any more articles on him because: "I am too overwhelmed with grief to be able to face publicity. Making pictures distracts me, but if I hear them spoken of, it pains me more than he [Aurier] knows."[108] Thus his negative reactions to Aurier's characterization of him must be read in the light of his degenerating mental stability.

In contrast to Vincent's forthright response to Aurier's personal profile of him, he neither rejected nor accepted Aurier's interpretation of his *art* outright. He said only that the critic had correctly identified the standards to which he aspired.[109] However, if one looks at other statements by Van Gogh, especially those before the onset of his illness, Aurier's interpretation of him as a Symbolist

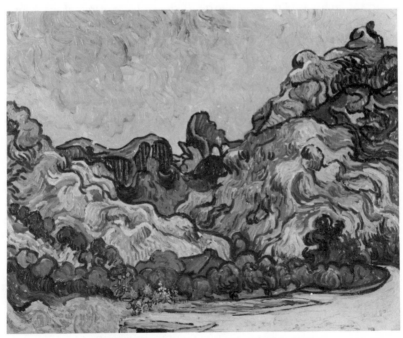

4 Van Gogh, Mountains at Saint-Remy, *1889.*
Oil on canvas, 28¼ x 35¾". Solomon R. Guggenheim
Museum, New York. Justin K. Thannhauser
Collection. Photo: Museum, Robert E. Mates

who relied more on nature than on memory or imagination seems justified.

I won't say that I don't turn my back on nature ruthlessly in order to turn a study into a picture, arranging the colors, enlarging and simplifying. . . . I exaggerate, sometimes I make changes in a motif; but for all that, I do not invent the whole picture; on the contrary, I find it all ready in nature, only it must be disentangled.[110]

Van Gogh's need to "disentangle" through "exaggeration" of what is already "in nature" seems also to support Aurier's belief in a superior order underlying nature.

Vincent's statement on the role of imagination reveals a similar attitude towards relativity and absolutes: "[Imagination] alone can lead us to the creation of a more exalting and consoling nature than the single brief glance at reality . . . can let us perceive."[111] As early as 1885, he even indicated a need for deformation, an important factor in Aurier's theory: "*I should be desperate if my figures were correct* . . . I do not want them to be academically correct . . . my great longing is to learn to make . . . incorrectnesses, . . . changes in reality, so that they may become, yes, lies if you like—but truer than literal truth."[112]

He wanted to grasp the essential in nature, "what does not pass away in what passes away,"[113] through the technique of synthesis. "What I want to make is a drawing [in which] the figure [is] essentially simplified with intentional neglect of those details which do not belong to the real character, and are only accidental."[114] This is exactly how Aurier conceived Vincent's work: "His . . . draughtsmanship exaggerates the character, simplifies, leaps over the detail like a master, . . . and achieves an authoritative synthesis. . . ."[115]

Although the masters of the Symbolist period continue to be categorized by the almost meaningless appellation of Post-Impressionism, the predominant Symbolist aesthetic affected all of them to some degree. Van Gogh's statements relate his aesthetic more closely to Aurier's Symbolist doctrine than to any other of the time.

The discourse established between Van Gogh and Aurier is a prototype of the relation between artist and critic in the twentieth century, and is, in fact, among the first of its kind. Aurier based his study on an ideology and an aesthetic theory that he had formulated himself. He did not force Van Gogh into this mold, but

rather saw Vincent as exemplary of it. Van Gogh's response, on the other hand, was not entirely formulated from an artistic position. It was also the product of his emotional instability, and, most important, of his desires and needs as a human being. In this case, one cannot rely solely on the artist's words to judge the validity of the critic's analysis. One must read between the lines and draw from other statements in order to untangle the complexity of Vincent's response to the critic. This situation points up the kinds of problems that make the estimation and systematic scrutiny of the relation between critical inquiry and artistic intention so difficult. But even more, it gives us a glimpse of the very human aspects of the dialogue between Van Gogh and his critic and supporter, Aurier.

Notes

1. Letter to Albert Aurier, Aug. 27, 1890, Paris, T55, Van Gogh, III, 589. Theo ends his letter on a poignant note: "... if you should be willing to do me the honor of looking me up some evening, . . . we could talk about these things and also about the man, whom I mourn every day . . ." (*ibid.*, 590). Aurier accepted Theo's offer to write Van Gogh's biography. In the rough draft of a letter in the Aurier Archives to a prospective publisher (with no addressee), Aurier asks if "monsieur" plans to publish the biography as Mme Theo van Gogh suggested, and adds: "J'écris actuellement, une étude critique et biographique sur Vincent Van Gogh, le grand peintre méconnu qui vient de mourir laissant une oeuvre si puissante et si originale." Aurier and Theo had a friendly relationship, beginning ca. 1888 and lasting until Theo's death. Theo mentioned the critic in several letters to Vincent, such as T29, Paris, March 19, 1890, Van Gogh, III, 566, and T33, Paris, May 3, 1890, Van Gogh, III, 569.

2. Alfred Valette, editor of the *Mercure de France* and Aurier's friend, considered the critic his personal link to contemporary artists, as seen in a letter he wrote to Aurier: "Il faut absolument que nous pénétrions dans le monde des peintres assez calé. Pour ce, nous publierons de temps a [sic] autre un clichage de la jeune école. Vous qui jouissez d'une réputation mirifique parmi ces jeunes gens, vous pourrez être d'une grande utilité à *Mercure* pour ces petites operations." (Unpublished letter in the Aurier Archives, dates August 14, 1892.) Shortly after Aurier's death, Remy de Gourmont called him a "maître en critique d'art" (*Promenades littéraires*, Paris, 1963, 193). His art criticism according to de Gourmont "fourniront des idées, une méthode et des principes . . ." (*Le IIème livre des masques*, Paris, 1898, 254). He further contended that Aurier, along with Félix

Fénéon, was the only art critic of the Symbolist era worthy of the title (*Lycée Jean Giraudoux de Châteauroux, mémorial du centenaire,* Châteauroux, 1954, quotes de Gourmont from 1898, 213). Many other testimonies could be cited in support of Aurier's reputation.

3. His theory, although consistent, coherent, and complete, exists only in piecemeal form in his critical writing; he died before he could consolidate and publish it. In my dissertation (Mathews; UMI Research Press, Ann Arbor, MI, in press), I have synthesized his theories of the creative process, the aesthetic experience, and the critical process. Even before my study, Aurier's reputation had been revived over the last decades, after a long period of scholarly neglect. However, citations concerning Aurier in the recent literature on Symbolism are often misleading, or without great depth. One example among many can be found in the article by Belinda Thompson, "Camille Pissarro and Symbolism: Some Thoughts Prompted by the Recent Discovery of an Annotated Article," *Burlington Magazine,* CXXIV, 1982, 14-21, in which she accepts Camille and Lucien Pissarro's misreading of Aurier. Lucien Pissarro declared that Aurier had falsely differentiated the equivalent terms, "émotivité" and "sensation" (p. 19). However, Aurier used "émotivité" in the context of "l'extase" and the transcendental, and "sensation" as more directly related to a naturalistic aesthetic. Neither Lucien nor Thompson grasped this distinction. Thompson also accepts the elder Pissarro's false pronouncement that Aurier simply dismissed the Impressionists (p. 19). Aurier did reject a Naturalist aesthetic, but he wrote articles praising Renoir and Monet and even Pissarro himself (although in that article, Aurier referred to Pissarro's works done after Impressionism). Such a misreading is understandable since no major study of Aurier's aesthetic has previously been undertaken. However, Robert Goldwater, in his book, *Symbolism,* New York, 1979, shows a basic understanding of Aurier.

4. Published in the first issue of the *Mercure de France,* January, 1890. Aurier was one of the founders of this important journal.

5. Aurier, 1891b, 272. He is indebted to Baudelaire for the concept of the critic as poet. In the poet's "Salon of 1846," he stated that: "a fine picture [un beau tableau] is nature reflected by an artist, the criticism which I approve will be that picture reflected by an intelligent and sensitive mind. Thus the best account of a picture may well be a sonnet or an elegy." (Charles Baudelaire, *Art in Paris, 1845-1862,* trans. and ed., Jonathan Mayne, London, 1965, 44.) This passage is marked and underlined in Aurier's copy of Baudelaire's *Curiosités esthétiques,* Paris, 1889, 82 (Aurier Archives).

6. Aurier, 1891b, 272. According to Aurier, education is the tool of a decadent civilization used to stifle man's innate understanding. He said, for example, that "l'éducation ait atrophié en eux cette faculté," which allows us to grasp the meaning of things (Aurier, 1892c, 301), and that "les génies instinctifs des premiers temps de l'humanité" divined naturally. (Aurier, 1891e, 216.)

7. Aurier, 1891b, 272. He referred to this ensemble and its effect on the viewer as the "prolongement spirituel." The aim of art is to contain this cluster of ideas.

8. Aurier went beyond Baudelaire's understanding of the critic here, in his insistence on critical rather than only poetic interpretation. He criticized Theophile Gautier for "tenta, mais sans aucun sens critique, des transpositions d'oeuvres picturales en oeuvres littéraires." (Aurier, 1891-92, 200.)

9. Aurier, 1890c, 258; trans. Welsh-Ovcharov, 55-56.

10. Aurier, 1892c, 303, defined the aesthetic experience as "la communion de deux âmes, l'une inférieure et passive, l'âme humaine, l'autre supérieure et active, l'âme de l'oeuvre."

11. Aurier, 1892c, 303. He described this aesthetic experience in 1891a, 348, as the ability to "frissonner à l'unisson du rêveur qui l'a créée." It is an experience analogous to "l'Amour." For further discussion of Aurier's theory of the aesthetic experience, see Mathews, chap. IV.

12. Aurier, 1890c, 258; trans. Welsh-Ovcharov, 56.

13. Aurier, 1891e, 214, quoted Baudelaire's poem "Correspondances," from *Les fleurs du mal*, and Swedenborg's theory of correspondences, in 1891e, 210. Idealism was an integral concept for the Symbolists. Its influence can be traced from around 1885 in all areas of their thought. However, it is not a simply defined, singular concept, but a complex phenomenon, whose borders are not easily drawn and whose advocates are not easily categorized. In general, the contour of one's Idealism depended on whether one subscribed to the German Idealists Schelling and Hegel or to Schopenhauer, among others. For further discussion of Aurier's correspondence theory and Idealism, see Mathews, chap. II, 73-105.

14. "*Dans la nature, tout objet n'est, en somme, qu'une Idée signifiée* . . . ce substratum idéiste . . . est partout dans l'univers et . . . selon Platon, est la seule vraie réalité—le reste n'étant que l'apparence, que l'ombre . . ." (Aurier, 1892c, 301); my translation, here and below, unless otherwise noted. I have translated passages into English that are not translated elsewhere (only a few passages have heretofore been translated), or in exceptional cases where I preferred my own translation.

15. ". . . Les symboles, c'est-à-dire les Idées, surgissent des ténèbres, s'animent, se mettent à vivre d'une vie qui n'est plus notre vie contingente et relative, d'une vie éblouissante qui est la vie essentielle, la vie de l'Art, l'être de l'Etre" (Aurier, 1891e, 217-18).

16. "Oh! combien sont rares ceux dont s'émeuvent les corps et les coeurs au sublime spectacle de l'Etre et des Idées pures!" (Aurier, 1891e, 217). Plotinus also believed that only superior individuals were capable of experiencing the revelation of Ideas. See M.-N. Bouillet, *Les Ennéads de*

31

Plotin, Paris, 1857-61, III, Ennéad V, ix, i, 132, and II, Ennéad VI, vii, 9-19, 426ff.

17. Aurier, 1890c, 260.

18. "Sous des ciels tantôt taillés . . . sous des ciels pareils . . ." (*ibid.*, 258); trans. Welsh-Ovcharov, 55-56. Filiz Eda Burhan, in "Vision and Visionaries: Nineteenth Century Psychological Theory. The Occult Sciences and the Formation of the Symbolist Aesthetic in France," Ph.D. diss., Princeton, 1979, 337, notes this use of hypnotic intonation in Aurier's article on Gauguin. Stéphane Mallarmé was most influential in the dissemination of such techniques, and for stimulating interest in alchemy. See, for example, his *Divagations*, Paris, 1897, 325, 326, and *passim*.

19. Alchemy fascinated writers throughout the 19th century, but there was a growing attraction to it from 1860. See Enid Starkie, *Arthur Rimbaud*, London, 1949, 101, 124-37, 171; and August Viatte, *Les sources occultes de Romantisme, 1770-1820*, 2 vols., Paris, 1928, for the earlier part of the century. M. Berthelot, *Les origines de l'alchimie*, Paris, 1885, and Louis Figuier, *L'alchimie et les alchimistes. Essai historique et critique sur la philosophie hermétique*, Paris, 1854, which Aurier owned, are scholarly studies on alchemy that were available during the Symbolist period. See Mathews, chap. II, "Intellectual Milieu: Alchemy," for a discussion of the influence of alchemy on Symbolist thought and literature.

20. R.C. Zaehner, *Mysticism, Sacred and Profane*, Oxford, 1957, 63. Starkie (as in n.19), 101, points out that Rimbaud was particularly influenced by alchemical theory in his own aesthetic theory.

21. See Mathews, chap. III: "Creative Process: Expressive Theory."

22. Berthelot (as in n. 19), 284, described this idea as follows: ". . . aux yeux des alchimistes, l'oeuvre mystérieuse n'avait ni commencement ni fin . . . le serpent annulaire, qui se mord la queue: emblème de la nature toujours une, sous le fond mobile des apparances."

23. Plotinus used the term "extase" to refer to such experiences. See for example, Ennéad VI, ix, 11, for "extase," and Ennéad I, i, 9 (as in n. 16), and *passim* for the ascension of the Soul to the absolute through a process of purification. For various other metaphorical interpretations of alchemy, see M. Caron and S. Hutin, *Les alchimistes*, Paris, 1959, 80.

24. His friend, Edouard Dubus, in "La théorie alchimiste au XIXme siècle," *Mercure de France*, I, 1890, 373, claimed that Aurier cited some examples of authentic alchemical transmutations in his *Pandémonium philosophal du XXme siècle*, and that he was actively involved in alchemical research. The only trace of this treatise, however, does not mention alchemy. See Remy de Gourmont, "Notice," the introduction to Aurier, 1893, xxviiff. The other direct reference to this interest in alchemy is his request in a letter to his mother dated September 13, 1888, that she send Figuier's *L'alchimie et les alchimistes*, which he had forgotten on his last visit to

Châteauroux (Aurier Archives). From all available evidence, it appears that he knew the philosophy of alchemy and incorporated its "spiritual doctrine," along with concepts derived from Plotinus, Baudelaire, etc., into his own aesthetic theory, but that was the extent of his involvement in it. See Mathews, chap. II, "Intellectual Milieu: Alchemy."

25. "... Ces obscurs alchimistes de ce qui sera peut-être le Grand-Oeuvre de demain" (Aurier, 1892a, 262).

26. "... Faire surgir de son creuset magique plein de gemmes, d'émaux et de métaux en fusion ... les rutilantes apparitions" (Aurier, 1891c, 315). "Rutilant," a word that Aurier often used (see Aurier, 1892b, 225, for example), signifies a red or gold or red-gold glow, which is also the color of metal in the alchemical process when it has transmuted into pure gold (Starkie, as in n. 19, 136).

27. Aurier, 1892b, 224-25; 1891d, 230; 1890a, 239.

28. Aurier, 1890c, 258; trans. Welsh-Ovcharov, 55-56.

29. Berthelot (as in n. 19), 218, 233; Figuier (as in n. 19), 29-30, 51. Aurier uses the word "délétère" here; Welsh-Ovcharov translates it as "poisonous," although "deleterious" would also be applicable.

30. Aurier, 1890c, 258; trans. Welsh-Ovcharov, 56, with my added parentheses.

31. See n. 26.

32. Aurier, 1890c, 258; trans. Welsh-Ovcharov, 56.

33. Berthelot (as in n. 19), 233; Figuier (as in n. 19), 51.

34. Berthelot (as in n. 19), 240; Starkie (as in n. 19), 170-71.

35. Aurier, 1890c, 258-59; trans. Welsh-Ovcharov, 56, except that "émaux" has been translated here as enamels (relevant to alchemical processes) as opposed to "glazes" (in the cited translation).

36. *Ibid.*, 259; trans. Welsh-Ovcharov, 56. Concerning the animism of all nature, it is of interest to note that according to Figuier (as in n. 19), 37, alchemists believed that inorganic elements were also endowed with a sort of life.

37. Aurier, 1890c, 259.

38. *Ibid.*, 258; trans. Welsh-Ovcharov, 56.

39. *Ibid.*, 260. Aurier elsewhere proposed that the term sincerity no longer referred only to the artist's sincerity to nature, but also to his own subjective sensations before nature, and to his imaginative conception as well: "Tout artiste est libre de ne pas s'en tenir à cette sincérité immédiate des réalistes, c'est-à-dire à cette absolue copie des impressions *naturellement* perçues, sans pour cela cesser d'être sincère ... le mot *sincère* pourra aussi bien s'appliquer aux oeuvres de Courbet, ce farouche réaliste, qu'à celles du Puvis de Chavannes ou d'Henner, ces poètes" (Aurier, 1889, 286).

40. Aurier said that he preferred "des essais maladroits" and "des efforts avortés" to Salon art, because such works are "originaux et personnels" and "plus intéréssants et plus vraiment de l'art" (1892a, 262).

41. Aurier, 1890c, 260.

42. Aurier, 1891a, 351-52. In a response to Van Gogh's letter, Aurier noted his own sincerity in his attempt to intuit Van Gogh's theories and temperament. (Aurier Archives, rough draft, probably the letter Theo mentions in his letter to Vincent, Mar. 19, 1890, Paris, T29, Van Gogh, III, 566: "Enclosed you will find a letter from Aurier.")

43. ". . . Intime communion avec l'immanente pensée de la nature, avec l'âme des choses" (Aurier, 1892c, 301).

44. Aurier, 1890c, 263, trans. L. Nochlin, 138.

45. Aurier's ideas on the subjective nature of reality stem from Schopenhauer's dictum, popular during the Symbolist period, "the world is my representation," as well as from the pervasive subjectivism and pessimism of the period. See Mathews, chap. II, "Intellectual Milieu: Subjectivism, Scepticism, Pessimism."

46. Aurier, 1889, 286. The terms used here to describe the steps of the creative process are drawn from Aurier's writings, but are used in a larger context. These steps lack distinctive designations with which to discuss them, and therefore I have given them what I consider to be appropriate titles. For clarification and sources of these terms, see Mathews, Lexicon.

47. Aurier, 1890c, 261.

48. ". . . He is a hyperaesthete, with clear symptoms who, with abnormal, perhaps even painful, intensity perceives the imperceptible and secret characteristics of line and form, and still more, those colors, lights, and nuances which are invisible to healthy eyes, the magic iridescence of shadows" (*ibid.*, trans. Welsh-Ovcharov, 57).

49. Aurier, 1892c, 305.

50. ". . . La sensibilité plus profonde and plus exquise." P.S. Ballanche, *Du sentiment considéré dans ses rapports avec la littérature et les arts*, Paris, 1801, 132-34. "Le Malheur" is best translated here as unhappiness or even misery.

51. Starkie (as in n. 19), 129.

52. "Le poète se fait *voyant* par un long, immense et raisonné déréglement de tous les sens" (Rimbaud, *ibid.*).

53. Baudelaire, "The Blessing" ("Bénédiction"), *The Flowers of Evil*, ed. Marthiel and Jackson Mathews, Norfolk, CT, 1963, 9. In "Rêve d'un curieux," *Les fleurs du mal*, the poet refers to pain as a "douleur savoureuse."

54. *Webster's New Twentieth Century Dictionary, Unabridged*, 2nd ed., 1976, 894. See also A.L. Claireville, *Dictionnaire polyglotte des termes médicaux*, Paris, 1950, 6930. In the *Dictionnaire de médecine*, pref. Jean Hamburger,

Paris, 1975, the term is defined as follows: "Hyperesthésie: Sensation cutanée anormalement intense provoquée par un stimulus normal. Ce terme, qui suppose une perception sensitive de qualité supérieure à la normale, n'est appliqué qu'à la sensibilité douloureuse."

55. Aurier, 1890c, 262.

56. Henri F. Ellenberger, *À la découverte de l'inconscient. Histoire de la psychiatrie dynamique*, trans. J. Feisthauer, Villeurbanne, 1974, 207ff. See Janet's publications, such as *Névroses et idée fixes*, Paris, 1898, and *Les névroses*, Paris, 1909. Articles by Janet were published as early as the 1880's; a collection of them appeared in 1893.

57. This was true even among Symbolist "bêtes noires" such as Hippolyte Taine; see especially his *De l'intelligence*, Paris, 1906, 11th ed., I, 13-15, for his concept of mental illness as a tool to clarify "tout le mécanisme de notre pensée."

58. Aurier, 1890c, 261; trans. L. Nochlin, 136.

59. José Hennebicq, *L'art et l'idéal*, Paris, 1907, 71. See also Ellenberger (as in n. 56), 238.

60. Felix Ravaisson, *La philosophie en France au XIXe siècle*, Paris, 1868, 199-200. Ravaisson was not in total agreement with Lombroso's later thesis, however. He denied a causal relation between madness and genius, for example.

61. Letter W20F to his sister, Wilhelmina, middle of Feb., 1890, St. Rémy, Van Gogh, III, 467.

62. These phases of the creative process are described at length in Mathews, chap. III. For passages in Aurier relating to this process, see Aurier, 1891-92, 195 (*la rêverie philosophique*, and 1892c, 303 (*la haute synthèse*).

63. Mathews, chap. III, and Aurier, 1892c, 303, and 1891e, 213, 215-16.

64. "*Il faut obtenir le plus grand effet possible avec les moindres moyens possibles*" (Aurier, 1890a, 240).

65. "Directement significateurs," Aurier, 1891e, 215; and Aurier, 1890a, 238.

66. See Mathews, Lexicon, "formal configuration." The critic described this process as follows: ". . . *l'émotion psychologique* éprouvée par l'artiste devant la nature ou devant son Rêve ... peut ... n'être qu'une sensation d'un accord particulier de lignes, d'une symphonie déterminée de couleurs" (Aurier, 1891a, 356).

67. Aurier, 1891e, 217.

68. *Ibid.*, 215.

69. Aurier, 1891b, 271-73. Scientific studies on the emotional properties of color and line such as those by Charles Henry, so important for Seurat, no doubt affected Aurier's belief in the expressive power of formal means.

But he also considered the limits of such studies to be their reliance on science in favor of suggestivity. See Aurier, 1892c, 302.

70. Aurier, 1891e, 215-16.

71. Aurier, 1890c, 262; trans. L. Nochlin, 137.

72. *Ibid.*, 261-62.

73. *Ibid.*, 262; trans. L. Nochlin, 137.

74. *Ibid.*, 261.

75. Aurier, 1892c, 308, and 1891e, 215.

76. Aurier, 1890c, 264.

77. Aurier, 1892c, 303. We recognize a "chef-d'oeuvre" through its "rayonnement sympathique."

78. That is, through simplification of means—a straightforward employment of line, color, and shape, liberated from conventional use. Decorative art relies on the ability of formal elements to have enough presence to convey significant meaning. To Aurier, art is a "sign," a hieroglyph in effect, a compact, immediate, unified statement. See Mathews, chap. III, "Creative Process: Decorative Art," and Lexicon; and Aurier, 1891e, 216, and 1892c, 303.

79. Aurier, 1891e, 215-16.

80. *Ibid.*, 217.

81. Aurier, 1890c, 261, paraphrased.

82. Aurier, 1891e, 217.

83. Aurier, 1890c, 265.

84. *"L'oeuvre d'art est, en valeur, inversement proportionnelle à l'influence des milieux qu'elle a subie"* (Aurier, 1891-92, 187-88). This axiom is proposed in opposition to Taine's theory that the artist is a product of his time, his environment, etc.

85. "Son âme de poète lui tenait lieu d'esthétique." Charles Morice, *Paul Gauguin*, Paris, 1919, 174, quotes from a conversation with Aurier.

86. Mark Roskill, " 'Public' and 'Private' Meanings: The Paintings of Van Gogh," *Journal of Communication*, XXIX, Fall, 1979, No. 4, 160, n. 3. Sven Loevgren, *The Genesis of Modernism*, Bloomington, IN, 1959, rev. ed., London, 1971, vii ff., agrees that Van Gogh was upset because the article put him too much in the limelight and exposed his mental state.

87. Vincent received the article from Theo shortly before he wrote to his brother on Feb. 1, 1890, from St. Rémy, a month after it was published (letter 625, Van Gogh, III, 251). He had just recovered from an attack.

88. Letter 629a, n.d. (ca. April, 1890), trans. in John Rewald, *Post-Impressionism*, New York, 1978, 347. (I prefer this translation to Van Gogh, III, 263.)

89. Letter to his mother, Feb. 15, 1890, St. Rémy, 627, Van Gogh, III, 259.

90. Theo must have known about the article beforehand, since Aurier visited him to see Van Gogh's paintings and no doubt studied them there in order to write his essay. Yet in a letter to Vincent from Paris, Dec. 8, 1889, he mentioned Aurier's visit but nothing about the article: "He [Aurier] is very interested in what you are doing, and he showed me a little paper he edits . . ." (letter T21, Van Gogh, III, 558). Rewald (as in n. 88), 340, agreed with this suggestion.

91. He said as much in his letter to Theo, Feb. 1, 1890, St. Rémy, 625, Van Gogh, III, 253, about painting cypresses. He realized that would be the thing to paint, but he was not quite ready for it. He said the same thing about abstraction: "maybe ten years from now." See the discussion on abstraction below.

92. Letter 626a, St. Rémy, Van Gogh, III, 257.

93. *Ibid.*, 256. He also mentioned its artistic value in a letter to Theo, Feb. 1, 1890, St. Rémy, 625, Van Gogh, III, 252.

94. This attack began in late Feb., 1890, after he spent two days in Arles, and lasted until the end of April. Letters 625, 626, 626b, 627, and W20, written before the attack, mention Aurier's article.

95. To Theo, Feb. 1, 1890, St. Rémy, 625, Van Gogh, III, 253.

96. *Ibid.*, 251; letter 626a, to Aurier, ca. Feb., 1890, Van Gogh, III, 256. Roskill (as in n. 86), 160, n. 3, calls this "false modesty."

97. Letter to Theo, n.d. (ca. Feb., 1890), St. Rémy, 626, Van Gogh, III, 254.

98. Van Gogh discussed this work in his letter to Aurier, n.d. (ca. Feb., 1890), St. Rémy, 626a, Van Gogh, III, 257. Aurier must have received the work since Theo told Vincent that he had had the painting framed according to Vincent's instructions before sending it. (Letter to Vincent, T33, Paris, May 3, 1890, Van Gogh, III, 569.) This painting was bought from Aurier's family by M. Kröller and is now in the Kröller-Müller Museum, Cat. No. 233 (Cat. de la Faille, 620), ill. in W. Scherjon, *Catalogue des tableaux par Vincent Van Gogh décrits dans ses lettres*, Utrecht, 1932, 23, No. 11.

99. "J'ai été peiné quand j'ai lu; c'est tellement exagéré; les choses sont d'une autre sorte," Feb. 15, 1890, St. Rémy, 627, to his mother, Vincent van Gogh, *Correspondance Complète de Vincent Van Gogh*, 3 vols., trans. M. Beerblock and L. Roelandt, Paris, 1960. (My trans. is, I believe, preferable to Van Gogh, III, 259.)

100. Van Gogh nevertheless understood the reasoning behind such a style. Letter to Theo, Feb. 1, 1890, St. Rémy, 625, Van Gogh, III, 252: "the writer *must* heighten the tones, synthesize his conclusions, etc."

101. Letter to his mother, Feb. 15, 1890, St. Rémy, 627, Van Gogh, III, 259.

102. In letter B19a to Bernard, end of Oct., 1888, Arles, Van Gogh, III,

519, he spoke of a renaissance of art, etc. This letter was in the possession of "Mme Mahe-Williams [sic] at Aix, a cousin of Albert Aurier," according to Van Gogh, III, 474. Even after his first attack and the scenes with Gauguin, he wrote Theo that he thought Gauguin and he could still work together (n.d., ca. Feb., 1890, 626, Van Gogh, III, 254; Jan. 19, 1889, 572, Van Gogh, III, 125; ca. Jan., 1890, 623, Van Gogh, III, 248), and he spoke again of his desire to create a community of artists (second half of June, 1888, B6, Van Gogh, III, 485; ca. end of April, 1889, 586, Van Gogh, III, 157). Further, he could not abide contention among artists, and their various groupings and inner-circle disputes eluded him. (Letter to Aurier, ca. Feb., 1890, St. Rémy, 626a, Van Gogh, III, 257.)

103. By abstraction, Van Gogh did not mean a total rejection of the object, but a conceptual art such as that of Gauguin, based more on memory and imagination than on nature.

104. Letter to Theo, n.d., ca. Feb., 1890, St. Rémy, 626, Van Gogh, III, 254. The abstract qualities of *Flowering Almond Tree*, Rijksmuseum Vincent Van Gogh, Amsterdam, February, 1890, are interesting in this respect, especially since the work was probably painted after he received Aurier's article. See letter 629, to Theo, April 29, 1890, St. Rémy, Van Gogh, III, 262.

105. Letter to Emile Bernard, first half of Oct., 1888, Arles, B19, Van Gogh, III, 518.

106. Letter to Theo, n.d., ca. Feb., 1890, St. Rémy, 626, Van Gogh, III, 254. No causal relationship is implied between events in Vincent's life and his attacks. I only mean to point out that Van Gogh's despair over his illness led him to be more cautious in his attitudes.

107. Letter to Theo, April 29, 1890, St. Rémy, 629, Van Gogh, III, 261.

108. *Ibid.*

109. ". . . The article is very right as far as indicating the gap to be filled, and I think that the writer really wrote it more to guide, not only me, but the other impressionists as well. . . ." (letter to Theo, Feb. 1, 1890, St. Rémy, 625, Van Gogh, III, 251).

110. To Bernard, first half of Oct., 1888, Arles, B19, Van Gogh, III, 518.

111. To Bernard, April, 1888, Arles, B3, Van Gogh, III, 478.

112. To Theo, 1885, Nuenen, 418, Van Gogh, II, 401. For Aurier's understanding of artistic deformations as central to the creative process, see Mathews, chap. III, "Expressive Theory: Deformations."

113. To Theo, 1882, The Hague, 253, quoted from Gavarni, Van Gogh, I, 513.

114. To Theo, 1883, The Hague, 299, Van Gogh, II, 77.

115. Aurier, 1890c, 264; trans. L. Nochlin, 138.

Bibliography

Aurier Archives: located at the estate of Mme Williame, near Moulins, France, a collection of Aurier's papers.

Aurier, G.-Albert, 1893, *Oeuvres-posthumes,* ed. Remy de Gourmont, Paris. [Aurier's articles are organized here by date, and then alphabetized.]

————, 1889, "J.-F. Henner," *Oeuvres-posthumes,* 283-89.

————, 1890a "Camille Pissarro," *Oeuvres-posthumes,* 235-44.

————, 1890b, "Raffaëlli," *Oeuvres-posthumes,* 245-53.

————, 1890c, "Vincent Van Gogh," *Oeuvres-posthumes,* 257-68.

————, 1891a, "À propos des trois Salons de 1891," *Oeuvres-posthumes,* 345-60.

————, 1891b, "Henry de Groux," *Oeuvres-posthumes,* 269-77.

————, 1891c, "Le faux dilettantisme: Monticelli, Paul Gauguin," *Oeuvres-posthumes,* 313-18.

————, 1891d, "Renoir," *Oeuvres-posthumes,* 226-31.

————, 1891e, "Le symbolisme en peinture: Paul Gauguin," *Oeuvres-posthumes,* 205-19.

————, 1891-92, "Essai sur une nouvelle méthode de critique," *Oeuvres-posthumes,* 175-202.

————, 1892a, "Deuxième exposition des peintres Impressionnistes et Symbolistes," *Mercure de France,* v, 260-63.

————, 1892b, "Claude Monet," *Oeuvres-posthumes,* 221-25.

————, 1892c, "Les peintres Symbolistes," *Oeuvres-posthumes,* 293-309.

Mathews, Patricia Townley, "G.-Albert Aurier: Symbolist Art Theory and Criticism," Ph.D. diss., University of North Carolina, 1984.

Nochlin, Linda, ed., *Impressionism and Post-Impressionism, 1874-1904, Sources and Documents,* Englewood Cliffs, NJ, 1966. Partial translation of G.-Albert Aurier, "The Isolated Ones: Vincent Van Gogh," 135-39.

Van Gogh, Vincent, *The Complete Letters of Vincent Van Gogh,* 3 vols., trans. J. Van Gogh-Bonger and C. de Dood, Greenwich, CT, 1958.

Welsh-Ovcharov, Bogomila, ed., *Van Gogh in Perspective,* Englewood Cliffs, NJ, 1974. Partial translation of Albert Aurier, "Vincent, an Isolated Artist," 55-57.

2
Gauguin's Religion

THOMAS BUSER

One of the many different things about Paul Gauguin was that he painted religious pictures. Religious paintings by the major artists of the late nineteenth century are undoubtedly few, and few of the major artists, even in private, were concerned with religion.[1] For Gauguin, however, religion played an important role in his art and in his life. Fundamentally he was, I believe, a spiritual man, searching for Faith, even though his moral conduct and his theological opinions might have shocked contemporary Christians.

Gauguin was by no means a creative nor a systematic theologian. Nevertheless his religious belief went beyond the ordinary anti-clericalism and apologectics of his time. His Faith was easily more mystical than that prevalent in the Church at the time. Quite simply, Gauguin seems to have been enamored of theosophy.

Theosophy, like theology, is a study of God and of God's relations with man and the world. But it differs from traditional Christian theology in that this knowledge of God is inspired. Modern theosophy was stimulated by nineteenth-century interest in the religions and philosophies of the East, especially of India. Theosophy contends to be a synthesis of all religions, to have arrived at their inner, esoteric meaning, and, implicitly, to be the highest of all religions. Its principal doctrines are a pantheistic evolution and reincarnation, while the only morality that it demands is an adhesion to the brotherhood of man.[2]

At various moments, what Gauguin writes and, as we shall see, what Gauguin paints closely parallel the theosophical doctrine of Edouard Schuré's popular book, *Les Grands Initiés*. In *Les Grands Initiés* Schuré studies the occult religion as found in Krishna, Buddha, Zoroaster, Hermes (of Egypt), Moses, Pythagoras, and

Jesus. There is no point in proving that Gauguin read Schuré. He may have read some other, similar work of theosophy. We have no external documentation as to whether Gauguin knew of this or that book of theosophy beyond the fact that his artist friend Sérusier was an avid fan of *Les Grands Initiés*. Sérusier met Gauguin in 1888, and he seems to have spent two periods of time with Gauguin in Brittany in 1889. *Les Grands Initiés* was published in 1889. It would seem, then, that the creation of Synthetism and Gauguin's discovery of theosophy went hand in hand. Indeed, Gauguin's synthetist paintings often manifest his belief.

Gauguin most fully expresses himself on religion in an as-yet unpublished manuscript, *L'esprit moderne et le catholicisme*, basically a diatribe that he wrote in 1897-98 against the Catholic Church and for the benefit of the Catholic authorities in Tahiti.[3] From the manuscript it appears that Gauguin believed in a God who breathed life into an original chaos of insubstantial atoms and thus set nature on her course. By doing so, God materialized himself; and, if God once existed, he is now dead. Christ was not an historical person but he represents the *type* of all ideal perfections, the image of a future life of pure spirituality. The human soul, in Gauguin's theosophy, seems to be located in the *noeud vital* of the brain. Destined to metempsychosis, the soul fits into a definite (Romantic) evolutionary framework of things; moreover, in the *noeud vital* it controls evolution.

Much of *L'esprit moderne et le catholicisme* attacks the blindness and pharisaism of the Catholic Church as opposed to the rationality of true Science. Modern Science, in Gauguin's vocabulary, does not mean Positivism but rather the special knowledge which allows him to understand the enigmatic meaning of things. When Gauguin quotes Scripture (and he quotes it often) or Confucius or some Oceanic legend, he is most often quoting it to confirm his own modern gnosis. For example, was not Christ speaking about the 1880s and 90s when he said: "there is nothing hidden now which will not become perfectly plain and there are no secrets now which will not become as clear as daylight."[4]

A number of pictures in American collections illustrate Gauguin's religious belief. They are a pair of portraits and a gouache from the first years of Synthetism and a painting from Gauguin's first trip to Tahiti. All were painted well before Gauguin wrote *L'esprit moderne et le catholicisme*, but they already embody its content.

1 *Paul Gauguin, Self Portrait, 1889. Oil on wood,*
31¼ x 20¼". National Gallery of Art, Washington.
Chester Dale Collection

Gauguin painted the complementary portraits of himself
and of Meyer de Haan on adjoining panels of a closet door (Fig. 1 and
Fig. 2).[5] The paintings were part of the decoration of an inn at Le
Pouldu, Brittany, where in 1889-90 a "community" formed around
Gauguin. The group included Meyer de Haan, Charles Filiger,
and Paul Sérusier.

The whole of Gauguin's self-portrait is reminiscent of an
heraldic device: the haloed head of Gauguin overlaps the two basic
planes of red and orange. His flat right hand rises up from the
bottom edge and, in cigarette-smoker's fashion, holds a blue-purple
S-curved snake. Stylized thistles in blue and yellow fan out from
the bottom edge too. Gauguin stares askew out of blue and green
eyes. The artist has established a primitive harmony out of the
primary and secondary colors. He has composed the picture by a
series of intersecting arcs. Even the axis (running through the
nose) of Gauguin's face is an arc intersecting the arc separating the
planes. Gauguin's glance arcs to our left. A constant dynamic
linear motif sustains an active rhythm.

Gauguin's head, modeled to some extent in flat patterns of
varying flesh tones, seems to float mirage-like between the red and
orange planes. Although the overlapping of all the planes greatly
determines the spatial relationships, these planes of pure color
tend to push and pull in and out with forces opposed to the over-
lapping and to rationality. Gauguin's vision of himself is both of the
earth and very much not of the earth.

Representational elements must also be synthetized with the
"musical" elements. Denys Sutton has written that the self-portrait
illustrates the aesthetics of Satanism that Baudelaire preached.[6] To
be sure, there appears to be a certain corresponding ambivalence
in the painting. On more than one occasion Gauguin himself
brought attention to what he considered his dual nature of sinner
(snake and apples) and saint (the halo). Nevertheless, the interpre-
tation can go further. When his self-portraits have any symbolic
overtones at all, Gauguin usually portrays himself as Christ or
associates himself with Christ. The image of the painter as the
creating God has a long tradition, and Gauguin once verbalized the
thought: in August, 1888, he wrote to his friend Schuffenecker:
"L'art est une abstraction, tirez-la de la nature en rêvant devant et
pensez plus à la creation qui résultera, c'est le seul moyen de monter
vers Dieu en faisant comme notre Divin Maitre, créer."[7]

43

2 *Paul Gauguin,* Meyer de Haan, *1889. Oil on wood, 31⅜ x 20⅜". Private Collection*

Gauguin's work around this time has Messianic overtones both because he felt that he was suffering for his cause and because he felt that he must save painting. Is it not legitimate, then, to believe that Gauguin in the Washington self-portrait painted himself as a Christ, the second Adam, who has the serpent "in hand" as it were and for whom the tree in Paradise is a source primarily of knowledge, not of evil? He is a theosophical Christ, a seer, an initiate with special vision and special "Science." He can penetrate beyond the superficial, literal, and materialistic appearances of things. The symbol of this Science, the tree of knowledge, will appear in a number of paintings. It will often imitate what Gauguin took to be the Buddhist counterpart, the Bo tree, as he saw it in Javanese sculpture.[8]

Although in Gauguin's developed "theology" he takes pains to prove that the Catholic Church created Christ in the third century, nevertheless Gauguin always believed that the esoteric Christ was, as Schuré puts it, "the prince of the initiates, the greatest of the sons of God."[9] There is, furthermore, an obvious corollary implicit in any theosophical author: that the gradual development of enlightenment implies that the modern seer who can synthesize Christ with Buddha, Krishna, and so on, is at least as great as Christ. Needless to say, Gauguin felt at this time that he was synthesizing the elements of painting. Later on he would be more explicit about synthesizing religion.

The portrait of Meyer de Haan even more certainly projects the image of an initiate. Gauguin composed the de Haan portrait with many more straight lines and angles compared to all the arcs and intersections of the self-portrait. Meyer de Haan stares straight down at the tilted dish of apples or beyond them. The axis of the lamp on the right parallels the line of his glance. The strong diagonal of the table lifted high up in the panel creates a forceful movement across the panel. Only the horizontal edges of the books and the tilted plate seem to check the strong movement of the diagonal barrier. Meyer de Haan wears a flattened, red garment, seemingly of the same hue as the plane behind Gauguin's head in the Washington self-portrait. The background is divided between a cerulean and a dark green area. The latter is pierced by a dark gray "door" leading somewhere beyond.

Whereas Gauguin's head floats in the ambiguous space of the two large planes of the panel, the figure of de Haan is cut off from the

objects of his contemplation by the knifing diagonal. Only his fierce unnatural vision penetrates to and through them. The lamp—a parallel vertical—has a parallel activity symbolically.[10] De Haan too is a seer, an initiate with the special vision that can illuminate the inner, enigmatic core of reality and of human myth.

Within this context of seer and initiate, the two books on the table—Carlyle's *Sartor Resartus* and Milton's *Paradise Lost* (only the latter part of the French title visible)—represent the myths of Religion and of Philosophy. John Rewald writes that de Haan "was equipped with a mind well trained in religious and metaphysical philosophy."[11] Perhaps the apples in the foreground re-affirm the primitive paradise in Milton's *Paradise Lost.* Gauguin, it will be recalled, went half-way around the world in search of that unspoiled paradise in order to learn its Truth.[12] In *Sartor Resartus* Thomas Carlyle translates German Idealist philosophy into words that any theosophist would appreciate:

. . . what is man? . . . A Soul, a Spirit, and divine Apparition. Round his mysterious ME, there lies, under all those wool-rags, a garment of Flesh (or of Senses), contextured in the Loom of Heaven; whereby he is revealed to his like, and dwells with them in UNION and DIVISION; and sees and fashions for himself a UNIVERSE, with azure Starry Spaces, and long Thousands of Years. Deep-hidden is he under that strange Garment; amid Sounds and Colours and Forms, as it were, swathed-in, and inextricably overshrouded: yet it is sky-woven and worthy of a God. Stands he not thereby in the centre of Immensities, in the conflux of Eternities? He feels; power has been given him to know, to believe; . . .[13]

Again in 1889 Gauguin painted a gouache of Meyer de Haan (Fig. 3) with much the same intent as the pair of portraits. His figure is stylized into S-curves, his eyes have become simple almond shapes, and in that curious fashion he holds an entwining thistle. Gauguin titled the portrait *Nirvana* and placed behind de Haan other works of his, just as Gauguin placed his works behind himself in his painting *Self-portrait with Yellow Christ.*[14] In the background of *Nirvana*, one woman looks down in terror and another looks up and beyond in the opposite direction. Meyer de Haan, meanwhile, with the slanted, almond-shaped eyes of another style and civilization, here stares out, through us. It must be more than mere coincidence that this painting seems to be almost an illustration for the following passage from Schuré's book:

Immense is the prospect opening out to one who stands on the threshold of theosophy. . . . On seeing it for the first time, one feels dazed; the sense of

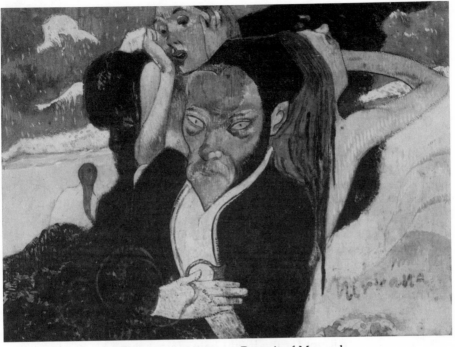

3 *Paul Gauguin,* Nirvana—Portrait of Meyer de
Haan, *ca. 1890. Essence on silk. Wadsworth
Atheneum, Hartford. Ella Gallup Sumner and Mary
Catlin Sumner Collection. Photo: Joseph Szaszfai,
Connecticut*

the infinite proves overpowering. Unconscious depths open within
ourselves, showing us the abyss from which we are emerging and the giddy
heights to which we aspire. Entranced by this sense of immensity, though
terrified at the distance, we ask to be no more, we appeal to *Nirvana!* . . . It has
been said that man was born in the hollow of a wave and knows nothing
of the mighty ocean stretching before and behind him. This is true; but
transcendental mysticism drives our barque on to the crest of a wave,
and there, continually lashed by the furious tempest, we learn something of
the sublimity of its rhythm; and the eye, compassing the vault of heaven,
rests in its azure calm.[15]

Undoubtedly, Gauguin was acquainted with theosophy by
1889. Indeed, theosophy went hand in hand with the creation of
Gauguin's mature styles. At the least, Gauguin's theosophy helps to
explain how he could find so much compatibility in the styles of

47

religious art of so many different civilizations: Javanese, Egyptian, Greek, and so on.

Gauguin will paint Meyer de Haan again, even in Tahiti. More frequently he will repeat the motif of Eve. In a loose sense, every Tahitian woman whom Gauguin painted is an Eve, and the Paradise story from Genesis is his central image. Gauguin's Eves comprehend the Biblical Eve, the Female, Mother, Primitive Man and at times Man confronting "the abyss from which we are emerging and the giddy heights to which we aspire."[16]

The painting *Hina Tefatou* (*The Moon and the Earth*) contains such an Eve (Fig. 4). Although in it Hina, the goddess of the moon, belongs to Maori legends about creation, nevertheless the stories depict a primitive search for the origin and meaning of the Universe.[17] In the painting Hina stands in a shadowy woods, her orange body shaded—rather than modelled—in green and blue. In fact there is a bluish tonality to the entire painting. In a modified Egyptian manner, the head of Hina is in profile at a right angle to her torso. She puts her thumb and index finger to her lips as she whispers her request in Tefatou's ear, or perhaps she is in the act of placing the stylized three-petalled plants that she is wearing in Tefatou's hair also. Tefatou would barely emerge from the undergrowth were it not for the bright halo effect behind his head. The varying reds of this "halo" to the left of his head matches the red of the pool beneath him. It is this red, of the pool especially, that stands out from the canvas, for the orange glow of her skin is subdued in the blue shade. The powerful features of Tefatou are worked out in blue-greens and dark olives. Touches of orange highlight Tefatou's upper lip and his eyes. Are they reflections from Hina? She stands a short distance from him, yet the hand raised straight over her head is behind Tefatou. He emerges—somehow —massive and immobile.

For the general relationship of the figures and for the massiveness of Tefatou, it has been said that Gauguin had Ingres' *Jupiter and Thetis* in mind (Thetis pleading for her son Achilles; Hina for her child).[18] He may have been thinking of the iconography of the wound in Christ's side as well ("But one of the soldiers pierced his side with a spear, and at once there was an outrush of blood and water." John 19.34).

Many have called *Hina Tefatou* "enigmatic" and "mysterious," even though Gauguin himself gives an explanation of the myth

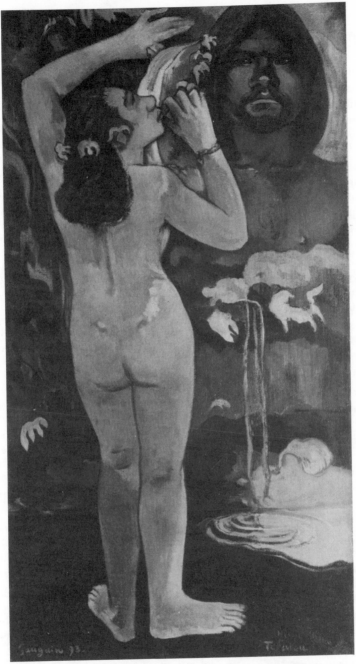

4 Paul Gauguin, The Moon and the Earth ("Hina
Te Fatou"), 1893. Oil on burlap, 45 x 24½".
*The Museum of Modern Art, New York. Lillie P.
Bliss Collection*

involved. Perhaps his explanation of it in *Ancien Culte Mahorie* seemed as enigmatic as the painting. In brief he states that, although all things must die, the material and spiritual principles of the universe (implicitly) will live. Matter and spirit must be transformed to live on into eternity. In the light of Gauguin's theosophical *L'esprit moderne et le catholicisme*, his interpretation of the myth may seem less enigmatic, but hopefully nothing can rob the painting of its "mysteriousness." For the question remains, how does all this theology and mythology explain Gauguin's rendering? Charles Maurice's "edition definitive" of *Noa Noa* initiates an answer to that question in a provocative interpretation of the legend:

The counsel of the moon who is feminine might be the dangerous advice of blind pity and sentimental weakness. The moon and women, expressions in the Maori conception for matter, need not know that death alone guards the secrets of life. Tefatou's reply might be regarded as the stern, but far-sighted and disinterested decree of supremest wisdom, which knows that the individual manifestations of actual life must give way before a higher being in order that it may come and must sacrifice themselves to it in order that it may triumph.[19]

The legend here becomes primarily a variation on the general occultist doctrine of death and transfiguration: that "the individual manifestations of actual life" do not know that death leads to transfiguration, that the way up is the way down. But this interpretation of the legend from *Noa Noa* also implies an antagonism between male and female: weak, "sensual" woman does not realize that man must suffer and sacrifice in order to triumph. I am sure that Gauguin's sacrifice of his wife and family for his art was implicit in this interpretation and in the painting.

The painting is by no means an allegory, however; it is merely a question of psychological resonance. Gauguin paints the myth in terms of the tension between male and female and between matter and spirit as he knew and believed them. Hina, one of the most sensual and compelling of Gauguin's Tahitian Eves, delicately tries to persuade Tefatou. At first sight she dominates the canvas. She is grandly monumental and real. Tefatou is massive and *unreal*: he is stern and unmoved, but only his head and shoulders appear in an ambiguous space and in unnatural light. Tefatou represents spirit; from his side flows the pool of "supernatural red"[20] just as the Spirit flowed from Christ's side. Tefatou is also the far-seeing visionary who must utter seemingly cruel replies if he will be true to his inner knowledge. He is a Great Initiate. In a sense,

Tefatou is another self-portrait of Gauguin, but this time portrayed with deep psychological insight into the tension that a special vision creates.

Gauguin was not usually interested in all the trappings of theosophy or occultism the way that Redon sometimes was. This is true, I believe, even of *D'où venons-nous?* with his long occult analyses of it contemporary with his writing *L'esprit moderne*. What did interest Gauguin in theosophy right from the start was its doctrine of the initiate or visionary who can penetrate the *beyond*. But Gauguin is no calm contemplative. We have seen a certain emotional tension in *Hina Tefatou*; his over-insistence and drumming in his religious writing also produces a tension. He is not such a very convinced believer, rather he forever struggles for the Truth. Indeed, as H.W. Janson has remarked, Gauguin "could paint pictures *about* faith, but no *from* faith."[21] Yet taken seriously as important religious statements of modern times, Gauguin's paintings haunt one with a kind of pathos.

It is not true by any means, however, that every sketch or every painting by Gauguin calls for an occult interpretation. Gauguin's unique methods of painting frustrate any systematic interpretation. As explicated so well by Robert Goldwater, Gauguin worked by

discovering the meaning of his own picture as he went along; finding it, to be sure, in the abstract pattern of the lines and shapes and colors which he had already set down, but not satisfied with that. He searched for a meaning in terms of subject-matter, or, to use his own word, of "parable," and having interpreted the sense of what he had, more or less unconsciously, already put down upon canvas, he then allowed the picture to finish itself. Thus both form and subject, vague at first, and only half understood, became clear to the painter himself in the process of creation.[22]

Although the subjects in Gauguin's painting can thus never be completely "explained," there is something that can be said about them. To put it crudely: when it came time for Gauguin to think about a subject, he thought theosophically. His imagination was theosophical. Theosophy was his world view. Hopefully, this knowledge of ours does not explain away the paintings but deepens their meaning.

Why theosophy? If there is any truth to the generalization that a person adopts the intellectual system that suits the proclivities of his temperament, then theosophy was tailor-made for Gauguin. There is also some justification here for borrowing

John Rewald's general remark that Gauguin had "the fondness of the half-educated for intricate and high-sounding theories."[23] The air Gauguin breathed contained occultism; in many ways occultism formed the basis for all Symbolism. In Gauguin's case, however much theosophy fulfilled his religious needs, theosophical theory supplied him with the intellectual construction on which to deepen the commitment of his painting while his sensibilities transformed the construction into highly imaginative creations.

Notes

1. On the other hand, some of Gauguin's contemporaries—Van Gogh and many Nabis—were deeply religious. José López-Rey has often remarked that during the last decade of the century everyone discussed religion.

2. The most important figure in nineteenth-century occultism was Abbé Alphonse Constant (alias Eliphas Lévi, d. 1875), prolific author and friend of Baudelaire and of Gauguin's grandmother (cf. Charles Chassé, *Gauguin et son temps*, Paris, 1955, 30-31).

3. The City Art Museum of St. Louis now has the 92 page manuscript. H. Steward Leonard has described the manuscript and published the illustrations from it in "An Unpublished Manuscript by Gauguin," *Bull. of the City Art Museum*, 34, Summer, 1949, 39-50.

4. This passage from Luke (8.17) is quoted by Gauguin on pages one and two of the MS.

5. Contemporaneously with these portraits, Gauguin painted several purportedly biblical subjects: his *Yellow Christ*, for example, or his *Jacob Wrestling with the Angel*. It is my implication that Gauguin may have understood these paintings theosophically. The conclusion of the Jacob story (Genesis 32: 28-30) readily suggests a theosophical interpretation: Jacob realizes that he has striven with God, prevailed, and seen God face to face.

Perhaps the idea for theosophical portraits came from Van Gogh. In 1888 Van Gogh exchanged self-portraits with Gauguin. He wrote to Gauguin that he had painted "le caractère d'un bonze simple adorateur du Bouddha éternel" (letter included in *Lettres de Gauguin*, Paris, 1946, 143-144). When Van Gogh died, Gauguin wrote to Emile Bernard: "c'est la fin justement des souffrances, et s'il revient dans une autre vie il portera le fruit de sa belle conduite en ce monde (selon la loi de Bouddha)" (*ibid.*, 201).

6. "The Paul Gauguin Exhibition," *BurlM*, 41, 1949, 284: "the halo, the serpent, and the apples suggest a composite effect designed to represent Gauguin as Lucifer, the fallen angel."

7. *Lettres de Gauguin*, 134.

8. *Eve Exotique* of 1890 (Wildenstein, *Catalogue*, no. 389), as Henri Dorra remarks (*GBA*, 41, 197), not only imitates a portrait of Gauguin's mother but also imitates a Buddha from the frieze of a Javanese temple. Gauguin probably considered the bush alongside Buddha and alongside Eve to be the Bo tree under which Buddha was rewarded with "the great enlightenment" concerning suffering and the release from suffering. The bush occurs again in association with other Eves.

9. *The Great Initiates*, London, 1913, xx.

10. Meyer de Haan is united visually with the apples in another sense: the whole upper triangle containing de Haan and the dish of apples are painted in deep, saturated hues; the table, book and lamp all share the same pastel tonality.

11. *Post-Impressionism*, New York, 1962, 297.

12. Gauguin seems to have made practical calculations even as to the relative richness of the occultism in this or in that "paradise":
Il est vrai que Taiti est un paradis pour les Européens. Mais le voyage est beaucoup plus cher car c'est en Océanie.
En outre Madagascar offre plus de ressources comme types, religion, mysticisme, symbolisme.
Vous avez là des Indiens de Calcutta des tribus noires des Arabes, et des Hovas, types de la Polynésie.—letter to Emile Bernard from Le Pouldu, July, 1890, *Lettres de Gauguin*, 198.

13. From Book I, Chapter X as reprinted in *English Prose of the Victorian Era*, ed. by C.F. Harrold and W.D. Templeman, New York, 1946, 91.

14. The distraught woman who holds both hands to her head was Gauguin's first Eve, *Eve Bretonne*, although the motif had been used earlier. (Cf. Henri Dorra, "The First Eves in Gauguin's Eden," *GBA*, 41, 189-202.) The other woman behind de Haan, with her right hand raised to her up-turned face, was also painted separately as *Ondine*. The composite background appeared in a rough fashion as an illustration in the catalog of the Volpini exhibition in 1889.

15. *The Great Initiates*, xxiii-xxiv.

16. Schuré, *The Great Initiates*, xxiv.

17. Gauguin copied down the major legend in his *Ancien Culte Mahorie* from J.A. Moerenhout's *Voyages aux îles du Grand Océan* (1837):
Eternité de la Matière.
Dialogue entre Tefatou et Hina (les génies de la terre—et la lune.

Hina disait à Fatou: "faîtes revivre (ou ressusciter l'homme après sa mort.
Fatou répond: Non je ne ferai point revivre. La terre mourra; la
végétation mourra; elle mourra, ainsi que les hommes qui s'en nourrissent;
le sol qui les produit mourra. La terre mourra, la terre finira; elle finira pour
ne plus renaître.
Hina répond: Faîtes commes vous voudrez: moi je ferai revivre la
lune. Et ce que possédait Hina continua d'être; ce que possédait Fatou périt,
et l'homme dût mourir.
—facsimile ed., Paris, 1951, 13.

18. This and the following insight were suggested by Robert Goldwater,
Gauguin, New York, 1957, 122.

19. *Noa Noa*, translated by O.F. Theis, New York, 1957, 113-114.

20. Gauguin thus describes a color in his *Christ in the Garden of Olives*
for Albert Aurier (Wildenstein, no. 326).

21. *History of Art*, New York, 1964, 508.

22. "The Genesis of a Picture: Theme and Form in Modern Painting,"
Critique, Oct., 1946, 7-8.

23. *Post-Impressionism*, 196.

3

Katherine Dreier and the Spiritual in Art

RUTH L. BOHAN

Katherine Dreier (Fig. 1) was a woman of remarkable energy and ability. As founder and president of the Société Anonyme, she initiated the activities and guided the programs that made that organization this country's staunchest supporter of international modernism in the arts during the 1920s. The Société Anonyme's many exhibitions, lectures and educational programs scrutinized the range and diversity of the movement's extensive international following with characteristic verve and intensity. German, Russian, Dutch and Hungarian modernists received attention equal to if not greater than their more familiar French counterparts. Equally unprecedented was the fact that Dreier's untiring efforts transcended both the aesthetic merit of the work and the need to compensate the modern artist. For her, modernism in the arts was no accidental or superficial phenomenon. Its presence signaled a global outpouring of previously submerged spiritual feeling. Dreier's deep-seated commitment to improving this country's social and moral fabric fundamentally complemented her belief in modernism's spiritual foundation. Together, these two powerful and deeply felt concerns guided the Société Anonyme in its drive to stimulate the American public to a more complete understanding of the social, spiritual, cultural and artistic benefits inherent in the modern movement.

The most complete statement of the philosophy with which Dreier guided the Société Anonyme is contained in her book *Western Art and the New Era*, published in 1923.[1] Written in a convoluted and loosely structured prose that is perhaps symptomatic of her Teutonic origins, the book reveals her to have been a highly eclectic, imprecise, and oftentimes contradictory thinker whose

55

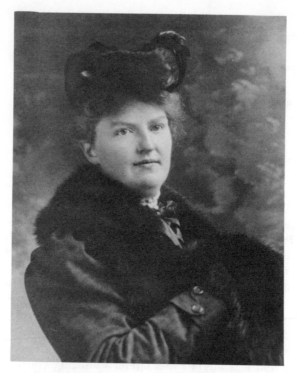

1 *Katherine S. Dreier,* (black and white photo,
no date). *Katherine Dreier-Société Anonyme
Collection. Collection of American Literature Beinecke
Rare Book and Manuscript Library, Yale University,*
New Haven

powers of persuasion derived largely from the evangelical fervor
with which she promoted her social-spiritual vision. The book, a re-
working of several lectures Dreier gave during the Société
Anonyme's first year,[2] locates the basis of her philosophy in the
mystical teachings of theosophy, the metaphysical theories of
Wassily Kandinsky (himself heavily influenced by theosophy), and
the socially oriented aesthetic ideals of John Ruskin and especially
William Morris, which Dreier employed to bolster her own
views about the social utility of art. Of these, theosophy was by far
the most fundamental. A close examination of this and other of
her writings reveals that theosophy pervaded every aspect of her
thinking. Her commitment to the philosophies of Kandinsky,

Ruskin and Morris was in large part determined by her long-standing allegiance to theosophy.

As a philosophical system of beliefs, theosophy traces its roots back to the ancients, but its greatest influence has been on the modern world. In the late nineteenth century, its dogmas were substantially reconstituted by the Russian-born religious mystic, Mme Helena Petrovna Blavatsky, who, together with Col. Henry Steel Olcott and William Q. Judge, founded the Theosophical Society in New York in 1875. The theosophical dogma promulgated by Mme Blavatsky offered a unique synthesis of Eastern philosophical thought and Western Christian morality. Claiming to have been instructed in the wisdom of the ages by Tibetan wise men, Mme Blavatsky merged her studies of the Buddhist and Brahmanic doctrine of karma with the occult traditions of Western Europe. She outlined her views in three books published shortly after the founding of the Theosophical Society: *Isis Unveiled* (1877), *The Secret Doctrine* (1888), and *The Key to Theosophy* (1889).[3]

In Blavatsky's hands, theosophy presented a strong challenge to the orthodoxies of both modern science and traditional Christian beliefs. Pseudoscientific in nature, it emphasized the existence of a deeper spiritual reality behind the material world of nature. It taught that man could attain higher psychic states through intuition and meditation and that with knowledge of these higher states would come an international brotherhood of man. Central to the teachings of theosophy was the belief that at the beginning of time man had been in command of life's most important possession, the one eternal truth. This truth had made him clairvoyant. With time, man's materialistic tendencies had seriously impaired his understanding of this truth. Mme Blavatsky likened the truth to a ray of white light. Over time, the white light had been refracted into the different colors of the spectrum, just as the truth of the ancients had been subdivided into the world's various religions and philosophies. It was the task of the theosophists to reunite the separated colors, each claiming to be the one true light, into the original white light of truth.[4] This synthesis was to be accomplished during the twentieth century, after which mankind would regain its former clairvoyance. With the return of man's former state, peace and harmony would reign in the world, and there would be greater brotherhood among men.[5]

A key element of theosophical doctrine was its emphasis on the spirit. Mme Blavatsky and the theosophists held that physical

matter was merely an illusion; all that mattered was the spirit.
For them, the spirit, or "life-essence," interpenetrated all things,
bringing together all aspects of reality into one cosmic whole. Fully
continuous, the cosmos was nevertheless viewed as existing on
several supersensory levels. Human action was to be graded
according to those levels, ranging from gross physical life to the
complete perfection of the Cosmic Self. A person's elevation to the
next higher level was dependent upon his acquisition of spiritual
knowledge. The more fully he comprehended the spirit, the higher
the level he attained. However, the progression through all seven
supersensory levels was too difficult to be accomplished in one
lifetime. It was felt that many lifetimes of conscientious striving
would be needed, a concept which accounts for the theosophical
belief in reincarnation.[6]

The latent spiritual power of man, realized in great spiritual
leaders (like the Mahatmas), was considered almost boundless.
The soul, rather than the mind, was the principal conduit through
which one acquired spiritual knowledge. Theosophists looked
beyond the intellect as a source of knowledge about the spirit, be-
lieving instead that spiritual knowledge was transmitted through
intuition, feelings and the senses. The sense of sight played a
particularly important role in theosophical literature. Rudolf
Steiner, the chief spokesman for the German Theosophical Society
and founder in 1913 of the related science of Anthroposophy,
maintained that man was equipped with two sets of sensory per-
ceptors—one physical and capable of perceiving objects in the
material world, the other spiritual and capable of sensing the spirit.
The spiritual vision was an inner vision, which made possible
man's advance to higher spiritual states.

In *Theosophy* (1904), one of Steiner's most important and
widely read books, he defined the nature and purpose of this vision
and explained how it was possible for one not yet capable of
"seeing" directly into the spiritual world himself to derive valuable
spiritual knowledge from what was perceived by another.[7] This
knowledge, he explained in one of the book's most descriptive
passages, was communicated through a "thought-picture of the
higher worlds." This was so because, to a clairvoyant or one with a
fully developed "spiritual eye," thought was "a direct expression of
what is seen in the spirit." That which was communicated repre-
sented a force which could "awaken slumbering capacities" in the

receiver. Steiner termed these thought-pictures "the *first step* towards personal vision,"[8] and judged them to be "a far better starting-point even for first-hand cognition of the spiritual world, than dubious mystical 'experiences' and the like."[9]

Theosophy experienced wide popularity in the late nineteenth and early twentieth centuries because of its probing inner orientation and its optimistic world view. Its idealistic and antimaterialistic stance attracted the attention of many artists and intellectuals frustrated by what they saw as an overemphasis on materialism in the world around them. At the same time, because it drew on science as well as religion, it appealed to those who distrusted the inexplicable nature of traditional religious beliefs. By going beyond the material world of nature, theosophy profoundly influenced the development of modern abstract art. Over the years, it has attracted such socially concerned leaders of modern culture as artists Wassily Kandinsky, Piet Mondrian, Hans Arp and Jackson Pollock; poets William Butler Yeats and Maurice Maeterlinck; composers Alexander Scriabin, Igor Stravinsky and Arnold Schönberg; and architects Le Corbusier and Rudolf Steiner.

Dreier once termed theosophy "one of the great philosophical movements of our times" and hailed Mme Blavatsky as "one of the great women of the last century."[10] She was introduced to its mystical tenets while still a child in Brooklyn and maintained an active interest in it and other occult beliefs throughout the remainder of her life.[11] Despite the depth and duration of her commitment to its arcane teachings, however, the exact sources of her knowledge about theosophy are difficult to ascertain. She was doubtless familiar with most, if not all, of the writings of Mme Blavatsky and seems to have been conversant with the writings of C.W. Leadbeater as well.[12] Leadbeater was one of Mme Blavatsky's most ardent followers and the author of several important books on theosophy, including *Man Visible and Invisible* (1903)[13] and *Thought-Forms* (1901),[14] which he co-authored with the former Fabian Socialist Annie Besant. It is likely, however, that Dreier's most extensive knowledge concerning the theosophical principles came from her familiarity with the work of Rudolf Steiner. Steiner was the most prolific writer on theosophy of his day and the most lucid. He was well known among members of the German avant-garde, who regularly attended the many lectures he gave in Munich and Berlin.[15] It is possible, moreover, that Dreier heard him

speak during the winter of 1911-12 when she was studying in Munich. If not, she was certainly familiar with his writings, many of which were translated into English shortly after their original German publication. Chief among his many books were *Theosophy*, published in Germany in 1904 and translated into English in 1910[16] (with the provocative subtitle, *An Introduction to the Super-sensible Knowledge of the World and the Destination of Man*), and *An Outline of Occult Science*, published in English in 1914.[17]

Compelled by her own interest in the occult, Dreier proved an eager student of theosophy. She was drawn in equal measure to its probing inner vision, its emphasis on the spirit, its concern for mankind and its anti-intellectualism. Her writings were freely sprinkled with the arcane jargon of theosophy, showing the extent to which its principles influenced her thinking, while her life was lived openly according to its precepts. She seems to have accepted its teachings quite literally, almost without question, going so far as to regard herself as the reincarnation of the Barbary pirate and later admiral of the Ottoman fleet, Frederick Barbarossa.[18]

In the opening pages of *Western Art and the New Era*, in a passage which fully reveals the level of her involvement with theosophy, Dreier forthrightly declared: "It is the Spirit which we must worship . . . the only thing of real value is Spirit—."[19] She believed, furthermore, that knowledge of the spirit was essential to man's spiritual development and that this knowledge was transmitted only through feelings and the senses. So deep was her commit-ment to this belief that she cautioned her fellow citizens not to leave their senses "crude," but to develop them "to their highest capacity, realizing that they are the true guardians of the development of our soul, for it depends upon their state of development as to the feelings which control us."[20]

From her readings of theosophy, Dreier came to regard the acquisition of spiritual knowledge as man's most pressing obliga-tion. She considered it fundamental for the advancement of both the individual and society. Dreier fully agreed with the assertion that Steiner made in a 1905-06 article published in the An-throposophical journal *Lucifer-Gnosis*:

The individual man you may help by simply supplying him with bread; a community you can only supply with bread by assisting it to a [spiritual] world-conception.[21]

She was also in accord with his views on the role of art in this

process. Steiner and other theosophical thinkers regarded art, science and religion as valid avenues to the spirit, principally because all were thought capable of probing the innermost reaches of the material world and of discovering its most hidden secrets.[22] In *Theosophy*, Steiner wrote that when the artist "penetrated to [the] spiritual basis [of color and form] with thought and feeling," then art was capable of exerting a "tremendous" influence on "all human evolution."[23] Several years later he declared: "All genuine art seeks the spirit."[24] Sixten Ringbom has shown that Steiner "went as far as to designate *artistic sensitivity the best prerequisite for the development of the spiritual abilities.*"[25]

Dreier's philosophy of art closely paralleled Steiner's views on the subject. Like Steiner, she judged art to be a wholly purposive act, whose principal function was to impart spiritual knowledge. She accepted Steiner's ideas about man's "spiritual eye," which she called his "seeing eye,"[26] and believed that in the artist the "seeing eye" was more fully developed than in most people.[27] The artist was therefore more capable than others of perceiving the spiritual underpinnings of the universe. Through his art, he conveyed his findings to others, much the way a thought-picture imparted spiritual knowledge to others.[28] In the opening pages of *Western Art and the New Era*, she termed it the "recognized function of art . . . to free the spirit of the beholder and to invigorate and enlarge his vision."[29] Further on she declared that "a picture which has no message of an enlarged vision, which gives no spiritual stimulation, whether painted realistically or abstractly, may contain excellent workmanship, but is not art."[30] Art was "art" only if it helped man to "see" the spirit. "This must always be true," Dreier declared, "when one places art where it belongs as a developing force within man."[31]

Dreier's profound concern for the spiritual value of art obtained strong reinforcement from her knowledge of the writings of Wassily Kandinsky. Dreier was intimately familiar with *Über das Geistige in der Kunst*,[32] which she first encountered in 1913. In 1923, at the time of the Société Anonyme's first one-man exhibition of Kandinsky's work (Fig. 2), she revealed that the essay had "helped to clarify many vague thoughts, which had formulated themselves" in her mind during her studies in Munich in 1911-12.[33] Dreier doubtless read the treatise in its original German, but the Société Anonyme owned a copy of the first English edition as well. Translated by Michael Sadler and published in London and Boston

in 1914, *The Art of Spiritual Harmony* occupied a prominent position among the organization's distinguished holdings.[34] The library also owned a copy of the catalogue published in conjunction with a 1913 exhibition of Kandinsky's work at Herwarth Walden's Der Sturm Gallery in Berlin,[35] and a copy of *Der Blaue Reiter*, the official organ of the loosely structured organization of the same name, first published by Kandinsky and Franz Marc in 1912.[36] Both publications contained important essays by Kandinsky and were acquired by Dreier prior to 1921, perhaps as early as 1913.

2 *Cover designed by Katherine Dreier for the brochure* Kandinsky, *published by the Société Anonyme in March 1923. Katherine Dreier-Société Anonyme Collection. Beinecke Rare Book and Manuscript Library, Yale University, New Haven*

Dreier's admiration of Kandinsky was as profound as it was effusive. When finally the two met in 1922, just prior to the publication of *Western Art and the New Era*, she reported being "in no way disappointed. . . . He seemed to stand above life. He controlled Destiny."[37] To honor him for his achievements as an artist and as a theoretician, Dreier made Kandinsky Honorary Vice-President of the three-year-old Société Anonyme, a position which he held until his death in 1944.

Dreier's commitment to Kandinsky was stimulated to a large extent by her commitment to theosophy. Kandinsky's own debt to the arcane teachings of theosophy made it likely that a close bond would develop between them. In two profusely documented articles detailing the nature of Kandinsky's indebtedness to theosophy, Sixten Ringbom has shown it to have been the single most important influence on Kandinsky's thinking.[38] Like Dreier, Kandinsky was widely read in the theosophical literature of the period, including works by Blavatsky, Steiner, Leadbeater and Besant. He also attended Steiner's lectures while living in Murnau and Berlin prior to the publication of *Über Das Geistige in der Kunst*.[39] Theosophy attracted him for many of the same reasons that it attracted Dreier: its emphasis on the inner self, its anti-intellectualism and anti-materialism, its idealism and its basic humanitarianism. It instilled in him a profound interest in and sensitivity to the spiritual oneness of the universe. Theosophy also helped convince him of the important role art could play in man's search for spiritual knowledge. He wrote in *Über das Geistige* in a passage which could hardly have escaped Dreier's attention:

Painting is an art, and art is not vague production, transitory and isolated, but a power which must be directed to the improvement and refinement of the human soul—to, in fact, the raising of the spiritual triangle.[40]

Kandinsky went further than the theosophists in formulating the specifics of a spiritual art. Such an art, he asserted, would seek to surpass both the simple act of recording objects in the material world and the superficial dictates of the world of art; it derived its subject and its validity instead from the "non-material strivings of the soul."[41] To communicate its findings, it required an abstract language derived from the expressive power of music, "the most non-material of the arts today."[42] By following the dictates of his own inner being and probing the hidden pulse of the world around him, the artist was capable of achieving an art of universal

significance. As Kandinsky wrote: "Every man who steeps himself in the spiritual possibilities of his art is a valuable helper in the building of the spiritual pyramid which will some day reach to heaven."[43]

Kandinsky's insistence that an artist be true to his innermost being rather than to the dictates of either nature or the world of art proved a powerful stimulus to Dreier. His detailed account of the spiritual underpinnings of non-mimetic art gave focus to the ideas which Dreier's readings of theosophy had first instilled in her. In a passage in *Western Art and the New Era* which provides evidence of the manner in which Dreier combined her knowledge of theosophy with her studied readings of Kandinsky, she wrote:

In tracing the influences which cause that inner urge to express itself in art, we find them, as always, belonging to the great spiritual forces that continue to unfold and develop the spirit of man.[44]

Equally important for Dreier was Kandinsky's probing analysis of how a genuinely spiritual art could benefit society. Through the analogy of the spiritual triangle, his metaphor for the life of the spirit, he described mankind's movement toward the spiritual and the divine. Artists occupied every segment of the triangle; those who could "see beyond the limits" of their segment were the "prophets." Their art helped advance "the obstinate whole." The greater the size of the segment, that is, the closer it lay to the base of the triangle, the greater the number who understood the artist's message. But every segment hungered for the artist's "spiritual food . . . and for this food the segment immediately below [would] tomorrow be stretching out eager hands."[45]

Dreier agreed that the artist was a prophet and that his art had the power to spiritualize society. By obtaining the spiritual advance of one member of society, the new spiritual art would ultimately effect the advance of society as a whole. For Dreier, as for Kandinsky, it was this factor which made the artist of the twentieth century, the one who would remain true to his inner urgings, such a vitally important member of society. Without his inspired leadership, the people of the twentieth century would be deprived of a valuable guide in their quest for spiritual knowledge.

An important theme underlying Dreier's and Kandinsky's philosophy of art was the *Zeitgeist* concept that art should reflect the spirit of its age. According to the *Zeitgeist* theory, each age possessed a dominant and distinguishing characteristic that could

64

never be repeated. For the artist, it was essential that his art express this characteristic if it was to be of value either to his own or to future generations. A core of European artists considered the task confronting the artist of the twentieth century particularly demanding, as they sensed radical changes taking place in the world around them. These changes signaled the emergence of a new era. There were two primary schools of thought as to what constituted the fundamental character of the new era, but both camps were adamant in their belief that it mandated a new art form.

In one camp were the Italian Futurists and the Soviet Constructivists, for whom the machine constituted the single most important phenomenon of the new age. They encouraged an art predicated on the evocation of the aesthetic potentialities of modern mechanized society. For the Futurists, this meant an art which objectified the pulsing dynamism of a throbbing, machine-dominated world.[46] The Constructivists carried their probing into this new order of experience even further by seeking to merge art and technology for the purpose of achieving an objectification of the creative act itself. Rejecting "easel" art, they aimed at making art serve utilitarian ends, believing that in this way they were best directing the technological power of the new age for use by artists and laymen alike.[47]

In the opposing camp were the Expressionists and other like-minded artists, principally in Germany, for whom the new era represented a profoundly spiritual phenomenon. Kandinsky best articulated the views of this group. In both *The Art of Spiritual Harmony* and "On the Question of Form," his most important essay in *Der Blaue Reiter*, Kandinsky proclaimed that the world was on the threshold of "a great spiritual epoch."[48] At present, only a few people, among them the creative artists, were aware of the "quickening" of the spiritual experience around them. He predicted, however, that this outpouring of spirituality would eventually touch the lives of all men everywhere, infusing them with greatly expanded powers of perception.[49] For the artist, this infusion of spirituality was making it possible for him to probe more deeply into the heart of the material world, into the very essence and meaning of life, in ways and to a degree never before imagined. The artist, Kandinsky wrote, was now able "to feel the spirit, the *inner sound*, in all things."[50]

It was with this latter interpretation of the essential character of the new age that Dreier felt the greatest sympathy. Like

65

Kandinsky, she believed that the new era was profoundly spiritual in nature and that it was affecting all men everywhere. She also believed that the artist, by virtue of his greater sensitivity, was among the first to sense its presence.[51] She fully agreed that this new outpouring of spirituality was endowing the artist with a more sensitized "inner vision" and that he was now able to probe a range of feelings, emotions, sounds and sensations which had previously been beyond his reach.[52] Whole new vistas of the nonmaterial world had suddenly become available to him. Like Kandinsky, Dreier considered this an accomplishment of the first order and a significant contribution toward man's spiritual development.

The fact that the artist's new experiences were expressed in a new language was vitally important to Dreier, who considered this one indication of the new art's greatness. She did not, however, allow her fascination with the forms to divert her from the belief that the forms were significant only insofar as they served to convey the artist's new message. She consistently referred to the forms as the "dress" of art; they were the outer garment which clothed the inner idea.[53] For her, as for Kandinsky, it was the inner idea which made this art of such great value to the people of the twentieth century.

Dreier's views on the relationship of art to society drew equal sustenance from the writings of Ruskin and Morris. The striking parallel between Morris's view of art as a vehicle for reforming society and Dreier's own philosophy of art suggests a source of inspiration that, as much as any other, helped focus the evangelical fervor with which Dreier promoted modern art's capacity for spiritual and social reform.

In *Western Art and the New Era,* Dreier asserted that art, as a conduit of spiritual knowledge, was also a "stimulus for [man's] finer qualities."[54] Dreier's statement was clearly an adaptation of the theosophical argument that knowledge of the spiritual world leads to a better and more moral earthly existence, culminating in what Blavatsky termed the "Universal Brotherhood of Man."[55] Elaborations on this belief reveal Dreier's blending of theosophical doctrines with Morris's views on art. Echoing Morris, she described art as fundamental to civilization. It was an "innate necessity of life" rather than a "luxury easily to be dispensed with."[56] Correspondingly, she expressed the belief that art had a strong "refining influence on man, [such that] man cannot under the influence

and stimulus of art act with the same brutality as he can without it."[57] Because of its strong moral value, art could lead to a "finer relationship towards life and man."[58]

Fundamental to Dreier's view of the spiritual and moral value of art was her argument, bolstered by a sympathetic reading of Morris's ideals, for integrating art more effectively into the basic fabric and structure of society. "Art in its greatest period has always entered into the very marrow of the bone of civilization, into every part of life,"[59] she wrote. Yet, at the present time, she feared, art's role in society was not sufficiently appreciated by her materialistic countrymen. She blamed the dictionary definition of art, with its emphasis on skill and craftsmanship, for having diverted large segments of the population from a clear understanding of the true meaning and significance of art.[60] Like Morris, Dreier also blamed the machine for having severely thwarted the true function of art. "Machinery brought to the fore the utilitarian point of view, and man's chief concern thereafter became quantity, not quality."[61] Such an attitude tended to dilute the significance of the object produced and to replace its intrinsic value with a purely monetary value. As she warned her fellow countrymen:

Until we rise above our greed for money and once more recognize the importance of art as a part of our daily life, art and its gentle influence of refining will vanish more and more from among the Western people.[62]

Dreier's desire to see art more tightly and creatively bound to life was intimately related to her desire to improve conditions in her native America. She judged art essential to the health and well-being of society and believed that the United States could never rise to its potential greatness as a world power until it recognized this fact and took strides to make art "an inherent part of life."[63] Only then could art's spiritual power reach deeply enough into the core of American civilization to nullify the country's excessive emphasis on material goods. Only then could the country begin to produce the number of "seeing eyes," people endowed with a probing spiritual vision, that Europe, because of its more established art tradition, had already produced.[64]

Dreier's insistence that modernism was a probing spiritual force born of the vibrations of a new era and endowed with profound social and moral purpose set her radically apart from the majority of her American contemporaries. While many Americans

67

agreed that modernism represented a profound new way of seeing, they tended generally to discount the ideological significance ascribed to it by their European colleagues. Modernism for them was not so much a philosophical system of beliefs intent on making art serve the social and intellectual needs of the people as a means for developing a more personal formal language. In the words of Lloyd Goodrich, modernism in America was valued less as an "intellectual program than [as] a liberation from the restrictions of naturalism and a freedom to develop personal viewpoints."[65]

In light of the gulf separating Dreier's beliefs from those of other modern art supporters in this country, her convictions take on added significance. Both the nature of her beliefs and the earnestness with which she presented them to the American public set Dreier radically apart from her fellow modern art enthusiasts. At a time when Americans were becoming increasingly conscious of their distinctly American heritage, Dreier was extolling the virtues of a philosophy that was decidedly European and international. Although she succeeded in converting few followers to her beliefs, she and the Société Anonyme created an important bridge between Europe and America during an era that demonstrated little interest in international exchange. Dreier's confidence that non-mimetic art could effect a better world led her and the Société Anonyme to pursue an optimistic and idealistic course during a period of social and artistic retrenchment. Her commitment to collective goals, broad social programs and an international exchange among artists had little in common with the personal goals and national preoccupations of the decade. Not least, her endorsement of the most radical forms of non-mimetic art was in direct conflict with the more realistic tendencies pursued by American modernists. That Dreier held these views and campaigned actively on their behalf throughout the 1920s conclusively proves that postwar modernism in America was actually far richer and more complex than has previously been thought.

Notes

1. Katherine S. Dreier, *Western Art and the New Era* (New York: Bretano's, 1923).

2. *Ibid.*, p. vii.

3. Helena P. Blavatsky, *Isis Unveiled* (1877; rpt. London: The Theosophical Publishing House, Ltd., 1972); *The Secret Doctrine* (London: Theosophical Publishing Company; and New York: William Q. Judge, 1888); rpt. Adyar, Madras, India: Theosophical Publishing House, 1979); *The Key to Theosophy* (1889; rpt. Pasadena, California: Theosophical University Press, 1946 and London: Theosophical Publishing House, 1968).

4. Blavatsky, *The Key to Theosophy*, p. 58.

5. *Ibid.*, pp. 306-7; see also Sixten Ringbom, "The Sounding Cosmos: A Study in the Spiritualism of Kandinsky and the Genesis of Abstract Painting," *Acta Academiae Aboensis*, ser. A, 38, no. 2 (1970), 57-58.

6. Blavatsky, *The Key to Theosophy*, pp. 112-13, 123-42.

7. Rudolf Steiner, *Theosophy* (London: Rudolf Steiner Press, 1970), pp. 26-27.

8. *Ibid.*, p. 125.

9. *Ibid.*, p. 126.

10. Katherine S. Dreier, "Intrinsic Significance in Modern Art," in *Three Lectures on Modern Art* (1949; rpt. Port Washington, New York: Kennikat Press, 1971), pp. 7-8.

11. Katherine S. Dreier, "Mother," in Margaret Dreier Robins, et al., *In Memory of the One Hundredth Anniversary of the Birth of Dorothea Adelheid Dreier* (Springfield, Massachusetts: The Pond-Ekberg Co., 1940), p. 75. Dreier was an admirer of the sixth century B.C. Chinese philosopher and reputed founder of Taoism, Lao Tze, and in 1921 spent time traveling and studying Confucianism in China. In New York she became involved with the Aso-Neith Cryptogram School of Universal Vibrations, a pseudo-science which taught the hidden meanings of colors, numbers, letters and geometrical shapes, and attended lectures from time to time on various topics by Indian philosophers. See Katherine S. Dreier, *Five Months in the Argentine From A Woman's Point of View, 1918 to 1919*, (New York: Frederic Fairchild Sherman, 1920), p. 48; Dreier, *Western Art*, p. 105; Katherine S. Dreier, "What About China?" *The Brooklyn Museum Quarterly* 13 (January 1926), 14. There is a brochure for the Aso-Neith Cryptogram School of Universal Vibrations among Dreier's papers in the Katherine Dreier-Société Anonyme Collection at Yale University.

12. Dreier mentions Leadbeater by name in *Five Months in the Argentine* and quotes at length from one of his as yet unidentified writings, pp. 48-49.

13. C.W. Leadbeater, *Man Visible and Invisible* (New York: John Lane, 1903; rpt. Wheaton, IL: Theosophical Publishing House, 1980).

14. Annie Besant and C.W. Leadbeater, *Thought-Forms* (1901; rpt. London: The Theosophical Publishing Society; New York: John Lane, 1905; Wheaton, IL: Theosophical Publishing House, 1986).

69

Ruth L. Bohan

15. Ringbom, "The Sounding Cosmos," p. 65; Sixten Ringbom, "Art in 'The Epoch of the Great Spiritual'—Occult Elements in the Early Theory of Abstract Painting," *Journal of the Warburg and Courtauld Institutes,* 29 (1966), 394.

16. In German this appeared as Rudolf Steiner, *Theosophie: Einführung in übersinnliche Welterkenntnis und Menschenbestimmung* (Leipzig: M. Altmann, 1904).

17. Rudolf Steiner, *An Outline of Occult Science* (Chicago and New York: Rand McNally and Company, 1914).

18. Aline B. Saarinen, "Propagandist, Katherine Sophie Dreier," *The Proud Possessor* (New York: Random House, 1958), p. 238.

19. Dreier, *Western Art,* p. 12.

20. *Ibid.,* p. 11.

21. Rudolf Steiner, *Anthroposophy and the Social Question,* trans. E. Bowen-Wedgwood (1905-6; rpt. New York: Anthroposophic Press, Inc., 1958), p. 38.

22. Ringbom, "Art in 'The Epoch of the Great Spiritual,' " p. 395.

23. Steiner, *Theosophy,* pp. 41-42.

24. Rudolf Steiner, *The Arts and Their Mission* (New York: Anthroposophic Press, Inc., 1964), p. 70.

25. Ringbom, "Art in 'The Epoch of the Great Spiritual,' " p. 406.

26. Dreier, *Western Art,* p. 8.

27. *Ibid.,* p. 73.

28. Dreier never used the expression "thought-picture" in referring to a work of art, although she was clearly influenced by Steiner's and other theosophists' emphasis on the power of thought. See especially, Dreier, *Western Art,* pp. 12-13 and 122.

29. *Ibid.,* p. 8.

30. *Ibid.,* pp. 125-26.

31. *Ibid.,* p. 8.

32. Wassily Kandinsky, *Über das Geistige in der Kunst* (Munich: R. Piper and Company, 1912).

33. Katherine S. Dreier, *Kandinsky* (New York: Société Anonyme, Inc., 1923), p. 3; rpt. in *Selected Publications Société Anonyme: (The First Museum of Modern Art: 1920-1944),* II (New York: Arno Press, 1972).

34. Wassily Kandinsky, *The Art of Spiritual Harmony,* trans. M[ichael] T.H. Sadler (London: Constable and Company, Ltd; and Boston: Houghton, Mifflin & Co., 1914).

35. *Kandinsky* (Berlin: Verlag Der Sturm, 1913).

36. Wassily Kandinsky and Franz Marc, eds., *Der Blaue Reiter* (Munich: R. Piper & Co., 1920). In English this is *The Blaue Reiter Almanac*, New Documentary Edition (New York: The Viking Press, 1974).

37. Dreier, *Kandinsky*, p. 3.

38. See notes 5 and 15 above.

39. Ringbom, "Art in 'The Epoch of the Great Spiritual,' " p. 394.

40. Kandinsky, *The Art of Spiritual Harmony*, p. 106.

41. *Ibid.*, p. 30.

42. *Ibid.*, p. 41.

43. *Ibid.*, p. 43.

44. Dreier, *Western Art*, p. 19.

45. Kandinsky, *The Art of Spiritual Harmony*, pp. 14-16.

46. Important discussions of the Futurists' vision of the new era and its relationship to the modern artist are to be found in: Joshua C. Taylor, *Futurism* (New York: The Museum of Modern Art, 1961); Marianne W. Martin, *Futurist Art and Theory, 1906-1915* (Oxford: Clarendon Press, 1968); R.W. Flint, ed., *Marinetti: Selected Writings, 1876-1944*, trans. R.W. Flint and Arthur A. Coppotelli (New York: Farrar, Straus and Giroux, 1972); and Umbro Appollonio, ed., *Futurist Manifestos* (New York: The Viking Press, 1973).

47. Important discussions of the Soviet Constructivists' vision of the new era and its relationship to the creative artist are contained in: John E. Bowlt, ed., *Russian Art of the Avant-Garde: Theory and Criticism, 1902-1934* (New York: Viking Press, 1976); Troels Andersen, comp., *Vladimir Tatlin* (Stockholm: Moderna Museet, 1968); Alan C. Birnolz, "The Russian Avant-Garde and the Russian Tradition," *The Art Journal*, 32 (Winter 1972-73), 146-49; Camilla Gray, *The Great Experiment: Russian Art 1863-1922* (London: Thames and Hudson; and New York: Abrams, 1962); and Anatole Senkevitch, Jr., "Trends in Soviet Architectural Thought, 1917-1932" (Ph.D. dissertation, Cornell University, 1974).

48. Kandinsky, "On the Question of Form," *The Blaue Reiter Almanac*, p. 154.

49. Kandinsky, *The Art of Spiritual Harmony*, p. 92.

50. Kandinsky, "On the Question of Form," p. 156.

51. Dreier, *Western Art*, p. 68.

52. *Ibid.*, p. 84.

53. *Ibid.*, pp. 74-79.

54. *Ibid.*, p. 123; see also p. 100.

55. Blavatsky, *The Key to Theosophy*, pp. 41-47.

56. Dreier, *Western Art*, p. 5.

57. *Ibid.,* p. 100.

58. *Ibid.,* p. 102.

59. *Ibid.,* p. 69.

60. *Ibid.,* p. 33.

61. *Ibid.,* p. 69.

62. *Ibid.*

63. *Ibid.,* p. 126. Unlike Morris, however, Dreier was not opposed to the machine in principle and even looked forward to the time when artists would be "called upon to create the models for our machinery to copy." Dreier, *Western Art,* p. 69.

64. *Ibid.,* p. 70.

65. Lloyd Goodrich, "Introduction," in *Pioneers of Modern Art in America* (New York: Whitney Museum of American Art, April 9-May 19, 1946), p. 16.

4

Mysticism in London:
The "Golden Dawn," Synaesthesia, and "Psychic Automatism" in the Art of Pamela Colman Smith

MELINDA BOYD PARSONS

In 1909, the American critic Benjamin de Casseres reviewed an exhibition of Pamela Colman Smith's visionary "paintings to music" which had recently opened to much critical acclaim at Alfred Stieglitz's New York gallery, "291." Many of the paintings had actually been created in concert halls where, as Smith listened to music, her mind's eye filled with unbidden images of legendary spirits and heroic figures, the stuff of dreams and myth. De Casseres, in his essay, praised Smith in wonderfully extravagant terms, describing how she had "smitten with the rod of her imagination this adamant world of such seeming solids and vaporized it, . . . shaping out of this vapor . . . her visions of life, her symbols done in color, her music matrixed and molded to concrete shape." She was, he felt, "a blender of visions, a mystic, a symbolist," and her paintings were not merely art, but "poems, ideas, life-values and cosmic values that have long gestated within the subconscious world of their creator—a wizard's world of intoxicating evocations."[1] Other critics were equally positive about Smith's work, even if their words were a degree less ecstatic.[2] Around the same time in England, Smith's apparent visionary abilities and her membership in the Hermetic Order of the Golden Dawn (a London-based Rosicrucian group) brought her to the attention of a fellow member, the well-known occult scholar Arthur Edward Waite, who commissioned her illustrations for his newly conceived and quite influential Rider-Waite Tarot card deck.[3] Smith had joined the Golden Dawn around 1901, and it seems in large part to have been the ideas she absorbed there which led to her visionary paintings to music, as well as to her involvement with Waite and the Rider deck.

Smith was a young woman of mixed lineage—American, British, and West Indian—who earned her living as an illustrator of

73

children's books and theatrical publications. Of more interest to
her contemporaries, however, was her mystical bent, most often
manifested in the uncontrollable visions she experienced when
listening to music. Such cross-circuiting of visual and auditory
sensory stimuli is called *synaesthesia* and has been documented as an
actual phenomenon in recent years by neuroscientists.[4] At the
turn of the century, however, synaesthesia was believed to have
either occultist origins or to result from an extremely refined
(at times even over-refined) sensitivity to aesthetic "vibrations." In
Smith's case, both ideas applied. As early as 1901, after her ex-
posure to several important aesthetic and mystical influences, she
had begun to record her synaesthetic visions, at first using brush and
ink but later working up her spontaneous sketches into delicately
finished watercolors. It was a collection of these watercolors
which initially brought her to Stieglitz's attention in 1907 and sub-
sequently stimulated de Casseres' rhapsodic description of the
contents of her subconscious world. Those contents, the mythic
gods, spirits, and fairies, had materialized out of European folklore,
an interest Smith had developed at the turn of the century through
her close friendship with the Yeats family, though the interest
had also been foreshadowed by her earlier involvement with West
Indian magic and folklore.

The basic elements of Smith's art—mysticism and magic, folk-
loric content, visionary experience, and the visualization of music—
were part and parcel of the Symbolist milieu out of which her
work evolved. Yet her synthesis of these components was unusual
in several ways. First, although many late nineteenth-century
artists theorized about the importance of music to the visual arts, for
the most part they used music analogically to explain the emotional
impact that the formalist aspects of art, abstracted from their
representational functions, could have on a viewer—in the same
way that the abstract auditory tones of music could evoke a listener's
emotional response. Smith's relationship to music was much
simpler and more direct, involving what was believed at the time to
be a spontaneous transliteration from the auditory medium into
a visual mode. This literal quality, in combination with her visionary
subjects, lent her work a truth value of great interest to her many
fin-de-siècle contemporaries who were pursuing a range of non-
materialist philosophies. As one writer said of her,

On the continent, her friends were Maeterlinck, Debussy, and others
who were endeavoring . . . to pierce the veil that hid the subjective world.

Pamela Colman Smith had not the great creative power of these men, but it soon became clear that she had something quite as rare—the power to see clearly the invisible realm of which they all dreamed.[5]

(Or, as Whistler was reputed to have said of her, "She can't draw and she can't paint, but she doesn't have to."[6]) In addition, Smith's work was set apart from that of most other artists by her method, which involved an "automatic" procedure foreshadowing, at an exceptionally early date, the "psychic automatism" that Surrealist artists and writers later strove so hard to achieve. Thus Smith's art was Janus-faced: On one hand, it faced the Symbolist past, typifying the major spiritual and aesthetic concerns of the 1890s. On the other hand, it was seminal, heralding one of the most ubiquitous obsessions of the twentieth-century avant-garde, the search for a means of directly accessing the realm of the unconscious mind. The paths Smith followed to reach this end were multiple, and her journey is a tale as absorbing as the folklore in which she was immersed.

The seeds of some of Smith's predilections were rooted in her family background. On her mother's side, she was descended from the Colmans and the Chandlers, two old Anglo-American families with pronounced artistic and mystical tendencies. For several generations back, the Colmans had been devout Swedenborgians, a heritage which probably explained Smith's later affinity for mysticism. Her career as an illustrator was also prefigured in her background. Her great-grandfather, Samuel Colman, was one of the first American publishers to produce books illustrated in color, and he and his wife Pamela Chandler both wrote books for children.[7] Colman's brother William was a print publisher who is believed to have opened the first art gallery in New York City. Samuel Colman's son, also Samuel, was the well-known painter associated with the Hudson River School of artists, and also the founder of the American Society of Painters in Watercolors. Finally, on the Chandler side of the family, Smith was related to Joel Chandler Harris, whose folkloric interests were a direct inspiration for her own.

It was her father's side of the family which took young Pamela Smith to Jamaica, however. Charles E. Smith was employed as an auditor in the West Indian Improvement Company, and after his daughter was born in London in 1878, the family spent the next twenty years quite peripatetically, dividing their time between London, Kingston, and New York. All three places proved to

be important formative influences in Smith's later development as an artist. In England, after her mother's early death, she was taken in and raised for some years by the famous British actress Ellen Terry, doyenne of the Lyceum Theatre Company managed by Henry Irving. Smith's time spent touring with the Lyceum group in her early teens familiarized her not only with many aspects of visual expression (such as pose, gesture and costume) but also with the emotive power of music when combined with visual elements, as Irving's dramatic productions were almost always accompanied by music. Smith later said that she had learned all she knew of pictorial matters from the theatre, and surely these experiences also reinforced her synaesthetic tendencies.[8]

It was in Jamaica, though, that she had her first exposure to the magical and the occult. One reviewer who had interviewed her said in 1912,

Environment and early training had much to do with the development of her strange and vivid individuality. . . . She felt intensely the oppression and excitement of Jamaica's psychic atmosphere, and she listened to many tales and legends of the unseen world, told by witch-like old women in the firelight.[9]

The Obeah woman and Rolling Calf, Breda Tiger and Anansi the spider man, singing trees and talking birds, chanting yams and three-headed bulls, and a whole host of other characters—Chim-Chim, Bluebeard, Shakin Dumma, Haylefayly, Breda Dry-Kull—filled the tales told by firelight and moonlight. While some of these characters lived only in the stories, others like the Obeah woman were real-world necromancers and witches who could cast spells and perform other services for their clients. Pamela Colman Smith absorbed all of these stories and beliefs during her years in Jamaica, and she learned to retell the tales in a traditional manner called "lilting"—a rhythmic, almost musical kind of chanting which seemed to draw the listener into its web of enchantment (and also reaffirmed her synaesthetic leanings). Smith collected many of these stories in her early years and published several books of them in their original lilting dialect, enhancing their strange magic with her own quirky, energetic illustrations.[10] Many years later, she still supplemented her income by dressing up in native costume and lilting her stories,[11] and indeed, it was her interest in this folkloric material that first drew her into the Yeats circle in London at the turn of the century, when she introduced

herself to new acquaintances as "god-daughter to a witch and sister to a fairy."[12]

Smith and her father moved back to London permanently in 1899, but just prior to that time, Smith spent several winters in New York taking her only formal art training at the Pratt Institute in Brooklyn. Here she was fortunate enough to study under Arthur Wesley Dow, a prominent American art educator whose awareness of both Japanese art and French Post-Impressionist theory rendered him one of the most important influences in Smith's stylistic development.[13] Dow had studied briefly at Pont-Aven in the 1880s, where he learned the principles of Synthetism. On his return to the States, Dow worked with the noted Orientalist Ernest Fenollosa in developing a Synthetist method of art education which placed heavy emphasis on the use of Japanese materials and techniques. In this system, the canvas was viewed as an autonomous world governed by a series of Synthetist formulae. Effective composition, Dow and Fenollosa felt, was created through the manipulation of line, color, and "notan," a Japanese term meaning dark-and-light. Notan-massing, as Dow called it, was not an attempt to imitate natural chiaroscuro but to create an abstract harmonious rhythm of dark and light areas in a work of art, independent of any relation to nature. The key word here for Dow was harmony, for Dow and Fenollosa believed that the most effective and beautiful visual compositions were those that were the most "musical." As Dow told his students, drawing and painting "may be called 'visual music' and may be studied and criticized from this point of view."[14] The greatest art, Dow felt, consisted of "delicately harmonized proportions" and was "a music of lines and spaces."[15] Colors, tones, and lines in the visual arts corresponded to the tones and notes in music, he believed, and the key to success as a painter, as in music, was the development of the proper, harmonious "intervals" between visual notes.

An examination of Smith's commercial illustration work from the 1890s reveals many of the formal characteristics Dow taught in his classes,[16] but his most important effect on Smith was his insistence that visual art had a musical character, an idea which bolstered her inborn synaesthetic tendencies. On her arrival in England in 1899, she fell in with two groups who furthered this inherent inclination for synaesthetic expression, as well as her interest in mysticism and magic. One group comprised her old friends Ellen Terry, Henry Irving, and Terry's children Edith and

Gordon Craig. The other group consisted of new acquaintances, the Yeatses. She and her father first met John Butler Yeats, a painter and the family patriarch, but Smith soon became a close friend and working colleague with Jack Yeats (also a painter) and William Butler Yeats, who at the time was deeply immersed in a range of occultist activities. The whole Yeats family found Smith interesting and congenial, though the elder Yeats summed her up most vividly when he described her and her father as

... the funniest-looking people, the most primitive Americans possible, but I like them much. She looks exactly like a Japanese. Nannie says this Japanese appearance comes from constantly drinking iced water. You at first think her rather elderly, you are surprised to find out that she is very young, quite a girl. I would say of her as was said of Robespierre—she will go far because she believes in all her ideas, this time artistic ideas. ... She has the simplicity and naïvete of an old dry as dust savant [but] with a child's heart.[17]

It was precisely this simplicity, innocence and "primitivism" which seemed to W.B. Yeats to link Smith with the spiritual world of occultism that so attracted him. In the late 1890s, he had been practicing various kinds of divination in hopes of conjuring visions of the archetypal gods of mythology,[18] so when he met Smith with her talk of magic spells, metamorphic men and animals, singing trees, and so forth, he was immediately interested. They began to collaborate on several projects, including his Symbolist stage production *Where There Is Nothing*, for which she created set designs.[19] They also planned a journal called *The Hourglass*, devoted to Yeats's "Art of Happy Desire."[20] A few years later, Smith embodied the same ideas in her own journal *The Green Sheaf*, a "little magazine" with contributions from all the Yeatses, John Masefield, Lady Augusta Gregory, John Synge, AE, Ellen Terry, Gordon Craig, and many others. While Smith had long been an adherent of the "faerie faith," these activities and publications in the Yeats circle encouraged a shift in her thinking from a West Indian context to European—especially Celtic—traditions.

Smith's intuitive understanding of the spiritualizing content of her joint ventures with Yeats led to one of the most important developments in her early life—her membership, under his aegis, in the Isis-Urania Temple of the Hermetic Order of the Golden Dawn.[21] The Golden Dawn was a secret mystical/occultist organization devoted to the study of esoteric spiritual traditions, primarily

Rosicrucian but with an admixture of more exotic Hebrew, Egyptian, and Greco-Roman elements too. Cabbalism, with its emphasis on numerology and Tree of Life symbolism, was central in Golden Dawn doctrine, for the Tree of Life was believed to map out the movements of cosmic forces from their divine origination (the "un-created source") through the ten Sephiroth (divine names or powers). These forces, as Kathleen Raine has so illuminatingly explained, were manifested in the four worlds of deity, creation, formation, and action,[22] and human life was considered part of the long attempt of the soul to wend its way back to the origination of the Tree through the ten "stations" of the Sephiroth.[23] Like this hierarchical structure of the cosmos, the organization of the Golden Dawn was also graded. New members and neophytes were part of the "Order of the Golden Dawn in the Outer," while more advanced adepts could move into two higher degrees, the *Roseae Rubeae* and the *Aureae Crucis*.[24] Many initiates also believed that there was a higher order of unmanifested Masters who remained in the spiritual world but gave shape and instruction to the Dawn's corporeal members.[25] The group had been founded in London in 1888 and through the 1890s had suffered some dissension among various members and factions. By the time Pamela Colman Smith joined around 1901, Yeats had ousted Macgregor Mathers, a founder of the organization, and Mathers' deputy, the necromancer Aleister Crowley, and assumed the office of Imperator himself.[26] Other contretemps were to follow, particularly between Yeats and Arthur Edward Waite, Smith's Tarot mentor.

Thus Smith was inducted into the Dawn under the mystical name *Quod tibi id alliis* during a period of some unrest within the Order.[27] Nevertheless, she commenced the course of study re-quired of new members, attending the "knowledge lectures" by the adepts, and it was here that she acquired some degree of formalized knowledge about certain principles of which she already had an intuitive grasp—particularly the all-important theory of correspondences, which lay at the heart of the doctrines of the Golden Dawn.[28] In essence, the theory summed up the corres-pondences between the manifested world and its spiritual sources. Platonically, it suggested that each aspect of creation was an imperfect reflection of a perfect spiritual prototype, and the Golden Dawn believed that this perfection was filtered through the ten Sephiroth or divine names. These, in turn, were manifestations of

the one "uncreated source." True reality lay only in this proto-
typical realm, though according to the alchemical traditions of the
Golden Dawn, earthly phenomena possessed a kind of beauty
because they were fragments of the Divine Body, that Dismembered
God who had been fractured and scattered in the process of
Creation but who, at the end of time, would be made whole again.[29]
These beliefs were the underpinning of Golden Dawn rituals and
rites, which were a congeries of correspondences between symbolic
numbers, colors, images, words, gestures, scents, and other mani-
festations of spiritual essences.

The group believed that such spiritual essences remained
the same throughout time, though they were capable of taking on
multifarious forms within the belief systems of different periods and
cultures. In this sense, the myths and gods of all cultures could
be said to correspond since all were manifestations of the same
divine forces, a belief which accounted for the extreme eclecticism
of Golden Dawn doctrine and the group's trust in visual symbols as
representations of true reality. As Yeats believed, such symbols
could not be discovered or invented, but they could be *revealed*
to a mind which was either naturally receptive to visionary ex-
perience or made so through meditation or other mystical prepara-
tion. Herein lay the importance of Pamela Colman Smith to Yeats
and the Golden Dawn: she was a natural visionary, one of those
receptive souls through whose mediumship the gods and spirits
were believed to manifest themselves in visual form. And Smith had
the added virtue of being an artist. Not only did she catch fleeting
glimpses of archetypal reality, but she could record its image for
others less gifted.

Curiously, however, Smith's occultist studies were not enough
in themselves to inspire her visionary faculties. It seemed that
a catalyst or vehicle was needed, and fortunately one soon emerged
in the person of Ellen Terry's son Gordon Craig. Craig, who had
been a friend of Smith's since she was a child, was an actor and
director who had been conducting experiments in the late 1890s in
synaesthetic stage design.[30] Together with the musician Martin
Fallis Shaw, he had forged a new type of stage production they
called the "Theatre of Mood and Movement."[31] In essence it was a
Symbolist approach to theatre based on synaesthetic principles.
Abandoning the illusionistic painted stage flats used in most
theatres, Craig devised more abstract designs made of panels of

gauze lit by colored electric lights.[32] In productions like Craig's and Shaw's *Dido and Aeneas* of 1900, the color of the lighting changed in conjunction with the mood of the action, the rhythms of the actors' movements, and the tempo of the all-enveloping musical score. The end result was an evocative, moody production that created its effects as much through the synaesthetic manipulation of expressive sound, color, and movement as through the narrative of the opera. The degree of their success may perhaps be gauged by Yeats's comment that this *Dido and Aeneas* took him "to the edge of eternity."[33]

For Smith, Craig's reliance on the manipulation of formal elements to produce an emotional impact recalled Dow's belief in formalist harmonies as the basis of all great art. Craig's thinking in this respect was Post-Impressionist as was Dow's. Even more importantly, however, Craig's productions brought synaesthesia out of the realm of theory, clothing it in an almost hypnotically beautiful physical form (if contemporary descriptions are to be believed). Craig's work thus seems literally to have "touched a chord" in Pamela Colman Smith, and the catalyst or vehicle was music. On Christmas Day 1900, as Smith relaxed at Ellen Terry's house listening to Craig play Bach on the piano, she was suddenly startled to find a small hole opening like a camera's shutter in the air in front of her eyes, and through it she saw a vision she later described:

A bank and broken ground, the smooth trunks of trees with dark leaves; across from left to right came dancing and frolicking elfin people, with the wind blowing through their hair and billowing their dresses. The picture was very vivid and clear, and of beautiful color, with bluish mist behind the tree trunks. I drew an outline in pencil of what I saw on the edge of a newspaper, and as I finished—in perhaps a minute—the shutter clicked back again.[34]

Music, then, was the stimulus that released Smith's inherent visionary talents, and during the next year, after she had joined the Golden Dawn and attended some of their "knowledge lectures," she realized the implications of these musical visions in an occultist context. Rather suddenly, it seems, the many pieces of the puzzle fell together in a way that allowed her to "see"—not just see her visions, but to see some connections between the several most important strands in her thinking—namely, the "faerie faith," the theory of correspondences, and the various modes of synaesthetic

expression. For now she realized that the theory of correspondences implied not only correspondences between the earthly realm and the prototypical spiritual world (of which spirits, gods, and fairies were but the principles made manifest as visions or symbols), but that the theory also implied correspondences between the various physical senses as well as between the full range of expressive media linked with each sense. The justification for this vast metasystem of correspondences was surprisingly simple. Although true beauty resided in the prototypical world of the Sephiroth, it was reflected in fragmentary form in earthly phenomena; and these vestiges of spiritual beauty could be perceived in their various forms—color, shape, scent, sound—by the human senses. Thus all the senses and their equivalent expressive media—painting, music, dance, poetry, perfumery—corresponded in their potential for the revealment of archetypal beauty. On the basis of that correspondence, the various arts could be considered parallel or even interchangeable, and the stimulus of one medium or sense might evoke a response in an entirely different sensory or artistic mode. In Smith's case, the stimulus was auditory and the response was visual.

These general connections were easy for Smith to understand and accept, and once she did, her mind seems to have shifted to a more receptive mode. Now her visions came in rapid succession, unbidden, almost every time she listened to music.[35] Her contemporaries in the Golden Dawn understood these visions as privileged glimpses of the achingly beautiful world of spirit—images of divine forces filtered through the Sephiroth into palpable form within the interior world of the mind. As her friend the poet AE had said of such visions, they had "the character of symbol" and were "ready for the use of the spirit, a speech of which every word has a significance beyond itself."[36]

Smith gave utterance to the visual "speech" in her mind's eye through drawing and painting. Her method took shape in the concert hall, where as the music began, she would take brush and ink in hand, often creating as many as twenty or thirty drawings during one concert. As she later told an interviewer, she saw her visions in color and would have preferred to reproduce them that way, but since the visions were so fugitive, lasting only as long as the mood of the music, she contented herself with quick ink sketches, later working up those that were most interesting or appealing into finished pictures. The visions came in different ways:

Sometimes the picture appears and grows in colour and form upon the paper as she draws, and she seems to just trace over it with her brush. At other times it is a living and moving picture that she sees before her in a frame. . . . She does not seek to analyse these impressions at the time, as this would interfere with the subconscious action; she is absolutely sincere, and sets down only what she sees, holding her imagination well in check.[37]

In fact, Smith said that if she made any change whatsoever from the interior manifestation, the whole image broke up and disappeared. This was one of the factors that convinced Smith's contemporaries that hers were *true* visions, "givens" rather than imaginings. Another factor was that the visions were unbidden, indeed uncontrollable. Smith often seemed unaware of what she was drawing until after she was finished. As one fascinated writer remarked, "She feels quite detached from these drawings and is immensely interested in them, viewing them as an outsider who has never seen them before."[38] Smith spoke of this phenomenon in a description of her work written out in December 1907, probably for Stieglitz, whom she considered a kindred spirit:

What I wish to make plain is that these are not pictures of the music theme— pictures of the flying notes—not conscious illustrations of the name given to a piece of music. But just what I see when I hear music. Thoughts loosened and set free by the spell of sound. I put them down with haste. Sometimes they are so strange that they almost shock me as they come. Subconscious energy lives in them all. (Sand makes patterns by vibration on a drum.)[39]

It is obvious that Smith, like Yeats, conceived her works as welling up from a source deeper than mere conscious or subconscious memory—the works came "through" a part of the human psyche in tune with the most elemental vibrations of the cosmos. Perhaps some notion of the "sounding cosmos" or the "music of the spheres" stimulated her response to music. In any case, she did not perceive her visions as purely personal, but rather as a reflection of an objective cosmic and musical reality into which any sensitive person could tap. As she remarked of one of her paintings which depicted a garden, "A drawing of this garden I have shewn to seven people, and said, 'Play that.'—and every one has played the same. I do not know the name, but well I know the music of that place."[40]

This mystical approach, embodied in her working methods as well as the works themselves, lent the paintings much interest, especially as they not only revealed the spiritual worlds informing

our own but did so through the medium of particular musical pieces. Different composers inspired different moods and images, but she particularly admired the "Impressionist" works of Claude Debussy, music which "played around the edges of things," hinting rather than stating, full of suggestions of tonal color but ultimately intangible and vague.[41] Smith responded to his work, she said, because it seemed to have more in common with the sounds of nature than most music—"not the ordinary singing or chirruping of birds, but sounds like bells in the wind, and a curious pulsing under-rhythm, beating and throbbing like the breath of living things and the sap running in the trees."[42] Her sensitivity to Debussy's pantheistic web of sound was paralleled in her responses to other composers too, including Beethoven, Bach, and Chopin:

For a long time, the land I saw when hearing Beethoven was empty— hills, plains, ruined towers, churches by the sea; then sometimes I saw far off a little company of spearmen ride away across the plain. But now the clanging sea is strong with the salt of the lashing spray, and full of elemental life. . . . Often when hearing Bach, I hear bells ringing in the sky, and pulled by whirling cords, held in the hands of maidens dressed in brown. A rare freshness fills the air, like morning on a mountaintop, with opal-coloured mists that chase each other fast across the scene. . . . Chopin brings the night—gardens, mystery and dread hide under every bush, but joy and passion throb within the air. The moon bewitches all the scene.[43]

Some of Smith's strangest and symbolically richest paintings were executed under the influence of Schumann's music, though they incorporated visual elements drawn from a multiplicity of sources, including folklore, astrology, mythology, Golden Dawn texts, the writings of William Butler Yeats, and the ancient doctrines embodied in the Tarot cards. Consequently, while Smith's paintings may seem on first glance to possess a child-like simplicity, they reverberated for her contemporaries with complex layers of mood and meaning, just like the music which brought them to birth. It was expected that each viewer of Smith's works would read them differently depending on his or her sensitivity and recondite knowledge; for like the images on the Tarot cards, her paintings were perceived as arenas for the revealment and interaction of archetypal realities, each embodying multiple symbolic possibilities. Such richness of interpretational potential was undoubtedly encouraged by the eclecticism of the Golden Dawn, as Kathleen Raine has noted:

... [T]he practice of the Golden Dawn, like that of the Theosophical Society, was an unbounded electicism [sic]: if several alternatives exist, accept all. Electicism may be unscholarly but must lead to enrichment of connotation. Such moments of impassioned synchretism have (as at the time of the Renaissance) often accompanied vital movements of the arts.[44]

Given all these factors, it is obvious that the usual art-historical methods of analysis, in which the art historian claims a privileged position of objectivity, somehow "knowing more" than the artist, will not suffice in the case of Smith's works, because there was no definitive one-to-one correspondence of object and meaning in her music paintings. What there was instead was a delicate though tangled web of interrelated contexts, the meaning of which would have varied depending on what the viewers knew and what they chose to emphasize. By teasing out and identifying these tangled skeins of meaning, the art historian, while not actually un-tangling them, can create a matrix of possibilities for meaning based on the historical contexts in which the works were created and viewed. In Smith's case the most important contexts were the Hermetic Order of the Golden Dawn and the mythological/folkloric interests she absorbed as an artist of the Yeats circle.

One of Smith's paintings to Schumann should be sufficient to demonstrate the perplexing warp and weft of her symbolism— *Castle of Pain* of 1906.[45] The image came to her "automatically" as a vision to music, but retrospectively it is possible to identify the forms in which the music took shape in the painting as ancient symbols with long histories of multiple meaning in a range of belief systems. *Castle of Pain* had been inspired by Schumann's *Concerto in A Minor*. As a visual image, it is easier to describe than to interpret with any certainty, though its ultimate message seems to have concerned the pain of personal sacrifice required for spiritual growth. The painting, a watercolor, is dominated by a huge craggy tower carved from a rocky outcropping in the middle of a vast and relatively featureless plain. In the foreground, a pensive, seem-ingly despondent figure of indeterminate gender reclines on a rock. Behind this figure's back, in the foreground closest to the viewer, three heads obtrude unexpectedly into the frame, one appearing to be female, one male, and the third the head of an ox or bull. The eyes of both the human faces are closed, conveying the impression that they are in a trance, while the bull's eyes remain open. None of the three heads appears to be aware of the others, nor

do they seem to notice the reclining figure. Between Smith's sinuous monogram in the lower left-hand corner of the picture and the date 1906 is another mark which is impossible to make out clearly, though it somewhat suggests the graphic symbol for the constellation Taurus. Finally, about halfway between the monogram and the bull's head is a small inverted triangle bisected by another line.[46]

Pamela Smith wrote once, briefly, about towers, and the rather mysterious tenor and content of her statements suggested that for her, as for Yeats, towers symbolized the sacred knowledge accessible only to adepts of mystical doctrine:

I often see towers white and tall standing against the darkening sky.
Those tall white towers that one sees afar topping the mountain crests
 like crowns of snow.
Their silence hangs so heavy in the air that thoughts are stifled.
The watchers' hands are lifted up to warn those wayfarers who wander
 idly.
But he who knows the way, but gives the sign and enters in towards that
 sacred way.[47]

Smith may have been influenced directly by Yeats's ideas, but alternatively, they may both have been swayed by the tower iconography of Golden Dawn rites and texts. The tower was a recurring symbol in Yeats's writing, where on one level at least, it represented the spiritual achievements of philosophers and mystics, those who of necessity lived above and apart from society so that they might contemplate the higher realities. The tower appeared most often in Yeats's late works—for example, his poem "The Black Tower," where it represented the defense of spiritual wisdom against the ignorance of the world at large.[48] But this identification of the tower as a guardian of wisdom undoubtedly had resulted from Yeats's familiarity with the four Watch-Towers of Golden Dawn ritual, which guarded the four directions of the world.[49]

As early as 1900, Yeats had spoken of the tower as a "very ancient symbol" through which spiritual knowledge was made manifest in "the abundance and depths of nature."[50] This was a point which added immeasurably to the richness of the tower as a symbol: it was not a heavenly or otherworldly place, but a place very much part of the physical world of nature, and thus bound up with the potential for corruption, decay, and human suffering. For Yeats

1 *Pamela Colman Smith*, Castle of Pain, *Watercolor,
1906. Whereabouts unknown. Reproduced from a
copy photograph in Stuart and Marilyn R. Kaplan
Collection, New York*

then, and for Smith, the tower symbolized not only the pursuit of supreme wisdom but its concomitant sacrifice, suffering, isolation, and loneliness. The association of the tower with sacrifice was at the core of Yeats's and Smith's studies in the Golden Dawn, occurring in both its texts and in the Tarot cards. For example, in *The Chymical Marriage of Christian Rosencreutz*, a primary Rosicrucian/alchemical text read by the group, the tower was a symbol of earthly life and the cycles of pain and personal sacrifice necessary for spiritual development and purification.[51] A similar conflation of the tower's earthbound nature and its potential for spiritual revealment could be found in the Tarot deck, whose "Tower" card depicted a tall narrow fortress atop a rocky crag; its pinnacle was crumbling under the impact of a lightning bolt, and its two human residents tumbled headlong to the ground. According to Smith's Tarot collaborator Arthur Waite, this tower symbolized "the materialization of the spiritual word,"[52] thus representing both world and spirit. However, his further explanation—as well as the image itself—made clear the painful dangers inherent in associating oneself with the tower of wisdom, since as soon as spirit is made manifest in the natural world it becomes subject to corruption—what Waite described as "false interpretation" or "the literal word made void."[53] Yeats too at times linked the tower symbol with the possibility of worldly ruin, as for example in the poem "My Descendants," in which his tower's "roofless ruin," "cracked masonry," and "desolation" had resulted from his descendants' too worldly inattention to the pursuit of spiritual truth.[54]

In 1903 Yeats and Waite split the Golden Dawn over the issue of Yeats's emphasis on occultist magic, which conflicted with Waite's interest in a more purely Christian mysticism. Waite seceded from the larger group, taking a number of the members with him, including Pamela Colman Smith.[55] Nevertheless, the two men's ideas retained a certain similarity, as can be seen in this discussion of the tower. For both of them, the tower was a point of communication between the world of spirit and the world of nature, what the religious historian Mircea Eliade has described as an *axis mundi*, around which the formless chaos of physical matter takes on form and meaning.[56] Essentially, like the rolands found in the centers of primitive settlements and the church spires of Christian towns, the tower was the esoteric equivalent of a hierophany—the meeting of the natural and the supernatural.[57]

Many of these implications of the tower as a symbol came into play in Smith's *Castle of Pain*. The isolation and loneliness of the tower were represented by its craggy height and its physical separation from the other landscape features in the painting. The title of the work also suggested loneliness, though it conveyed even more clearly the tower's association with the pain of personal sacrifice, as suggested in Rosicrucian texts read by the Dawn. These books had detailed many kinds of sacrifice—primarily physical—required to ascend through the various levels of the mystic tower of spirituality. For Yeats, however, the particular nature of the sacrifice associated with the tower was the pain and loneliness of intellectual solitude. As Raine has pointed out, "Wisdom, for Yeats, is essentially lonely, because for him wisdom is the hard-won knowledge of the initiate, possessed by few; and the custodians of truth become the more lonely as they advance in knowledge."[58] Yeats himself had likened the pursuit of wisdom to the "loneliness of death."[59]

These themes of sacrifice in the tower were reiterated in *Castle of Pain* by the triad of heads in the corner of the painting. The bull or ox, in particular, was a long-standing symbol of sacrifice in a number of belief systems, esoteric as well as Christian, and was perceived as such by the Golden Dawn. Many members of the Dawn were familiar with James Frazer's book *The Golden Bough*, including Yeats and, undoubtedly, Smith. In the book Frazer had described in detail the cultures who associated the bull or ox with the sacrificial "Dying and Reviving Gods" of seasonal vegetation, such as Dionysus or Osiris. The stories of all these gods were much the same, usually involving their murder, resurrection, and subsequent apotheosis as the central figures in fertility cults, most of whom sacrificed bulls or oxen to re-enact the cycle of rebirth. For example, Dionysus—Greek god of wine and viticulture—was also, as Frazer explained it, a god of trees and of grain.[60] In his role as husbandman of the grain, Dionysus was associated with the oxen who pulled the plough, but he was also able to assume animal forms himself to escape various enemies. Eventually he was murdered and dismembered while in the shape of a bull but, in the end, was resurrected—an event which came to be associated with the rebirth of life-giving vegetation each spring, when the ritual was re-created through the sacrificial dismemberment and ingestion of live bulls by frenzied Dionysus worshippers. The story of Osiris was similar as Frazer told it, for Osiris introduced the

89

cultivation of grain and grapes to Egypt, and he also came to be identified as a god of trees.[61] So great was his popularity that his jealous brother Seth murdered him and eventually dismembered his body. His wife Isis, bereft, recovered the body and, with the help of the jackal-headed god Anubis, reconstructed Osiris and restored him to life, after which he reigned as god of the underworld and final judge of the dead. As was the case with Dionysus, Osiris worship soon came to be linked with the annual cycles of vegetative growth, as well as with the sacrifices of bulls or oxen, which were intended to spur this regrowth of crops. With both Dionysus and Osiris, then, as well as a number of similar gods, the bull was a powerful symbol of the sacrifice necessary for the rebirth of life.

Many aspects of these legends of Dying and Reviving Gods paralleled Christian tradition, similarities which had been made explicit in the writings of the Church fathers. There, gods like Dionysus were seen as "types" or forerunners of Christ for several reasons, including their association with grapes, with trees, and with the idea of life-giving resurrection. For Christ too was associated with all these things—according to St. Augustine, he was the "Mystic Grape" who had been sacrificed in the wine press only to emerge revivified in the life-giving Eucharistic wine;[62] Christ was also a God of trees since his incarnation originally had been necessitated by the Two Trees in the Garden and had ended on the Dry Tree of the Cross.[63] The bull too had a Christian counterpart in the Scriptures and writings of the Church Fathers as the ox, one of the Four Living Creatures of Ezekiel's vision (Ezekiel 1:5-14). By the early Christian period, these four Creatures—man, lion, ox, and eagle—had come to be accepted as symbols of the four Evangelists, Matthew, Mark, Luke, and John. The ox, because of its association in past cultures with sacrifice and patient endurance, was linked with St. Luke since his Gospel placed so much emphasis on the sacrificial aspects of Christ's ministry.

The interrelatedness of all these religious themes was of great interest to the Golden Dawn, who saw the Dying and Reviving Gods as "types" of the one Dismembered God of alchemical tradition. The figures of Isis, Osiris, and Dionysus were central in the rituals of the Dawn, where they often took on additional esoteric connotations. Dionysus, to take one example, was identified—at least in Yeats's mind—with the sacrificial and salvational implications of the "Hanged Man" in the Tarot card deck, a figure

hanging upside-down by one foot from a Living Tree.[64] Bulls and oxen also took on new meaning in the esoteric and occult traditions, particularly in an astrological context. There the bull was the symbol of the constellation Taurus, ruled by the planet Venus (among whose qualities were harmony, creativity, and artistry) and ruling, in turn, the human throat and voice. In terms of its characteristics, Taurus was said to symbolize fecundity and creation, especially through its association with sacrificial rites, and it was believed to correspond mystically with the number two, thus representing the principle of duality composed of the masculine and the feminine.[65]

As a member of the Golden Dawn, Pamela Colman Smith would have been familiar with much of the material in these corresponding symbolic systems. Indeed, an examination of *Castle of Pain* in light of these ideas reveals a matrix of possible meanings. The most striking feature of the work is the parallelism of the sacrificial themes represented by the two major symbols, the tower and the bull. This formed the basis for an interpretation on both the esoteric and the Christian levels, either or both of which would have been significant to members of the Golden Dawn. Esoterically speaking, the primary message of the painting was the suffering and sacrifice necessary for spiritual purification and rebirth. If the tower was the location of the sacrifice, then the bull symbolized the sacrificial victim whose death led to new life and fertile growth. The two human faces with the bull—man and woman—could be interpreted as an aspect of the fertility engendered by the sacrifice of the bull. Their eyes were closed here because the sacrifice had not yet been undertaken, thus leaving them in a dormant state, their fertility unreleased—just as the vegetation associated with Dionysus and Osiris lay dormant in the winter until it was liberated by ritual sacrifice in the spring. Astrologically, the heads represented the masculine and feminine duality embodied in Taurus the bull, who was invoked additionally by the small written symbol of Taurus inscribed by Smith in the corner of the painting.

However, *Castle of Pain* could also be read in a Christian context, an interpretive possibility which certainly would not have been ignored by the eclectic Golden Dawn, particularly by its more Christianizing members such as Waite and Pamela Smith, who converted to Catholicism in 1911. Reading the bull as the ox of St. Luke not only meant that the message of the painting was still

91

predominantly sacrificial, but that it referred in a satisfyingly syncretic manner to yet another God—Christ—who was associated with trees, as were Dionysus and Osiris. In addition, the ox could be read as a symbol of Luke's Gospel, the concretization of the Word of God. This provided further links between the levels of interpretation possible in Smith's painting, since the tower, as it appeared in the Tarot cards, was also a symbol of "the materialization of the spiritual word," and the bull in its guise as Taurus referred to the word in its domination of the human throat and voice.

What of the solitary figure? It was too nonspecific in its rendering to be read as a symbol of any particular person or even any quality, except perhaps a generalized melancholy suggested by the reclining posture. However, the lack of action did make the figure appear to be pondering some thought or question, and its isolation from the other creatures in the image emphasized the solitary nature of this pursuit. Placed as it was, between the tower of sacrifice and the sacrificial bull, it is likely that the question the figure pondered had to do with its own relationship to the tower, an assumption reinforced by the title of the painting. Given these factors, it seems probable that members of the Golden Dawn read *Castle of Pain* as an emblem of the decision each initiate of the group had to make about his or her own commitment to the stern discipline of the Order—and especially to the intellectual solitude that followed on a successful scaling of the spiritual tower of sacrifice.

Smith, as a member of the group, would naturally have understood these implications of her visionary image; but she may also have felt that it contained a more personal message to her as an artist, since it carried a double reference to art: the creativity and artistry attributed to Venus, the planet that ruled Taurus, and St. Luke's status as the patron saint of artists. If this were the case, then in addition to the above connotations of *Castle of Pain*, Smith might have viewed the reclining figure as a representation of the melancholy that had been traditionally associated with artists over the centuries,[66] just as she saw her own contribution to the spiritual knowledge housed in the tower as one based on her visionary and artistic abilities.

Images like *Castle of Pain*, so deeply immersed in the romantic fogs and dreams of British mysticism and the occult, anchored Smith firmly in the fin-de-siècle, with its end-of-century climate of

world-weariness and despair. So did her fluid style, which remained resolutely Art Nouveau in its essentials until the end of her days, even though the context that had given shape to her work—the idealism of the Golden Dawn and the Celtic Revival—had ceased to exist by the end of World War I. And yet several writers since then have noted a transitional aspect to Smith's art—that in some ways it occupied a pivotal position between nineteenth-century aestheticism and twentieth-century avant-gardism. The basis for this assessment lay neither in her subjects nor her style, but rather in her method of working—her automatism—which clearly anticipated certain characteristics of twentieth-century art, especially the Surrealists' interest in automatism. Early critics of Smith's work, such as Benjamin de Casseres or James Huneker, while aware of her "automatic" method, chose not to emphasize it in their reviews, focusing instead on the content of her vision and its revealment of the subjective universe believed by many to underlie the outer one. Some years later, however, after the 1924 publication of the Surrealist manifesto with its definition of "psychic automatism," writers concentrated instead on Smith's automatic procedure and its link with music, the vehicle for her automatism. For example, in the mid-1920s, she was the subject of a psychological study by John G. Vance, a professor of psychology at St. Edmund's College, Ware, and the author of a thesis on the experimental psychology of recognition. In a letter to the *Times* Vance marvelled that in repeated experiments with music unknown to Smith, she had been able to "see" and delineate images which paralleled or replicated the subject expressed by the composer of the music. A number of these sketches were reproduced shortly thereafter in the *Illustrated London News* with appropriate quotations from Vance's study:

We have tested her on many occasions with new and unknown music, and have been surprised at . . . the accuracy of the delineation of the music and its title. Her hand works feverishly while the music lasts. When it ceases, the brush falls from her hand, as she *sees* no more. It is to her as if the sun had suddenly been totally obscured as she watched some landscape. It seems almost as if she *sees* sound; so rapid is the translation, and so strangely vivid and varied the impression.[67]

According to the Surrealist manifesto, the purest form of psychic automatism was "thought dictated in the absence of all control exerted by reason, and outside all aesthetic or moral preoccupations."[68] In trying to combat the restrictive rationalism of waking

reality, the Surrealists employed what they saw as the liberating irrationality of dreams and automatic drawing. Smith's automatism, however, was somewhat different in kind, a difference pinpointed by Yeats in his book *A Vision,* in which he discussed the context of British occultism at the turn of the century:

... I look back to it as a time when we were full of a phantasy that has been handed down for generations, ... now an interpretation, now an enlargement of the folk-lore of the villages. That phantasy did not explain the world to our intellects, which were after all very modern, but it recalled certain forgotten methods and chiefly how to so suspend the will that the mind becomes automatic and a possible vehicle for spiritual beings. ... [69]

In contradistinction to the Surrealists then, psychic automatism functioned for Smith and for Yeats as the key to a world more real, more permanent, and far more rational than our own—a world which in spite of its magicality (or in Smith's mind *because* of it) was permeated with an immutable logic. For her, the pure rationality of this dream world stood in sharp contrast to the utter inconsistency and fragmentation of modern life.

In a postwar environment, however, it was more difficult to maintain such beliefs than it had been in the "Celtic Twilight" at the turn of the century.[70] Writers like John Vance had already fallen prey to empirical thinking—in his study of Smith there was no mention of legendary spirits or mythological heroes. What was of interest to him was not Smith's revealment of supernatural reality but the psychological fabrication of that reality within the physiological and all too human mechanisms of the brain. Smith's friend AE had occasionally succumbed to a similar sort of skepticism, although he seems to have recognized the pattern of error as he stated it in *The Candle of Vision* in 1920:

Yet though the imagination apprehended truly that this beauty was not mine, ... for some years my heart was proud, for as the beauty sank into memory it seemed to become a personal possession, and I said, "I imagined this" when I should have said, "The curtain was lifted that I might see."[71]

Smith, however, never wavered in her conviction that the source of her visions was not the human mind but the transcendent stuffs from which and by which that mind had been fashioned, realities for which the mind was only a conduit. In the end then, the magic of her art lay in this fact—that unconcerned with systematic aesthetic programs and uninterested in radical manifestoes, Pamela

Colman Smith followed her own lights. Pursuing the siren song of Bach and Beethoven, Chopin and Schumann, Fauré and Debussy, she created an art which embraced the demands of both the nineteenth and the twentieth centuries. Her images fulfilled the Symbolist obsession with Neo-Platonic immutabilities, describing a world of immortal spirits, gods, and heroes playing out their passions in her mind's eye; and yet her method presaged the more Modernist interest in the automatist "play of disinterested thought." The pivotal position her work occupied had been recognized by the art historian Lewis Hind as early as 1912, when he described Smith and her painting as "sign-posts on the bye-path to the art of the future."[72]

More contemporary art historians, too, have begun to turn their attention to the links between mysticism and modern art, undertaking detailed iconographic analyses, tracing philosophical influences, establishing a theological context[73]—yet it is more difficult to re-create the *atmosphere* in which these links between spiritualism and art originally were forged. Kathleen Raine summed up the problem in a comment made some years ago concerning occult scholarship:

... Academic study of magical symbolism may be likened to the analysis of musical scores by a student who does not know that the documents he meticulously annotates are merely indications for the evocation of music from instruments of whose very existence he is ignorant.... No reading of the score of symbolic forms can enable us to hear the music.[74]

Similarly, it is unlikely that we will ever really recapture the twilit spirit of those prewar days when the Golden Dawn flourished in London, and Smith, Yeats, AE, Lady Gregory, and many others pursued the realities of myth, music, and magic. The writer Arthur Ransome lived through that time, and his evocative description of the atmosphere at Pamela Smith's "at-homes," attended by many in the Yeats circle, perhaps takes us a little further along that elusive path:

I never let a week pass without going to that strange room to listen to the songs and tales, and to see the odd parties of poets and painters, actors and actresses, and nondescript irregulars who were there almost as regularly as I.... Always we were merry.... There I heard poetry read as if the ghost of some old minstrel had descended on the reader, and shown how the words should be chanted aloud. There I heard stories that were yet unwritten, and talk that was so good that it seemed a pity that it never would be.[75]

The telling of tales, the playing of music, the practice of magic—all were part of the fabric ripped asunder between 1914 and 1918. As it was with the Golden Dawn's Dismembered God, all we have now are beautiful fragments which may never be reconstructed, even in the fullness of time. To paraphrase Pamela Colman Smith, who knew not the name but knew well "the music of that place," we know the place and its name, but we cannot any longer clearly hear the music.

Notes

1. Benjamin de Casseres, "Pamela Colman Smith," *Camera Work* 27 (July 1909): 20.

2. See, for example, Stieglitz's review of an earlier Smith show at 291, in *Camera Work* 17 (Jan. 1907): 49; and James Huneker's review in the *New York Sun* (7 Mar. 1912), 4. See also "Pictured Music," *Current Literature* 45 (1908): 174; and "Pictures in Music," *The Strand* (1909), 635.

3. Originally published by Rider and Co., London, 1910. Reprinted today by U.S. Games Systems, Inc., New York. For the historical context of the Tarot cards, see Stuart Kaplan, *The Encyclopedia of Tarot*, vol. 1 (New York: U.S. Games Systems, Inc., 1978). More specifically for the Rider deck, see Arthur E. Waite, *The Pictorial Key to the Tarot* (New York: University Books, 1959) and Waite's descriptions of his dealings with Smith in his memoirs, *Shadows of Life and Thought* (London: Selwyn and Blount, 1938), 184-85, 194-95. For Yeats and the Tarot, see Gladys V. Downes, "W.B. Yeats and the Tarot," in *The World of W.B. Yeats: Essays in Perspective*, ed. Robin Skelton and Ann Saddlemyer (Victoria, B.C.: Adelphi Bookshop, distributed by Univ. of Washington Press, Seattle, 1965); and Kathleen Raine, *Yeats, the Tarot and the Golden Dawn* (Dublin: Dolmen Press, 1972).

4. See Norman Geschwind, "Specializations of the Human Brain," *Scientific American* 241, 3 (1979): 180-99; and V.B. Mountcastle, "The View from Within: Pathways to the Study of Perception," *Johns Hopkins Medical Journal* 136 (1975): 109-31.

5. M. Irwin Macdonald, "The Fairy Faith and Pictured Music of Pamela Colman Smith," *The Craftsman* 23 (1912): 33.

6. Cited in a review of PCS exhibition by Joseph Edgar Chamberlin, "A Radical Group," *Journal American*, n.d., n.p. Scrapbook clipping, private collection.

7. Genealogical information gleaned from a relative of the Colman family.

8. Pamela Colman Smith, "Should the Art Student Think?" *The Craftsman* 14 (1908): 417-18.

9. Macdonald, 32.

10. Smith's earliest publication of Jamaican folklore was "Two Negro Stories from Jamaica," *Journal of American Folklore* 35 (Oct.-Dec. 1896): 278. She also wrote and illustrated *Annancy Stories* (New York: R.H. Russell, 1899) and *Chim-Chim; Folk Stories from Jamaica* (London: Green Sheaf Press, 1905).

11. Edward A. Craig to the author, 4 April 1974: "Here, around 1912-14, 'Pixie' would entertain us and other children—she sat us around her in a circle, and with the aid of little figures she had made out of wood and paper, she would tell her wonderful stories about a'Nancy. She generally wound a scarf around her head to add to her West Indian features and the special background to the stories. She was . . . rather plump and very soft and lovable—we all adored her."

12. Arthur Ransome, *Bohemia in London* (London: Chapman and Hall, Ltd., 1907), 54.

13. For Dow, see Frederick C. Moffatt, *Arthur Wesley Dow (1857-1922)* (Washington: published for the National Collection of Fine Arts by the Smithsonian Institution Press, 1977).

14. Dow, *Composition*, 6th ed. (New York: The Baker and Taylor Co., 1905), 5. The text of this edition duplicates Dow's first edition of 1899.

15. *Ibid.*, 21.

16. These characteristics include flat color, dark outlines, and composition according to the principles of "symmetry, subordination, opposition, transition, and repetition." See *Composition* for details.

17. John B. Yeats, *Letters to His Son W.B. Yeats and Others, 1869-1922*, ed. Joseph Hone (London: Faber and Faber, Ltd., 1944), 61.

18. See Raine, 35-41.

19. W.B. Yeats, *The Letters of W.B. Yeats*, ed. Allan Wade (London: R. Hart-Davis, 1954), 444.

20. *Ibid.*, 389.

21. R.A. Gilbert to the author, 6 August 1975. For the Golden Dawn, see Israel Regardie, *The Golden Dawn, an Account of the Teachings, Rites and Cere-monies of the Order of the Golden Dawn* (Chicago: Aries Press, 1937); Kathleen Raine; George Mills Harper, *Yeats's Golden Dawn* (New York: Barnes and Noble, 1974); and Ellic Howe, *The Magicians of the Golden Dawn* (New York: Samuel Weiser, 1978).

22. Raine, 16.

23. *Ibid.*, 15-17.

24. For detailed descriptions of the degrees, see Regardie, Harper, and Howe.

25. Raine, 9.

26. Raine, 10-12. See also Harper and Howe. It is interesting in an art-historical context that Mathers' wife was Mina Bergson, sister of the philosopher Henri Bergson.

27. R.A. Gilbert to the author, 6 August 1975, citing information from Ellic Howe.

28. For discussion of the "knowledge lectures," see Virginia Moore, *The Unicorn; William Butler Yeats' Search for Reality* (New York: Macmillan, 1954), 42-150. See also Regardie, vol. 1, 99-226.

29. Raine, 28-30.

30. For Craig, see Edward A. Craig, *Gordon Craig, the Story of His Life* (London: Victor Gollancz Ltd., 1968) and Edward A. Craig, "Gordon Craig and Hubert von Herkomer," *Theatre Research* 10, 1 (1969): 7-16. See also Bernard Hewitt, "Gordon Craig and Post-Impressionism," *Quarterly Journal of Speech* 30 (February 1944): 75-80; and Brian Arnott, *Edward Gordon Craig and Hamlet* (Ottawa: National Gallery of Canada, 1975).

31. Arnott, 16.

32. See Edward A. Craig and Arnott. For the sources of this technique in the work of Hubert von Herkomer, see Herkomer, "Scenic Art—I," and "Scenic Art—II," *The Magazine of Art* 15 (1892): 259-64, 316-20.

33. Arnott, 16-17.

34. The Hon. Mrs. Forbes-Semphill, "Music Made Visible," *Illustrated London News*, 12 February 1927, 260.

35. See "Pictured Music," "Pictures in Music," and Forbes-Semphill. According to Forbes-Semphill, the one composer whom Smith could not abide was Wagner, whose music "sends her mad with irritation and fury, and she cannot draw to it, as she sees nothing but the obvious material fact, which does not inspire her." In Smith's own words, when she listened to Wagner, she saw "scratchy little brown fir-trees rising through a brown fog; my scalp tingles and my hair pricks; I feel so full of rage that I want to crack the heads of people together like nuts." Smith said she often had to leave concerts when Wagner's music was being played, and that if she came into a room *after* it had been played, she would see there "thick curtains of brown spiders' webs" and find "a sickly, sweet, evil smell clinging to everything." This is interesting for two reasons. First, most people saw Wagner as the embodiment of synaesthetic endeavor, so it is very curious that Smith would "see" nothing appropriate to his music. Second, her description indicates that she was synaesthetic in more than two senses, since some music apparently inspired her olfactory senses.

36. A.E. [George Russell], *The Candle of Vision* (London: Macmillan and Co., 1920).

37. Forbes-Semphill, 260.

38. *Ibid.*

39. A copy of this autograph manuscript can be found in the Stuart R. Kaplan collection, New York, and another in the Beinecke Rare Book and Manuscript Library, Yale University. Smith probably wrote it for Stieglitz after the overwhelming response to her 1907 exhibition at 291. According to Stieglitz, the dates of the show had had to be extended two weeks, and well over 2000 visitors crowded the gallery, purchasing over half the collection.

40. *Ibid.*

41. According to several interviewers, as well as the evidence of her own letters, Smith was a personal friend of Debussy, and a number of her drawings were done as he played for her. He owned a portfolio of these drawings of which he is reputed to have said that they extended his own ideas in many cases and were his "dreams made visible." (Forbes-Semphill, 259-260; James Huneker, *New York Sun*, 7 March 1912; and letters, Stuart R. Kaplan collection, New York.)

42. Forbes-Semphill, 260.

43. Smith autograph manuscript, Kaplan collection.

44. Raine, 6.

45. The whereabouts of the original painting, *Castle of Pain*, is unknown. It exists today only in copy photographs, one taken by Alfred Stieglitz and formerly in the collection of Dorothy Norman [its present whereabouts is also unknown] and another copy, made from the Stieglitz photograph, now in the Kaplan collection.

46. An upright triangle bisected by a line is one of the symbols used to represent the element air (see Herbert Silberer, *Problems of Mysticism and Its Symbolism* [New York: Moffat, Yard and Co., 1971], 194). I do not yet understand the significance of this symbol as it appears, inverted, in *Castle of Pain*, nor do I know if Smith placed it there herself or if it was drawn in later by another hand.

47. Smith autograph manuscript, Kaplan collection.

48. *The Collected Poems of W.B. Yeats, Definitive Edition* (New York: Macmillan Publishing Company, Inc., 1956), 340.

49. Regardie, vol. 2, 264-279.

50. W.B. Yeats, *Essays*, 3rd ed., rev. (New York: The Macmillan Co., 1924), 106-07.

51. Summarized and discussed in Arthur Edward Waite, *The Real History of the Rosicrucians* (London: George Redway, 1887), 99-196.

52. Waite, *Pictorial Key*, 132.

53. *Ibid.*, 132-35.

54. *Collected Poems*, 201.

55. For the Waite split with Yeats, see Harper and Howe.

56. Mircea Eliade, *The Sacred and the Profane; the Nature of Religion* (San Diego, New York, London: Harcourt, Brace, Jovanovich, 1959), 8-65.

57. *Ibid.* For rolands and their relation to church steeples, see John R. Stilgoe, *Common Landscape in America, 1580 to 1845* (New Haven and London: Yale UP, 1982), 18-19, 56-57, and 349, note 15. See also Yi-Fu Tuan, *Landscapes of Fear* (New York: Pantheon, 1979).

58. Raine, 49.

59. Yeats, *Is the Order of the R.R. and A.C. to Remain a Magical Order?* (London, 1901). Cited in Raine, 49-50.

60. Sir James George Frazer, *The Golden Bough; A Study in Magic and Religion*, abridged ed. (New York: Macmillan Publishing Co., 1922). For Dionysus, see pp. 448-56.

61. *Ibid.*, 420-47, 433-38. For general discussion of European borrowings from Egyptian culture, see S. Morenz, *Die Begegnung Europas mit Ägypten* (Zurich, 1969).

62. St. Augustine, as quoted in Emile Male, *L'Art religieux de la fin du moyen âge en France* (Paris, 1925). See pp. 116ff. for discussion of the Mystic Grape. See also Ingvar Bergstrom, "Disguised Symbolism in Madonna Pictures and Still Life," *Burlington Magazine* 97 (1955): 303-08, 340-49; and E. De Jongh, "Grape Symbolism in Paintings of the Sixteenth and Seventeenth Centuries," *Simiolus* 7 (1974): 166ff.

63. For Christ's association with trees, see for example C. de Tolnay, "La resurrection du Christ par Piero della Francesca," *Gazette des Beaux-Arts* 46 (1954); Eleanor S. Greenhill, "The Child in the Tree: A Study of the Cosmological Tree in Christian Tradition," *Traditio* 10 (1954): 323ff.; Gerhardt Ladner, "Mediaeval and Modern Understanding of Symbolism: A Comparison," *Speculum* 54 (April 1979): 223-56; W. Meyer, "Die Geschichte des Kreuzholzes vor Christus," *Abhandlungen der Koniglich Bayerischen Akademie der Wissenschaften*, Philosophisch-philologische Classe 16, 2 (1882): 101ff.; or Fritz Saxl, "A Spiritual Encyclopaedia of the Later Middle Ages," *Bul. John Rylands Library, Manchester* 40 (1958): 497ff.

64. Raine, 38-40.

65. J.E. Cirlot, *A Dictionary of Symbols* (New York: Philosophical Library, 1962), 313.

66. For melancholy and artists, see Rudolf Wittkower, *Born Under Saturn* (New York: W.W. Norton and Co., Inc., 1963) and Ernst Kris and Otto Kurz,

Legend, Myth and Magic in the Image of the Artist (New Haven and London: Yale UP, 1979).

67. Forbes-Semphill, 258.

68. Cited in Patrick Waldberg, *Surrealism* (New York and Toronto: Oxford UP, 1965), 11.

69. W.B. Yeats, *A Vision; an Explanation of Life Founded Upon the Writings of Giraldus and Upon Certain Doctrines Attributed to Kustaben Luka* (London: privately printed by T. Werner Lauries, Ltd., 1925).

70. This widespread tendency in the modern period to secularize the divine has been recently discussed in Mark C. Taylor, *Erring: A Postmodern A/Theology* (Chicago and London: U of Chicago Press, 1984). See especially Chapter One, "Death of God."

71. AE, *Candle of Vision*, 7.

72. Cited in Forbes-Semphill, 260.

73. See for example the recent exhibition catalogue, *The Spiritual in Art; Abstract Painting, 1890-1985*, ed. Maurice Tuchman (New York: Abbeville Press, 1986).

74. Raine, 5, 35.

75. Ransome, 62. See also *The Autobiography of Arthur Ransome*, ed. Rupert Hart-Davis (London: Jonathan Cape, 1976), 87-89.

5

The Theosophical Origins of Franz Marc's Color Theory

JOHN F. MOFFITT

Si vis me flere,
dolendum est primum ipsi tibi.

(If you'd force ME to grieve,
then first YOU yourself must be
so stricken.)

　　　　Horace, Ad Pisones

What Expressionist artists wished to "express" so forcefully some three-quarters of a century ago was *emotion*, and certain colors and certain shapes were understood to convey pure emotionality— *without any necessary reference to the objects of the phenomenal world*. To put it another way, the Expressionist artists came to believe that, by themselves, colors and shapes could act independently—as pure "abstraction"—and thus the painter no longer attempted to employ these simply to represent people, animals, plants, architecture, landscapes, and so forth, in order to evoke a certain, desired emotional state in the viewer. Henceforth, mere colored shapes (at least in theory) should suffice, by themselves, to allow one to "read," and then to feel, the appropriate primal emotional response, that which had generated the resulting disposition of pigments on the painter's canvas. Accordingly, these hues and forms no longer "described" objects existing *beyond* the canvas and situated out there in the "real" world. Moreover, as will be revealed here, these emotional states, represented by just colors and shapes alone, could be given very specific psychological meanings, such as "intense anger," "heartfelt devotion," "murderous rage," "self-renunciation," and so forth.

Although two major groups of "Expressionist" artists had been

102

formed in Germany as early as 1905 (in Dresden) or 1909 (in Munich), the term *"Expressionismus"* does not seem to have been employed as we use it today until as late as April 1911 (in the preface to the catalogue of the Berlin Sezession exhibition) and, a year later (in the exhibition catalogue of the Sonderbund in Cologne), "the movement known as Expressionism" was by then being clearly described as intending "to simplify and intensify the forms of expression, to achieve new rhythm and colorfulness, to create in decorative or monumental forms."[1] Above all, *color* is central to (as E.H. Gombrich puts it) "the core of the Expressionist argument[:] every color, sound and shape has a natural feeling-tone, just as every feeling has an equivalence in the world of sight and sound."[2] In order to evoke his "synaesthetic equivalences" of purely "spiritual resonances," states Gombrich, the Expressionist painter need only "select from his palette the [*one*] *pigment* from among those available that, to his mind, *is most like the emotion he wishes to represent*. The more we know of his palette, the more likely we [art historians] are to appreciate his choice."[3]

Unfortunately, as it turns out today, we really seem to "know" next to nothing about the exact significance of the Expressionist emotional color-spectrum. A case in point is Franz Marc's wholly abstract, or "non-representational" (*"gegendstandlose"*), canvas of 1914, *Fighting Forms* (Fig. 1). However, as will be seen, it is possible, at least in this particular example, to properly "read" a given German Expressionist painting, like this one with no familiar reference to the objects in the phenomenal, "real" world surrounding us.

In his provocative and influential study on the spiritual roots of modern art, as specifically developed in the northern Romantic experience, Robert Rosenblum has observed how the qualities of "primal, mystical simplicity," and the constant search for "a universal symbol [revealing] the intrusion of a divine, shaping force [leading] to the presentation of transcendental experience through immaterial images [conveying] some kind of universal religious experience without subscribing to a specific faith," are distinctive traits which modern art has absorbed from a tradition established by Germanic artists as long ago as the Romantic era.[4] Particularly characteristic of such deeply entrenched notions, finds Rosenblum, is the work of the German painter Franz Marc (1880-1916), an artist who endeavored, by his own definition, to create "symbols for

the altar of a new spiritual religion."[5] At the very outset, Marc's remark (and more of these will be cited) might suggest to the informed reader that this painter was likely to have been influenced by those numerous alternative-religious philosophies prevalent in his time which today are generally subsumed into a collective, distinctively modern, spiritual experience called "Occultism."[6]

One of Marc's closest friends and admirers was an older expatriate artist, the painter Wassily Kandinsky (1866-1944), who evidently first became acquainted with the young German artist after an exhibition in which the Russian participated, held in the Moderne Gallerie in Munich in September 1910. As Kandinsky later recalled, he and his then-maligned Expressionist colleagues:

stood with both feet implanted in the spirit of the awakening art, and lived in this spirit with soul and body ... [but] no words of sympathy were directed towards us. And then one day came the word. Thannhauser [the Moderne Gallerie director] showed us a letter from a Munich painter, as yet unknown to us, who congratulated us on our exhibition, and proclaimed his enthusiasm in the most expressive of words. This painter was a true Bavarian, Franz Marc.[7]

Marc, however, had already come under the influence of the Russian's paintings as early as December 1909, when he had seen an earlier exhibit hung in Thannhauser's Moderne Gallerie. According to Maria Marc, the 1909 exhibition gave her husband:

The greatest influence ... Through the experience of Kandinsky's pictures his eyes were opened and he soon knew the reason why his works had not [previously] arrived at the effect of complete unity. He wrote at that time: "Everything [then] stood before me on an organic basis—*everything but color.*"[8]

Indeed, Marc was to praise lavishly the works of Kandinsky and his fellow exhibitors of 1910 on the basis of their art's "complete spiritualization, and their dematerialized inwardness of perception."[9] As a fellow enthusiast of the total "spiritualization and dematerialized inwardness" of the new artistic form, Marc was formally accepted into the group led by Kandinsky in January 1911. Marc's biographer, Frederick S. Levine, speaks of the influences of Kandinsky, particularly as these relate to Marc's newly liberated sense of non-naturalistic color, and in a characteristic earlier work of 1911, *The Yellow Cow*, we clearly observe what Levine calls "Marc's use of color in terms of its symbolic value,"[10] (Marc's symbolic use of color will be discussed in full.)

Fortunately for the art historian investigating the matter some seventy-five years later, Marc had described in some detail the meaning of his color-symbolism. It is the purpose of this study to demonstrate that this symbolic-chromatic scheme was imaginatively adapted from certain ideas which had been initially worked out by Kandinsky who, in turn, is known to have derived these notions from occultist publications popular in the pre-World War I years. However, in a general sense, and as was recognized by my friend Sixten Ringbom some years ago,

Among the Blue Riders [the Munich group of German Expressionists], Franz Marc was considerably influenced by Kandinsky's mysticism, [and similarly] Marc regarded the *"mystisch innerliche Konstruktion"* as the great problem of the present generation. According to Marc, ". . . there is no great and pure art without religion, that art was the more artistic the more religious it was (and the more artificial, the more irreligious the period)." . . . From such speculation he came to abstraction[:] "to the second sight, which is entirely Indian temporal." The European eye had perhaps poisoned and distorted the world, and [thus] Marc instead sought this "second sight"[:] "Today we no longer dream narrowly of the Things, but instead we purify them, so that our knowledge is advanced of the other-life [*jenes Leben*] which these hide." The last assertion in particular shows Marc's debt to Kandinsky, whom he believed to be on the track of truth. *Then, as now, only occultists claimed to be in possession of knowledge of "the life concealed by the things."* [However,] not until the documentary materials on the relations between these artists has been made public will it be possible to assess Kandinsky's role as the transmitter of various occult ideas [particularly those of Theosophical origins] to his fellow artists [although] *in the published writings of Marc there are indeed passages suggesting an active interest in Theosophy."*[11]

Therefore, in order to add to the documentary materials which Prof. Ringbom has called for, we may now consider the example of Marc's curious *"Farbentheorie"* (color-theory), evidently of Theosophical origins. It is also relatively easy to demonstrate that, in general, this essentially occultist-derived art theory was also a seeming commonplace among other of the Munich artists. For example, the painter August Macke (1887-1914), whom Marc had first met in January 1910, wrote to Franz Marc early in December 1910. In this letter the subject of a mutually shared theory of color symbolism (later to be developed in somewhat different directions and details by the two young German painters) was apparently first openly discussed. As Macke put it in words,

I am again busying myself quite a lot with a theory ... giving a foundation to all the laws of painting [*allen Malgesetzen*], especially knotting together the most modern to the oldest, thereby to be able to link together naiveté with art. ... Probably this will not be new to you. I have unraveled this from my very guts:

3 colors:	Blue	Yellow	Red
parallel appearances:	sorrowful	serene	brutal (in musical tones as well as in colors)

All lines (e.g. melodies) determine the series of the colors (e.g. tones). ... The color complex is guided by the lines (melodies), being the questions put to the answer of the counter-complex. ... Therefore, most often brightness and darkness play the role of the leaders of the melody, as do yellow and violet, orange, blue, green and red—similar is the yearning for pure tones without gray and a mishmash [of muddy tones]. ... Composition by these means has to occur in an undetermined moment from a, to us, still hidden source [*uns noch verborgenen Quelle*] [which is] joyful, sorrowful, powerful, thoughtful, fearful. ... Hence I am studying the forms of the emotions in order to learn them [*ich studierte die Formen des Leides, um es zu lernen*]. ... As earlier men had sunk within themselves, there resulted their greatest art. Today [however] one only sinks into the subways and bars. But the painter sinks into solitude, and works by himself.[12]

It is noteworthy that a number of elements contained in Macke's letter of 10 December 1910 anticipate statements (actually already written down by 1910) that Kandinsky was eventually to publish in December 1911 in the first printed edition of his *Über das Geistige in der Kunst*,[13] an epoch-making book which is recognized to be "the first theoretical treatise on abstract art."[14] In this work, the Russian also reveals himself to have been deeply concerned with the "internal" quality of art, that which "contains the seed of the future within itself" as Kandinsky explained:

After the period of materialist effort, which held the soul in check until it was shaken off as evil, the soul is emerging, purged by trials and sufferings [leading to] some inner feeling, expressed in terms of natural form (as we say, a picture with atmospheric mood [*Stimmung*]).[15]

A much more concrete link to Macke's ideas is seen in Kandinsky's concern with music as an expression of the cosmic "inner harmony," particularly as:

Perhaps we unconsciously hear this real harmony sounding together with the material or, later on, with the nonmaterial sense of the object. But, in the latter case, the true harmony exercises a direct impression on the soul. The soul undergoes an emotion which has no relation to any definite object [found in nature], an emotion more complicated, I might say, more super-sensuous than the emotion caused by the sound of a bell or of a stringed instrument.[16]

Therefore, continues Kandinsky, sounding almost as though he were quoting from Macke's letter (itself apparently a paraphrase of the earlier manuscript version of *Über das Geistige in der Kunst*):

Generally speaking, color is a power which directly influences the soul. Color is the keyboard; the eyes are the hammers, the soul is the piano with many strings. The artist is the hand which plays, touching one key or another, in order to cause [corresponding] vibrations in the soul. *It is evident, therefore, that color harmony must rest only upon a corresponding vibration in the human soul; and this is one of the guiding principles of the inner-need [die innere Notwendigkeit].*[17]

Like Macke, for his forthcoming book Kandinsky had also drawn a diagram depicting symbolic pairs of fighting, living "antitheses of the primitive colors." As he too explained,

As in a great circle, a serpent biting its tail [the ouroboros]—the symbol of eternity, of something without end—the six colors appear [yellow-blue, orange-violet, red-green] that make up the three main antitheses. And to the right and left stand [white-black] the two great possibilities of silence—death and birth.[18]

Just as Macke had already suggested to Marc, for Kandinsky also a picture (composition) is not just a "picture," but instead it should represent a metaphorical diagram of the workings of cosmic harmonies and hidden psychic life-forces:

The strife of colors, the sense of balance we have lost, tottering principles, unexpected assaults, great questions, apparently useless strivings, storm and tempest, broken chains, antitheses and contradictions, these all make up our harmony. *The composition arising from this harmony is a mingling of color and form, each with its separate existence, but each blended into a common life which is called a picture by the force of the inner need.*[19]

In Marc's reply to Macke's letter (dated 21 December 1910), confirmation is found for the ubiquity of these ideas in the Blue Rider circle. Moreover, this letter is also of great significance because here Marc laid out the details of his own emerging notions of

color-symbolism which are, as the painter took pains to point out, somewhat different and rather more developed in the "spiritual" and "symbolic" aspects than were Macke's ideas. In short, for Marc, color had a clear-cut emotional-iconographic significance:

Your color-wheel [i.e., Macke's *"Farbscheibe"*] is quite familiar to me: there are people who have always had it hung up in their studios, but I don't think it's quite right. For me, colors are in this way drained [of meaning], rather like a commercial paint-dealer's charts. . . . I will explain to you now my theory of blue, yellow, red. Blue is the *male* principle, severe and spiritual. Yellow is the *female* principle, gentle, cheerful and sensual. Red is *matter*, brutal and heavy, the color that has always to struggle with, and then to succumb to, the other two! For instance, if you mix blue—so serious, so spiritual—with red, you then intensify the red to the point of unbearable sadness, and the comfort of yellow (the color-complementary of violet) becomes *indispensable*: woman as comfort-giver, not as lover!

If you mix red and yellow to obtain orange, you endow the passive and female yellow with a "turbulent," symbolic power [*sinnliche Gewalt*] so that the cool, spiritual blue once again becomes the indispensable male principle. A blue automatically falls into place next to orange: the colors are in love with each other [*die Farben lieben sich*]. Blue and orange—this is the color-harmony of celebration. Now, if you mix blue and yellow to obtain green, you awaken red—Matter: the "Earth"—to life; but here, as a painter, I always feel a difference: With green you never quite bring the brutality and materiality of red to rest, as was the case with the previous color-tones (just recall how, for example, red and green are used in the industrial arts!). Green always requires the aid of blue (heaven) and yellow (the sun) in order *to reduce matter to silence*. And there is yet more (this will strike you as laughably literary, but I don't know how to express it better): blue and yellow are again not equally distant from red. Notwithstanding all the spectral analyses given credence by the painters, I will not give up the idea that yellow (woman!) stands nearer to red—the earth—than does blue, the masculine principle. The higher concordance with the primeval psychological theories concerning "woman" may sound a bit comical here, but it supports my fantasies of the significant characteristics I give to colors. . . . But what you say about melodic movements through light and dark, this I find quite good. Surely, line and melody grow from similar artistic perceptions of the same primeval source, but there are still two roots, two offspring, which are distantly linked by technique. As I am not of so musical a frame of mind, in regards to this it remains certain that I can't test, by means of a musical score, the technique and composition of a given piece of music and, especially as I am so woefully uneducated in musical technique, I would scarcely dare to argue the point.[20]

In another letter written a fortnight later, August Macke mentioned in passing to Marc that his own color-system, particularly in

its general symbolic implications, was indeed a parallel to Marc's:

I was delighted with your color-theory [*Farbentheorie*]. It is, after all, similar to mine:

[Blue]	[Red]	[Yellow]
Melancholy	Brutality	Serenity
Man	Matter	Woman

And the approximation of red and yellow is also quite accurate, but it is still up to the painters to determine the particulars of the intensity of the pigments. According to pure theory [however], it is conceivably bad because of the tripartite division. But this is not so; one part red counterbalances at least ten parts of green, while one part of green will be devoured by ten of red.[21]

Macke's summary, seemingly emphasizing problems of chromatic values at the expense of "spiritual" ones, did not quite satisfy Marc who, on 28 December 1910, replied, pointing out that:

We *must* search for and learn this powerful expressive vehicle [*diese mächtigen Ausdrucksmittel*] in order to break out of the swamp of dull thinking; there is certainly no other way out. . . . We must first learn to know this vehicle, *all* such vehicles, formal as well as coloristic—then we can once again become plain and simple and be "ourselves." Don't you think so? I have by me some [unidentified!] books which I have procured, and which I am quickly studying. . . . I have found some interesting things.[22]

Some two months later (14 February 1911), Marc again wrote Macke, now telling him more about his readings, including Brücke's *Physiologie der Farben* (1887), Wauvermann's *Farbenlehre* (1891), and Bezold's *Farbenlehre* (1874), to which now another (unnamed) fourth book may be added, such as this will be presently identified in this paper. As Marc then stated,

My painting appears quite different from that of last summer, but it is not easy to describe it. I am gradually succeeding in "organizing" the colors, completely making them into the tools of artistic expression, and without any consideration of either "naturalistic appearance" or local color. . . . My pair of occultist principles concerning color [*aberglaubischen Begriffe über Farben*] in any event serves me far *better* than all these theories [by Brücke, Wauvermanns and Bezold]. . . . I saw Kandinsky's latest things in his studio, and I must confess that I have scarcely ever gotten such a deep and awestruck impression from pictures. Kandinsky penetrates deeper than all of them.[23]

As becomes readily apparent here, Marc was very much in the

thrall of Kandinsky's artistic and "spiritual" ideas, so much so in fact that by December 1910, that is, a mere three months after having initially met the Russian, Marc had outlined for Macke a *Farbentheorie*, and the closest written parallel to this presently known is to be found in the then (as yet) unpublished manuscript pages of *Über das Geistige in der Kunst*, where there are found numerous comments by Kandinsky concerning the essentially *symbolic function of colors as spiritual symbols*, including:

> The second main result of looking at colors [besides the merely physical] which is *their psychic effect*. They [then] produce a corresponding spiritual vibration and it is *only* as a step towards this spiritual vibration that the elementary physical impression is of any importance. For example, *red* may cause a sensation analogous to that caused by flame.... While a warm red may prove exciting, another shade of red may cause pain or disgust through associations with running blood.
>
> In such cases, *color awakens a corresponding physical sensation, which undoubtedly works upon the soul.*[24]

Whereas Marc had spoken of *red* as "matter, brutal and heavy," a color "that always had to struggle with, but then succumb to" the other two primaries, *yellow* and *blue*, Kandinsky—apparently slightly earlier—had in turn written how:

> *Red*, as seen by the mind, and not by the eye, exercises at once a definite and an indefinite impression upon the soul, and produces spiritual harmony.... It rings inwardly with a determined and powerful intensity; it glows in itself, maturely, and does not distribute its vigor aimlessly.... It gives a feeling of strength, vigor, determination, triumph; in music, it is a sound of trumpets, strong, harsh, and ringing.... Taken by itself, this red is material ... in red there is always a trace of the material.[25]

Whereas Marc simply called *yellow* "the female principle, gentle, cheerful and sensual," Kandinsky, on the other hand, went much further—and in rather different "spiritual" directions (which, however, are those which Macke had paraphrased in the letter):

> One might say that a keen *yellow* looks sour because it recalls the taste of a lemon. But such definitions are not universally possible.... Yellow, if steadily gazed at in any geometrical form, has a disturbing influence, and reveals in the color an insistent, aggressive character (it is worth noting that the sour-tasting lemon and the shrill-singing canary are both yellow).... Yellow is the typically earthly color. It can never have profound meaning. An intermixture of blue makes it a sickly color. It may be paralleled in human nature with madness, not with melancholy or hypochondrial mania, but rather violent, raving lunacy.[26]

In the case of *blue*, however, we find both Macke and Kandinsky (although, again, Marc only to a lesser degree) in complete agreement. For Marc, "blue is the male principle, severe and spiritual," although, nevertheless, "blue [is] (heaven)." According to Kandinsky, however:

Blue is the typically heavenly color. The ultimate feeling it creates is one of rest (supernatural rest, not the earthy contentment of green; the way to the supernatural lies through the natural and we mortals, passing from the earthy yellow to the heavenly blue, must pass through green). When blue sinks almost to black, blue echoes a grief that is hardly human. When it rises to white, a movement little suited to it, its appeal to men grows weaker and more distant.[27]

As it turns out, one can directly link a specific passage in Kandinsky's manuscript to a specific painting by Marc. As the younger painter was to write to his future wife (2 February 1911), at that moment he was at work on a canvas called *The Red Horses*,

A large picture with three [red] horses in the landscape [which is] completely colored from one corner to the other. The horses are drawn in a triangle. The colors are difficult to describe. The landscape is pure cinnebar, nearly pure cadmium and cobalt-blue, deep green and carmine red. . . . The forms are all exceedingly strong and clear, within which the color is fully sustained.[28]

The passage in Kandinsky's *Über das Geistige in der Kunst*, as published eleven months later, and which exactly corresponds to this canvas by Marc, reads as follows:

The fundamental value of red remains in every case. . . . The red horse provides a further variation. The very words put us in another atmosphere. The impossibility of a red horse *demands* an unreal world. It is possible that this combination of color and form will appear as a freak—a purely superficial and non-artistic appeal—or as a hint of a fairy story—once again a non-artistic appeal. To set this horse in a carefully [rendered] naturalistic landscape would create such a discord as to produce no appeal and no coherence. The need for coherence is the essential of [artistic] harmony—whether founded on conventional discord or concord. The new harmony demands that the inner value of a picture should remain unified— whatever the variations of outward form or color. The elements of the new [spiritual] art are to be found, therefore, in the inner—and not the outer—qualities of nature.[29]

From whence did Kandinsky (and presumably Marc, as well as Macke) derive these truly "otherworldly" ideas about the colorful new "spiritual art"? In the case of the Russian art-theoretician,

111

fortunately, the writer was quite generous in acknowledging his spiritual indebtedness to Mme Helena Petrovna Blavatsky, the founder of the Theosophical Society, a contemporary spiritual group which specifically dealt with what Kandinsky called:

Those questions which have to do with "non-matter," or matter which is not accessible to our minds [but which was of great interest to] the Indians, who, from time to time, confront those learned in our [materialist] civilization with problems which we have either passed by unnoticed or brushed aside with superficial words and explanations. Mme Blavatsky was the first person, after a life of many years in India, to see a connection between those "savages" and our "civilization." From that moment there began a tremendous spiritual movement which today includes a large number of people [including Kandinsky and his followers], and which has even assumed a material form in the *Theosophical Society*. This Society consists of groups who seek to approach the problem of the spirit by way of the *inner*-knowledge. . . . Theosophy, according to Blavatsky, is synonymous with *eternal truths*. . . . Literature, music and art are the first and most sensitive spheres in which this spiritual revelation makes itself felt. They reflect the dark picture of the present time, and show the importance of what at first was only a little point of light noticed by few, and, for the majority, it was non-existent. . . . [Theosophists] turn away from the soul-less life of the present towards those substances and ideas which give free scope to the non-material striving of the soul. . . . In drawing, the abstract message of the object drawn tends to be forgotten, and its meaning is lost. Sometimes, perhaps, we unconsciously hear this real harmony sounding together with the material or, later on, with the non-material sense of the object. But, in the latter case, the true harmony exercises a direct impression on the soul. The soul undergoes an emotion which has no relation to any definite object, an emotion more complicated, I might say, more supersensuous, than the emotion caused by a bell or a stringed object.[30]

As Kandinsky the Theosophist repeatedly stressed, artistic creation is "synonymous with eternal truth," being a kind of "spiritual revelation," and the specifically "modern" artist's

. . . inner need is built up from three *mystical* elements: (1) Every artist—as a creator—has something in him which calls for expression (this is the element of personality). (2) Every artist—as a child of his age—is impelled to express the spirit of his age (this is the element of style). . . . (3) Every artist—as a servant of art—has to help the cause of art (this is the element of pure artistry). . . . The elements of style and personality make up what is called the periodic characteristics of any work of art [but] these forms can be spoken of as one side of art: *the subjective*. Every artist chooses from the forms which reflect his times—those which are most sympathetic to him.[31]

Kandinsky's final conclusion was that *"the artist must have some-thing to say, and mastery over* [representational] *form is not his goal, but rather* [that is] *the adaption of form to inner meaning."*[32] Therefore, "one forgets the material form and probes down to the artistic reason for the whole: one finds primitive geometrical forms or an arrangement of simple lines which help toward a common motion."[33] In short, for Kandinsky and his closest followers, "the adaption of form to inner meaning" was—in strictly pictorial terms—to result in a style of radical *abstraction*. In general, this was, of course, the predominant stylistic characteristic of the art of Franz Marc from 1911 on. Moreover, by mainly focusing upon Marc's *"Farbentheorie"* (his written statement of December 1910, con-taining the most easily documented, specific proof of occultist influences upon his artistic thought), it is possible to show how this artist, like his spiritual mentor Kandinsky, was himself apparently deeply immersed in a study of Theosophical publications.

At the outset, however, it must be realized that Theosophy—in addition to its many, once potent, "spiritual" attractions—was a movement which, more so than any other single occultist system, offered numerous, literally "colorful," attractions which would have been seen as being specifically germane to *artists* as such. Accord-ing to James Webb, the most acute student of modern occultism:

[Theosophy's] recommended method was to allow the imagination to play up "impressions [and] this technique was used . . . to expand the Theosophical theology of Mme Blavatsky in amazingly literal directions. . . . [Theosophists] propounded the theory that every human thought becomes clothed in an "elemental essence" which surrounds mankind, and it is for a short time a living form perceptible to clairvoyants. *These forms appear in a variety of colors, all of which are symbolic.*[34]

Moreover, according to Ringbom's comprehensive art historical assessment of their great importance,

Apart from being interesting documents for the history of expression, these [Theosophical] color illustrations can be regarded as *the first non-objective representations*, executed about a decade *before* Kandinsky's famous water-colour of 1910. They are not ornaments, nor are they works of art in the normal sense of the word. But they do comply with Kandinsky's basic requirement that the artist should disregard the physical appearance of matter in favor of the *psychic reality* of the spiritual.[35]

Given this, we can now set about to the identification of the *other* book(s) which Franz Marc was apparently studying assiduously

sometime between December 1910 and February 1911 (and it will be recalled that he was implicitly thinking of an unmentioned work which he found superior to the works of Bezold, Brücke and Wauvermann). This book cannot, however, be Kandinsky's manuscript, given Marc's frequent interpretative departures from the letter of Kandinsky's chromatic symbolic dicta. Nor is this work, moreover, Blavatsky's *The Secret Doctrine* or *Isis Unveiled* (although both had been published in German translations, in 1897 and 1907). It is instead most likely a co-authored work by the most notable of the "second generation" of Theosophists: Annie Besant and Charles W. Leadbeater, *Gedankenformen* (Leipzig, 1908; original English text: *Thought-Forms*, 1901).[36] As the two co-authors stated in their introduction, their concern was with "the things of the invisible world [revealing] forces and beings of the next higher plane of nature [that is, phenomena all quite *'occulta'* to the un-initiated], which are beginning to show themselves on the outer edge of the physical field, [particularly given] the fact that emotional changes show their nature by changes of color in the cloud-like ovoid, or *aura*, that encompasses all living things." Further citations from this text (which, in any event, Ringbom has already shown to have been employed by Kandinsky) will immediately reveal the ultimate origins of Marc's symbolic, but hastily drawn-up, *Farbentheorie* of December 1910. According to the authors of *Thought-Forms*, there are certain:

GENERAL PRINCIPLES

Three general principles underlie the production of all thought forms:
1. Quality of thought determines color.
2. Nature of thought determines form.
3. Definiteness of thought determines clearness of outlines.[37]

These "General Principles" in turn directly lead to what I take to be the most explicit statement directly defining all such German Expressionist "*Farbentheories*":

THE MEANING OF THE COLORS

Red, of all shades, from lurid brick-red to brilliant scarlet, indicates anger . . . while the anger of "noble indignation" is a vivid scarlet, by no means unbeautiful, though it gives an unpleasant thrill. . . . Affection [however] expresses itself in all shades of crimson and rose; a full clear carmine means a strong healthy affection of a normal type; if stained heavily with brown-grey, a selfish grasping feeling is indicated, while pure pale rose marks that absolutely unselfish love which is possible only to high

natures; it passes from the dull crimson of *animal love* to the most exquisite shades of delicate rose, like the early flashes of the dawning, as love becomes purified from all selfish elements, and flows out in wider and wider circles of generous impersonal tenderness and compassion to all who are in need.[38]

The *blue* of devotion . . . may express a strong realization of the universal brotherhood of humanity. . . . The different shades of blue all indicate religious feeling, and range through all hues, from the dark brown-blue of fetish-worship, tinged with fear, up to the rich, deep, clear color of heartfelt adoration, and the beautiful pale azure of that highest form, which implies self-renunciation and union with the divine; the devotional thought of an unselfish heart is very lovely in color, like the deep blue of a summer sky. Through such clouds of blue there will often shine out golden stars of great brilliancy, darting upwards like a shower of sparks. . . . The brilliancy and depth of the colors are usually a measure of the strength and the activity of the feeling.[39]

The various shades of *yellow* denote intellect or intellectual gratification, dull yellow-ochre implying the direction of such faculty to selfish purpose, while clear gamboge shows a distinctly higher type, and pale, luminous primrose-yellow is a sign of the highest and most unselfish use of intellectual power, the pure reason directed to spiritual ends. . . . Yellow in any of man's [astral] vehicles always indicates intellectual capacity, but its shades vary and may be complicated by the admixture of other hues. Generally speaking, it has a deeper and duller tint if the intellect is directed chiefly into lower channels, more especially if the objects are selfish. In the astral or mental body of the average man it would show itself as yellow-ochre, while pure intellect, devoted to the study of philosophy or mathematics, appears frequently to be golden, and this rises gradually to a beautiful clear and luminous lemon or primrose-yellow when a powerful intellect is being employed absolutely unselfishly for the benefit of humanity.[40]

Besant and Leadbeater's *blue*, the color of "devotion" and the "universal brotherhood of humanity," Marc chose to identify generally with "the male principle, severe and spiritual." *Red* indicating "anger," even "noble indignation" if scarlet-colored—but also "animal love" when crimson-colored—Marc had called "matter, brutal and heavy," or a range of choleric hues which are in a perpetual state of opposition, of struggle (*Bekämpfung*) against the other two primary color-symbols. The most interesting of Marc's trio of emotional-psychological color-symbols is *yellow*. Yellow, symbolizing for Besant and Leadbeater unselfish "intellectual gratification and pure reason," became for the young German artist a concrete manifestation of "the female principle, gentle, cheerful and sensual . . . indispensible—woman as comfort-giver, but

115

1 *Franz Marc,* Fighting Forms, *1914. Bayerische Staatsgemaldesammlungen, Munich*

not as lover," because, as one might easily suppose, then the pure
(even platonic) yellow of *"das weibliche Prinzip"* would then neces-
sarily become tinged with "the dull crimson of *animal love.*"
This then is the nature of Marc's first flirtation with strictly Theo-
sophical *Farbentheorien,* now datable to December 1910.

As one might suspect, with the passage of time Marc was to
become far more skilled in his employment of Theosophical color-
symbolism. In fact, this technique of pure color-symbolism, making
no reference at all to the physical phenomena of the "outer-
world," was eventually to allow his art to relinquish all hints of
representational subject-matter, thereby finally permitting him to
arrive at that desideratum which his mentor Kandinsky had called
"gegenstandslose Malerei" (non-objective painting). Proof for
this assertion is the painter's monumental canvas called *Fighting
Forms (Kämpfende Formen),* painted on the very eve of the outbreak of
the Great War (Fig. 1). Here, there is now no reference whatsoever
to the phenomena of external nature, only to the "objectless"
forms of the pure color-system of the psychic "inner-world." A great
bluish-black form occupying the entire right half of the painting
"struggles with" the red mass on the left; zig-zags of yellow at
the top "struggle with" the red form, while spears of green erupt
from the bottom-left.

In fact, what is occurring in Marc's *Fighting Forms* is a symbolic
act prefiguring "war," certainly an appropriate theme in those
tension-ridden months located immediately before the actual, al-
though long-expected, outbreak of the European conflict. This
interpretation is made clear by the text—including an appropriately
"non-objective" illustration—of another book by C.W. Leadbeater,
Man Visible and Invisible, which had also been published in Leipzig
in 1908 in a German translation.[41] As is the case in Marc's *Fighting
Forms,* Leadbeater's "non-objective" illustration of "Intense Anger"
(Fig. 2) also depicted whirling black masses "fighting" with jagged
red forms. Accordingly, in suitably apocalyptic terms Leadbeater
announced that this plate depicting "Intense Anger"

... is perhaps the most striking in appearance of the whole series, and, even
without any explanation, it would, of itself, be an eloquent warning
against the folly of yielding to a fit of passion. As in the previous cases, the
ordinary background of the astral body [or aura] is temporarily obscured
by the rush of feeling, but now the strong and vivid thoughts are, un-
fortunately, those of malice and ill-will. They express themselves once more

117

as coils or vortices, but this time as heavy, thunderous masses of sooty blackness, lit up from within by the lurid glow of active hatred. Less defined wisps of the same dark cloud are to be seen defiling the whole astral body, while the fiery arrows of uncontrolled anger shoot among them like flashes of lightning.

A tremendous and truly awful spectacle; and the more fully it is understood, the more terrible it appears. For this is the case of a man who is absolutely transported and beside himself with rage—a man who, for the time being, has utterly lost control of himself.[42]

The ultimate significance of the *"kämpfende,"* highly colored but completely "non-objective" motifs of the German painter's *Fighting Forms*—further supporting the interpretation of Marc's apocalyptic canvas as a quasi-allegorical Theosophical prefiguration of the coming European conflict—is completed by an analysis of the iconographic correspondences found in two further Theosophical and "non-objective" illustrations. These are in Besant and Leadbeater's *Thought-Forms,* and they illustrated "Murderous Rage and Sustained Anger" and "Explosive Anger" (Figs. 3, 4). As the two co-authors explained,

2 *Intense Anger. From C.W. Leadbeater,* **Man Visible and Invisible,** *Plate XIII*

Murderous Rage and Sustained Anger [represent] two terrible examples of the awful effect of anger. The lurid [red] flash from dark clouds was taken from the aura of a rough and partially intoxicated man in the East End of London, as he struck down a woman; the flash darted out at her the moment before he raised his hand to strike, and caused a shuddering feeling of horror, as though it might slay. The keen-pointed, stiletto-like dart [to the left] was a thought of steady anger, through years, and directed against a person who had inflicted a deep injury on the one who sent it forth. It will be noted that both of them take the flash-like form, though the upper is irregular in its shape, while the lower represents a steadiness of intention which is far more dangerous. . . .

Explosive Anger [represents] an exhibition of anger of a totally different character. Here is no sustained hatred, but simply a vigorous explosion of irritation. It is at once evident that, while the creators of the forms shown in [Fig. 3] were each directing their ire against an individual, the person who is responsible for the [red and orange] explosion in [Fig. 2] is, for the moment, *at war with the whole world* around him. . . . Here we see indicated a veritable explosion, instantaneous in its passing and irregular in its effects, and the vacant center shows that the feeling that caused it is already a thing of the past, and that no further force is being generated. [But if,] on the other hand, the center is the strongest part of the thought-form, showing there is a steady continuous upwelling of the energy, [then] the rays show, by their quality and length and the evenness of their distribution, the steadily sustained effort which produces them.[43]

This particular, concrete example of Marc's dependence upon the literature of occultism (not to mention Theosophical "art") is only the most overt expression of his covert, overall pattern of a consistently "occultist" perception of the world around him, and this is, after all, the vision which is the psychic-philosophical basis of his mature art. As we have seen, Kandinsky (among others) repeatedly proclaimed that there was need for a "spiritual rebirth" which would overcome and sweep away all the old forms of the discredited, materialist culture of Europe. This, if nothing else, is a truly *apocalyptic* vision, and—as Levine has repeatedly pointed out in his monograph on Franz Marc—Marc's art was indeed "apocalyptic" in its avowed intentions. A generally chronological selection of the painter's recorded statements reveals his characteristic intermingling (actually, quite typical of the time) of occultist perceptions of certain hidden ("*verstecken und verborgenen*") forces latent in nature and of the need for an apocalyptic, cataclysmic and millennial refreshing of culture, nature and art. For instance, as early as the spring of 1906, Marc had proclaimed his acute sense of nihilism and of spiritual *Angst*:

3 *Murderous Rage and Sustained Anger. From Annie
Besant and C.W. Leadbeater,* Thought Forms,
Plates 22 and 23

I so often experience a sense-deluding fear of simply being in this world.
One must create gods to whom one can pray.... Others have their gods; they
carry their religion within themselves. I know it. From their endless
longing, they enter into a joyful heaven—I need something completely
different, and yet I can only grope towards it.[44]

Later, in December 1908, he expressed his desire to perceive in a
pantheistic fashion, describing:

The organic rhythm that I feel in all things, and I am trying to feel panthe-
istically the rapture of the flow of blood in nature, in the trees, in the animals,
in the air.... [Therefore] I can see no more successful means towards
an "animalization" of art, as I like to call it, than the painting of animals. That
is why I have taken it up.[45]

In May 1912, the *Blaue Reiter Almanach* appeared in print, in which
an article by Marc ("Die wilden Deutschlands") was included.
Here (somewhat tardily) was announced the fact of Marc's earlier
conversion to mystical or occultist ideas:

One came to understand that art was concerned with the deepest things, that a true revival could not be a matter of form, but instead had to be a matter of spiritual rebirth. Mysticism awoke in [our] souls, and with it the primeval elements of art. . . . [Marc's colleagues in the Blue Rider] had a different goal: to create symbols for their age, symbols for the altar of a new spiritual rebirth.[46]

In March 1914 (the period of the genesis of *Fighting Forms*) Marc underscored his idealistic belief—also common to the occultist milieu of his youth—in the continual confrontation between materialist and "spiritual" forces:

We know that everything can be destroyed if the germination of a spiritual race does not endure the test of the greed and impurity of the masses. We struggle for pure ideas, for a world in which pure ideas can be thought and expressed without becoming impure. Then only will we, or those more qualified than we, be able to show the other face of the Janus-head that today remains hidden and turned away from the [materialist] view of our age.[47]

Yet earlier, in 1912, Marc had explained his motivation in creating

4 *Explosive Anger. From Annie Besant and C.W. Leadbeater,* Thought Forms, *Plate 24*

121

his art and, by his own definition, these ideas, again, were patently occultist in nature:

Today we seek behind the veil of appearance the hidden things in nature that seem to us more important than [for example] the discoveries of the Impressionists. . . . We seek out and paint this inner spiritual side of nature, not out of caprice or desire to be different, but because we see this side in the same way that earlier ones "saw" [as did, for instance, the Theosophists] violet shadows and the atmosphere [i.e., "the aura"] surrounding things.[48]

The fact that Marc also subscribed to the type of apocalyptic millennialism commonly expounded by contemporary occultists (most notably Rudolf Steiner[49]) is similarly revealed in Marc's statement (published in January 1912) in which he announced that:

Art today proceeds upon paths one's fathers never imagined possible; one stands before the new work as in a dream, and hears the apocalyptic riders in the air. One feels an artistic tension over the whole of Europe.[50]

Here he also spoke of a coming apocalyptic confrontation (which he was later actually to render in *Fighting Forms*) between the forces of the spirit and materialism:

Furthermore, the hour is right for such a confrontation since we believe we are now at the juncture of two long ages [i.e., from materialism to the *"Epoche des grossen Geistigen"* proclaimed by Kandinsky]. . . . But everywhere ruins remain, old ideas and old forms which refuse to vanish, even though they now belong to the past. They linger on like ghosts, and a Herculean task faces us—how can we dispel them, and so make room for the new which is already waiting.[51]

The answer, especially given the occultist milieu in which the question was posed, was inevitable: "The spirit can tear down citadels."[52]

As it would appear, the artist first committed his apocalyptic vision to canvas in the fall of 1913 (still then, however, retaining recognizable or "materialist" elements) in another painting which he was fittingly to call *Das Tierschicksal* (*The Fate of the Animals*). Much later (7 March 1915), he was to say of this work that it

. . . startled and astonished by its immediate effect upon me. I saw it as an utterly strange work, *a premonition of war* that had something shocking about it. It is such a curious picture, as if created in a trance. At first glance, I was completely shaken. It is like *a premonition of this war*, horrible and gripping; I can hardly believe that I painted it.[53]

As we now know (and had Marc thought to say so), the same comments would have applied in equal measure to his later *Fighting Forms*, truly another "premonition of war." Now, with the aid of Besant and Leadbeater's *Thought-Forms* we can go yet further, now specifying that the essentially symbolic blue deer placed in the exact center of the apocalyptic canvas depicting *The Fate of the Animals* represents "the universal brotherhood of man," having the "rich, deep, clear color of heartfelt adoration" particularly appropriate to specifically "spiritualist," that is, Theosophical, devotion. This symbolic motif is threatened by a series of jagged red thunderbolts, which then in turn represent "Murderous Rage," "Sustained Anger," and "Explosive Anger" (Figs. 2, 3), all now understood to be patently obvious (and most appropriate) symbolic motifs expressive of a prescient "premonition of war."

Perhaps driven by his philosophical belief in the coming apocalypse, Marc had volunteered for active service immediately after the outbreak of war, and he soon found himself in the front lines. He accepted the horrors of combat with a curious mixture of fatalism and a characteristic sense of apocalyptic historical destiny. Franz Marc was killed by a grenade near Verdun on 4 March 1916, thus fulfilling his own historic destiny at the age of thirty-six.

In the larger sense, we have examined the evidence for a shared belief in a system of musical tones—color values, that is, a synesthetic equation, which was acknowledged by both August Macke ("Parallel appearances . . . in musical tones as well as in colors. . . . The color-complex is guided by the lines [or] melodies") and by Franz Marc ("similar artistic perceptions of the same primeval source"). Kandinsky, of course, entertained similar notions: "Color is the keyboard . . . caus[ing] vibrations in the soul." Actually, this was a ubiquitous idea which had been first popularized in the German-speaking world by Johann Wolfgang von Goethe (e.g.: "It would not be unreasonable to compare a painting of powerful effect with a piece of music in a sharp key, another of soft effect with a piece of music in a flat key," and so forth).[54] Nevertheless (especially given the tentative nature of Goethe's statements to this effect) the strictly "*modern*," or Theosophical, origins of the statements by the Blaue Reiter artist are easily demonstrated. According to Annie Besant's emphatic assertion in *Thought-Forms*, for example,

Sound is *always* associated with color [although] it seems not to be so generally known that sound produces form as well as colors, and that *every*

123

piece of music leaves behind it an impression of this nature . . . clearly visible and intelligible to those [i.e., clairvoyants] who have eyes to see.[55]

It is, moreover, easy enough to trace the synesthesia-dictum back to the principal founder of the Theosophical Society, Mme Blavatsky, who had formulated the equation in this manner:

Each prismatic color is called in Occultism the "Father of the Sound" [itself "Logos"]. . . . Sensitives [clairvoyants] connect every color with a definite sound. . . . The creative force, at work in its incessant task of trans-formation, produces color, sound and numbers in the shape or rates of vibrations, which compound and dissociate the atoms and molecules. . . . The "Great Tone" . . . is, even by scientific confession, the actual tonic of Nature, held by musicians to be the middle *fa* on the keyboard of a piano. We hear it distinctly in the voice of Nature . . . in everything in Nature which has a voice or which produces sound.[56]

As we have seen, Marc also stated another implicit equation: colors—emotional states ("Spiritual . . . sensual . . . sad . . . brutal"). This too was an idea championed by Kandinsky:

To a more sensitive [i.e., clairvoyant] soul, the effect of color is deeper and intensely moving. And so we come to the second result of looking at colors: their *psychological effect*. They produce a correspondent spiritual vibra-tion—and it is only as a step towards this spiritual vibration that the physical impression is of importance.[57]

In *Thought-Forms* this idea, of course, conforms to the repeated *Leitmotiv*:

Thoughts *are* things . . . the object of this book is to help us to conceive this. . . . The vast majority [of non-clairvoyants] are absolutely limited to the consciousness of three dimensions and, furthermore, have not the slightest conception of that Inner-World, to which Thought-Forms belong, with all its splendid light and colors.[58]

As becomes quickly apparent, Besant and Leadbeater's literally "colorful" occultist thesis is, after all, only an elaboration of Blavatsky's earlier notion that

It is by the predominance of this or that *color*, and by the intensity of its vibrations, that a clairvoyant—*if* he be acquainted with [emotional-chromatic] correspondences—can judge of the inner state or character of a person, for the latter is an open book to every practical Occultist.[59]

Yet another notion implicit in Marc's utterances is the idea of color as being a factor directly expressive of the principles of the up-wardly progressive stages of the evolution of life forms: "We

purify [things], so that our [clairvoyant] knowledge is advanced of the Other Life which these [things] hide." Kandinsky, as one would expect, expressed his beliefs in much greater detail:

The nightmare of materialism, which has turned the life of the universe into an evil, useless game, is not yet past. . . . Only a feeble light glimmers like a tiny star in a vast gulf of darkness. This feeble light is but a presentiment. . . . The soul is emerging, purged by trials and sufferings. . . . The spiritual life, to which art belongs, and of which she is one of the mightiest elements, is a complicated but definite and easily definable movement forwards and upwards. . . . Those feelings (joy, grief, etc.), which have been quoted as parallels of the colors . . . are only the material expressions of the soul. . . . For this reason, words are, and will always remain, only hints, mere suggestions of colors.[60]

Such chromatic-evolutionary notions, again particularly as transmitted by such indefatigable exegetes as Besant and Leadbeater, can be once again easily traced back ultimately to the esoteric doctrines of Mme Helena Blavatsky, who had ponderously asserted that:

As the astral shadow starts the series of principles in man, on the terrestrial plane, up to the lower, animal *manas* [levels of understanding], so the violet ray starts the series of prismatic colors, from its end up to green, both being, the one as a principle and the other as a color, the most refrangible of all the principles and colors. Besides which there is the same great occult mystery attached to all these correspondences, both celestial and terrestrial bodies, colors and sounds. In clearer words, there exists the same law of relation between the moon and the earth, the astral and the living body of man, as between the violet end of the prismatic spectrum and the indigo and the blue. . . . Every student, whether he is striving for practical Occult powers or only for the purely psychic and spiritual gifts of clairvoyance and metaphysical knowledge, [must] master thoroughly the right correspondences between the human, or nature principles, and those of the Cosmos. It is ignorance which leads materialistic science to deny the inner man and his divine powers; [it is, to the contrary,] knowledge and personal experience that allow the Occultist to affirm that such powers are as natural to man as swimming [is] to the fishes. . . . In this age, when oblivion has shrouded ancient Knowledge, men's faculties are no better than the loose strings of the violin to the Laplander. But the Occultist, who knows how to tighten them and [to] tune his violin in harmony with the vibrations of color and sound, will extract divine harmony from them.[61]

One concludes this textual survey by wondering now: Why is it that Mme Blavatsky—not to mention Annie Besant and C.W. Leadbeater—are so conspicuously absent in standard textbook accounts of the historical genesis and intrinsic meanings of the

125

original creations of modern abstraction? So much for *Materialische Kunstwissenschaft*. . . !

Notes

1. Sonderbund catalogue, as quoted by W.D. Dube, *Expressionism*, London, 1972, p. 19. On this movement in general, see also the pioneering study by Peter Selz, *German Expressionist Painting*, Berkeley, CA, 1974 (wherein will be found illustrated those paintings by Marc or his Blaue Reiter colleagues which cannot be reproduced here).

2. E.H. Gombrich, "Expression and Communication," in *Meditations on a Hobby-Horse, and Other Essays on the Theory of Art*, London, 1971, pp. 56-69 (p. 59).

3. *Ibid.*, p. 63 (emphasis mine); see also Gombrich, *Art and Illusion. A Study in the Psychology of Pictorial Representation*, Princeton UP, 1969, p. 359ff., "From Representation to Expression," with many useful comments on other kinds of artistic "rhetorical" devices, employed since classical antiquity.

4. R. Rosenblum, *Modern Painting and the Northern Romantic Tradition*, New York, 1973.

5. For Rosenblum on Marc, see *ibid*, pp. 138-46. For a useful survey of Marc's thought and artistic career, see F.S. Levine, *The Apocalyptic Vision: The Art of Franz Marc as German Expressionism*, New York, 1979. The overall occultist thesis presented here, however, owes nothing to Levine's otherwise thorough study of Franz Marc's art.

6. For the historical background of modern occultism in general, one study stands out in particular: J. Webb, *The Flight from Reason*, London, 1971. For the overall influences of occultism upon early modern art, particularly radically abstract painting, see a useful study by Peter Cornell, *Den hemliga källan. Om initiationsmönster i konst, litteratur och politik*, Stockholm: Gidlunds, 1981; and, especially, M. Tuchman (ed.), *The Spiritual in Art: Abstract Painting, 1890-1985*, New York, 1986 (with 16 essays by specialist scholars; for other previous general studies on modernist-occultist art, see the extensive bibliographic listings on p. 59). For the present study, I am greatly in debt to Sixten Ringbom, author of the following fundamental studies on the Occultist roots of Expressionism: "Art in 'The Epoch of the Great Spiritual': Occult Elements in the Early Theory of Abstract Art," *Journal of the Warburg and Courtauld Instututes*, XXXIX, 1966, pp. 386-418; "Mystik und gegendstandlose Malerei," in *Mysticism* (S.S. Hartman & C-M. Edsman, eds.), Stockholm, 1969, pp. 168-88; *The Sounding Cosmos: A Study in the Spiritualism of Kandinsky and the Genesis of Abstract Painting*, Åbo (Finland),

1970; "Kandinsky und das Okkulte," in *Kandinsky und München: Begegnungen und Wandlungen*, 1896-1914 (A. Zweite, ed.), Munich, 1982, pp. 86-105. I am also especially grateful to Professor Ringbom for his good counsel and bibliographic advice, given me during a visit with him in his seminar-rooms at Åbo Akademi in November 1981.

7. Kandinsky, in K. Lankheit, *Franz Marc in Urteil seiner Zeit*, Cologne, 1960, p. 46.

8. Maria Marc, in K. Lankheit, *Franz Marc*, Berlin, 1950, p. 75; emphasis mine.

9. Marc, in K. Lankheit (ed.), *Der Blaue Reiter, herausgegeben von Wassily Kandinsky und Franz Marc*, Munich, 1965, p. 225.

10. Levine, *Apocalyptic Vision*, p. 60 (his Fig. 18). For more on Marc's "horses," also emphasizing some of the general principles of his color theory, see K. Lankheit, *Franz Marc: der Turm der blauen Pferde*, ("Werk-monographien," Nr. 69), Stuttgart, 1961.

11. Ringbom, "Great Spiritual," pp. 409-10; emphasis mine.

12. Macke, in *August Macke—Frank Marc: Briefwechsel*, Cologne, 1964, pp. 25-27 (I wish to thank Professor Ringbom for his kindness in providing me with copies of the materials dealing strictly with color-theory).

13. My citations will be from the standard English translation: W. Kandinsky, *Concerning the Spiritual in Art*, (M.T.H. Sadler, trans.), New York, 1977.

14. Ringbom, "Great Spiritual," p. 393.

15. Kandinsky, *Spiritual in Art*, p. 2.

16. *Ibid.*, p. 15.

17. *Ibid.*, pp. 25-26; Kandinsky's emphasis.

18. *Ibid.*, p. 41.

19. *Ibid.*, p. 43; Kandinsky's emphasis.

20. Marc, in *Briefwechsel*, pp. 27-30; Marc's emphasis.

21. Macke, in *ibid.*, p. 34.

22. Marc, in *ibid.*, p. 35.

23. Marc, in *ibid.*, pp. 45, 47.

24. Kandinsky, *Spiritual in Art*, p. 24; emphasis mine.

25. *Ibid.*, pp. 28, 40-41.

26. *Ibid.*, pp. 24, 37-38.

27. *Ibid.*, p. 38. The reader familiar with these texts will recognize that here I am only dealing with Kandinsky's—and Marc's—symbolic interpretation of the three *primary*-colors; for the other colors (following, however, the same symbolic reasoning), see the various statements by Kandinsky and Marc in *Spiritual in Art* and *Briefwechsel*.

28. Marc, in A.J. Schardt, *Franz Marc*, Berlin, 1936, p. 78.

29. Kandinsky, *Spiritual in Art*, pp. 48-49; for illustrations of this painting see Selz or Levine.

30. *Ibid.*, pp. 13-15. For more on the Theosophists and the nature of their patently occultist ideas, see Webb, *Flight from Reason*, pp. 44-65; and B. Campbell, *Ancient Wisdom Revived: A History of the Theosophical Movement*, Berkeley, CA, 1980.

31. *Ibid.*, pp. 33-34.

32. *Ibid.*, p. 54; Kandinsky's emphasis.

33. *Ibid.*, p. 56.

34. Webb, *Flight*, p. 57; emphasis mine.

35. Ringbom, "Great Spiritual," p. 404; emphasis mine.

36. I will be quoting from the 1969 reprinting of *Thought-Forms* (Theosophical Publishing House, Wheaton, IL).

37. *Ibid.*, p. 21.

38. *Ibid.*, pp. 22-23.

39. *Ibid.*, pp. 23-24.

40. *Ibid.*, pp. 23-40.

41. C.W. Leadbeater, *Der sichtbare und der unsichtbare Mensch*, Leipzig, 1908; I will be quoting from the 1980 reprinting of *Man Visible and Invisible: Examples of Different Types of Men as Seen by Means of Trained Clairvoyance* (Theosophical Publishing House, Wheaton, IL).

42. *Ibid.*, pp. 88-90.

43. *Thought-Forms*, pp. 42-44.

44. Marc, in Levine, *Apocalyptic Vision*, p. 39.

45. Marc, in K. Lankheit, *Franz Marc: Watercolors, Drawings, Writings*, New York, 1959, p. 14.

46. Marc, in Lankheit, *Blaue Reiter*, pp. 29-31.

47. Marc, in *ibid.*, pp. 33-34.

48. Marc, in Levine, *Apocalyptic Vision*, p. 85.

49. For Steiner's apocalyptic messages in relation to Kandinsky, see Ringbom, *Sounding Cosmos*, p. 67ff., and R-C. Washton Long, "Kandinsky and Abstraction: The Role of the Hidden Image," *Artforum*, X, June 1972, pp. 42-49; for Steiner's place in the general history of modern occultism, see J. Webb, *The Occult Establishment*, LaSalle, IL, 1976, pp. 61-72, 285-98, 493-99. See also note 61 below.

50. Marc, in Lankheit, *Blaue Reiter*, p. 316.

51. Marc, in *ibid.*, pp. 33-34.

52. Marc, in *ibid.*, p. 24.

53. Marc, in *ibid.*, p. 35; emphasis mine. For illustrations of this painting, see Selz or Levine.

54. J.W. von Goethe, *Theory of Colour* (C.L. Eastlake, ed.), London, 1840, p. 346.

55. Besant & Leadbeater, *Thought-Forms*, p. 67.

56. H.P. Blavatsky, *The Esoteric Writings—A Synthesis of Science, Philosophy and Religion*, Wheaton, IL (this collection of papers was first posthumously published in 1897). For the newly revealed (and exceedingly colorful) details of the life of the high-priestess of Theosophy, see now M. Meade, *Madame Blavatsky: The Woman Behind the Myth*, New York, 1980.

57. Kandinsky, *Spiritual in Art*, p. 24.

58. Besant & Leadbeater, *Thought-Forms*, pp. 6-7.

59. Blavatsky, *Esoteric Writings*, p. 381.

60. Kandinsky, *Spiritual in Art*, pp. 2, 4, 41.

61. Blavatsky, *Esoteric Writings*, p. 369. Another obvious textual intermediary for Marc's *Farbentheorie* are the writings of Rudolf Steiner (see note 49 above). Amongst his numerous publications, one need only cite an apposite passage from his basic treatise entitled *Theosophie. Einführung in übersinnliche Welterkenntnis und Menschenbestimmung* (1904): "No physical eye can see feelings and thoughts, yet they are real. . . . [To the clairvoyant] the psychic phenomena in the soul-region surrounding him, and the spiritual phenomena in the spiritual region, become supersensibly visible. . . . A human thought, which otherwise lives only in the understanding of the listener, appears, for example, as a spiritually perceptible color-phenomenon. Its color corresponds with the character of the thought. . . . Thoughts that spring from the sensual life course through the soul-world in shades of red. A thought by which the thinker rises to higher knowledge appears in beautiful light-yellow. A thought that springs from beautiful and unselfish love radiates out in glorious rose-red. . . . Unintelligent beings show a great part of their aura permeated by brownish-red, or even by dark, blood-red currents. . . . Shades of blue appear in soul-moods full of devotion [and so forth, through the entire psychic-prismatic spectrum]. . . . The most varied shades of color flood the aura. This color-flood is a true picture of the inner-human life. As this changes, so do the shades of color change." (R. Steiner, *Theosophy. An Introduction to the Supersensible Knowledge of the World and the Destination of Man*, New York: Anthroposophic Press, 1971, p. 140ff.).

6

Paul Klee and
the Mystic Center

ROBERT KNOTT

In his Jena Lecture of 1924 Paul Klee said, "It is the artist's mission to penetrate as far as may be toward that secret place where primal power nurtures all evolution. . . . In the womb of nature in the primal ground of creation where the secret key to all things lies hidden."[1] Klee's *Omphalo-Centric Lecture* of 1939 (Fig. 1) can be seen as a restatement of what Klee felt was the mission of all artists: to move toward this mystic center as the beginning of all creative thought. And Klee, as much as any other artist of the twentieth century, sought the many paths that would lead him there.

In his early lectures to the Bauhaus, Klee describes this creative center as a point which he associated with the center or navel of the human figure: "When central importance is given to a point: this is the cosmogenetic moment. To this occurrence corresponds the idea of every sort of beginning."[2] Nearer the end of his life, *Omphalo-Centric Lecture* acts as a summary of these thoughts and lectures about creativity. The mysterious figure in this painting faces us directly, and in its cupped hand we see a glowing navel, the internal divine light from which all knowledge spreads. The navel has further importance because of its obvious associations with the womb, birth, creation, and the continuation of life. As the Omphalos, it is also a life/death symbol of particular significance to Klee, because he had a terminal illness and continually dealt with images of death in this last full year of his life. For Klee, death was not an ending but a passage beyond, which could only bring him closer to the creative center that he so actively sought during his lifetime.

Klee's painting has a specific visual source in the beautiful mid-sixth century B.C. *Berlin Kore (Aphrodite of the Pomegranate)*

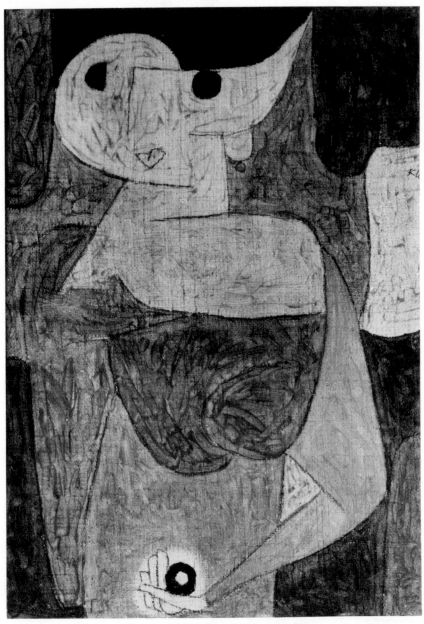

*1 Paul Klee, Omphalo-Centric Lecture, 1939.
Oil on canvas, 27 x 19". Collection: Kunstsammlung
Nordrhein-Westfalen, Dusseldorf*

2 Aphrodite of the Pomegranate, *570-550 B.C.*
Staatliche Museen, Berlin

(Fig. 2) in the Staatliche Museum.[3] There are obvious similarities in
the hands, which enclose the circular form (pomegranate, navel)
at the center of the belly. And although Klee has reversed the
hands, there is still a trace of what could be the original position of
the left hand: an outline form which echoes the shape of the left
hand in the Greek sculpture. Other parallels exist, not only in the
overall shape, the broad shoulders and tapering cylindrical form of
the body, but also in specific details such as mouth, ear lobe, and
earrings. Beyond the specific visual relationships, the associa-
tion with this ancient fertility goddess leads us to probe further into
the meaning of Klee's painting.

In analyzing a painting such as *Omphalo-Centric Lecture*, we must consider the full significance of the title. As so often in Klee's work, the relationship between title and image evokes those mysteries which elude the powers of representation. Klee had great powers of observation, but his greatest vision was inward. And no matter how carefully the formal structure has been worked out, there is always the evocative power of a less tangible, more mysterious spirit in his work, a power which speaks out of this personal relationship to another plane of existence. It is upon such an inward journey that Klee's figure in *Omphalo-Centric Lecture* takes us.

As a monumental fact, the Omphalos, a round stone in the Temple of Apollo at Delphi,[4] is supposed to mark the middle point of the earth. According to literary tradition, it is the grave mound of the sacred snake at Delphi, but as a grave mound its association was not only with Apollo. As Jane Harrison relates, "Wherever there is worship of Mother Earth there we may expect the Omphalos."[5] The Omphalos is the very seat and symbol of the Earth Mother. Thus the Omphalos or navel as the center of the world goes beyond the sanctuary of Apollo to other important "centers" corresponding with other sacred mountains, where heaven and earth come together forming the *axis mundi*, the sacred meeting point of heaven, earth and hell.[6]

The idea of the center is of great importance in all mysticism. The popular mystic Mme H.P. Blavatsky, who was well known to Klee and others, wrote:

The Ancients placed the astral soul of man, his self-consciousness, in the pit of the stomach. The Brahmans shared this belief with Plato and other philosophers. . . . The navel was regarded as "the circle of the sun," the seat of internal divine light. Among the Parsis there exists a belief up to the present day that their adepts have a flame in their navel, which enlightens to them all darkness and discloses the spiritual world as well as things unseen.[7]

What is important to remember is that this contact with the unconscious provides a link to a spiritual center—to one's own past. The navel is not only the seat of divine light, but of illumination, of inspiration—the symbol of birth and reincarnation and the endless chain of generations. In 1939 when Klee painted *Omphalo-Centric Lecture*, he knew that his own death was near at hand. He had an obsession with his own past—a more remote past. Themes of

death, eternity, and life cycles come up again and again in his work. Thus, the figure that holds its navel in its hand is more than a human figure; it becomes a link to those other, more remote regions that Klee felt so much a part of. In his notes from a trip to Egypt, Klee wrote, "In me there circulates the blood of a better age. I wander through the present century like a sleepwalker. I remain attached to the old homeland."

Similarly in Joyce's *Ulysses*, which Klee had read, Stephen Dedalus, in his own kind of Omphalic lecture, speaks of an attachment to "another time":

The cords of all link back, strandentwining cable of all flesh. That is why mystic monks. Will you be as gods? Gaze in your Omphalos. Hello. Kinch here. Put me on to Edenville. Aleph, Alpha: nought, nought one.

Spouse and helpmate of Adam Kadmon: Heva, naked Eve. She had no navel. Gaze. Belly without blemish, bulging big, a buckler of taut vellum, no, whiteheaped corn, orient and immortal, standing from everlasting to everlasting.[8]

Here, then, in Stephen's conception of an umbilical telephone line from Dublin Bay to 001 Edenville, we find a literary parallel to Klee's visual image; in both cases a modernization of the ancient belief that the navel is the seat of prophetic power and insight.[9] In his monologue Stephen Dedalus "closes off the external world of space by shutting his eyes and living altogether in the world of time."[10] To find your center is a form of meditation. Stephen Dedalus imagines the total life cycle "everlasting to everlasting," for there are symbols of birth and fertility (grain, belly) but also of death, as later in the monologue when he sees death coming to kiss a girl "mouth to her mouth . . . mouth to her womb. Oomb, all-wombing tomb." Thus as in the traditional symbolism of the Omphalos, birth and death provide a link in the chain of lives.

In the early part of the twentieth century there was a wave of interest throughout Germany, and all of Europe, in Asian philosophy and religions. A popular writer speaks sarcastically, "In the lecture halls of Berlin and Paris, the Eastern hierarchy of the occult revealed its magic doctrines to a new generation. In darkened rooms throughout Europe they held their seances. The fakirs came to Paris in swarms, stuck knives in their cheeks and throats, were buried alive, and lay on beds of sharp nails."[11] But with this there was a serious interest in the more profound philosophical aspects of Eastern religion, and its approach to the inner world of the spirit.

One mystic in particular, Helena Blavatsky, seemed to have a strong popular influence and deeply affected the thinking of such artists as Kandinsky and through him, Klee. In his famous work *Concerning the Spiritual in Art*, Kandinsky spoke specifically of her approach to "the problem of the spirit" by way of inner enlightenment:

[Spiritual] methods are still alive and in use among nations whom we, from the height of our knowledge, have been accustomed to regard with pity and scorn. To such nations belong the people of India, who from time to time confront our scholars with problems which we have either passed without notice or brushed aside. Madame Blavatsky was the first person, after a life of many years in India, to see a connection between these "savages" and our "civilization." In that moment rose one of the most important spiritual movements, one which numbers a great many people today, and has even assumed a material form in the Theosophical Society. This society consists of groups who seek to approach the problem of the spirit by way of *inner* knowledge.[12]

Many examples from the twenties and thirties reveal Kandinsky's interest in a cosmic center that one reaches by meditation.[13] Kandinsky shared his enthusiasm for Mme Blavatsky with Klee, and both practiced a kind of self-hypnosis meditation for a time. As Kandinsky said, "I had to wait for the dictates of the mysterious voice." Or as Klee put it, "My hand is entirely the tool of a distant will."[14] Certainly Blavatsky was of interest to Klee in revealing the mysterious forces that speak on a different level of human consciousness, a level for which Klee always felt a kinship. In his work Klee almost always removes things from their immediate surroundings, placing them in ever-expanding realms which result in a close correspondence between earth and cosmos, the living and the dead, things past and present.

With Klee the link between the inner and the outer world is perhaps more complete than with any of his contemporaries, as he drew on so many levels of experience. And Klee's movement towards a fixed center is clear. Perhaps this intense concentration on the center, whether center of the self (navel) or of the universe (Omphalos), was formed in those early years of intense quasi-mystical meditation, but the influences were many. For example, from the "Maxims" of Goethe, who was as much as anyone Klee's spiritual leader, we read, "Seek within yourself. There you will find everything." In the *Creative Credo* Klee himself begins

with the simple statement: "Let us take a little trip into the land of deeper insight following a topographic plan. The dead center being the point."[15] Numerous Klee paintings focus on such a point in the center of the painting. In his *Point and Line to Plane* Kandinsky expresses a similar attitude in describing the point as "the archetype of pictorial expression." It is "the zero point" which is the beginning of both art and life. For Klee the center becomes even more specifically and more mystically defined:

> I seek a remote source of creation point wherein I can apprehend a formula for earth, air, fire, water, and all circulating forces at once.
>
> My light burns so white-hot that to most people it seems to lack warmth. So I shall not be loved by them; no sensuous link, however subtle, exists between them and me. I do not belong to the species, but am a cosmic point of reference.[16]

How close this is to ancient mystical writings such as these lines by the thirteenth-century Spanish Jewish mystic, Moses of Leon: "The supreme point threw out an immense light of such subtlety that it penetrated everywhere." Or the seventeenth-century German mystic Jacob Boehme: "Lease thine own activity, fix thine eye upon one point. . . . Gather in all thy thoughts and by faith press into the Centre."[17]

Both of these mystics were read by the leader of the Surrealists, André Breton, who had an avowed interest in hermeticism, esoterism, and alchemy. In the famous beginning lines of the *Second Manifesto* he says, "Everything leads us to believe that there is a certain point in the spirit from which life and death, real and imaginary, past and future, communicable and incommunicable, are no longer perceived as contraries. It would be in vain to look for any other motivation in Surrealist activity than the hope of determining this point."[18]

Thus, it is this supreme point which is the focus of Surrealist cosmology, where even the greatest contradictions are resolved. As the Surrealist poet Paul Eluard has said, "I am at the center of time and I surround space."[19] It is the Surrealist aspiration to a point sublime which is at once the center and circumference of the universe. It is a mysterious point to which modern thinkers (poets, artists, philosophers), like their ancient mystical counterparts, aspire. But at the same time it is a real point. For the Surrealists, the theoretical, the dream world, and the fantastic are just as real as the other reality. Breton states, "What is eye-opening about the

fantastic is that there is no fantastic—there is only reality."[20] So this point is not just theoretical but a real point—the focal point of the true totality of the universe where diverse forms can no longer be perceived as opposites.

In Klee's painting *The Fruit* (Fig. 3) we see, by means of an umbilical spiral, the process of growth pointing both forward and backward—to life and to death. We see the actual growth process culminating in the larger form of the fruit itself. But we cannot take this as a culmination in "time," for there is the intense light of the spot in the center (Klee's white-hot light)—the seed, the embryo which starts the whole process all over again. It is the "natural"

3 Paul Klee, The Fruit, *1932. Oil on jute, 21⅝ x 27⅝". Anonymous Collection*

equivalent of the same idea that is contained in Klee's *Omphalo-Centric Lecture*. Mystics believe that the umbilical cord represents the contracting involution of our physical being; or as in Klee's painting, the spiral inward to the heart of creation, the seed, the Hindu conception *Bindu* (seed), homologous with the One, the Cosmogonic Egg. As Klee said: "The point as a primordial element is cosmic. Every seed is cosmic."[21] In so much of his work, even in the late works with their recurrent themes of death, Klee places an emphasis on origins, and on the total continuity of life. It is an attempt to transcend the dualism of life and death and to put them on an equal plane—to reconcile death as a part of life.

Klee was preoccupied with his search for origins, a more pure time of beginnings. But with Klee, as with other artists of the thirties, the search for origins represents a search for the self, an "outlet" in the inner self. Erich Neumann states: "Just as the psychic totality of the individual takes form around a mysterious center, the mandala of modern art, in all its vast diversity, un-folds around a mysterious center, which as chaos and blackness is pregnant with a new doom, but also with a new world."[22] In order to evoke that mysterious center, Klee often used the spiral, and we know from his writings (*The Thinking Eye*) that he understood well its dual implications. The potential for the spiral is simul-taneous movement in either direction, both as a beginning or unfolding (as we saw in *The Fruit*) and as an inward spiral in anticipa-tion of death. And so it is appropriate for Klee to use the spiral to push into this void of the center which is not only an ending in "chaos and blackness" but also the center of birth and forma-tion and light.

In contrast to the more visually representational *Omphalo-Centric Lecture*, in one of his very last works, *Inside the Body's Cavern*, a black spiral with legs and a dark cavity inside, Klee moved to the simple hieroglyph, for the symbolic form speaks most directly. Here the navel has been opened to reveal the dark mysterious nature of the body (self), a passage to the other side—Joyce's "allwombing tomb." Klee said, "Can I have gotten lost inside myself? In this case it would have been better never to have been born." What Klee tried to achieve, both in his thinking and in his art, was a state that is neither life nor death, but beyond birth—a state belonging to the mystics. But with Klee it was his own personal mysticism. Klee himself admitted in the epitaph he furnished

for his own gravestone that he had not reached the center, but he had begun to approach it:

> I cannot be grasped in the here and now
> For I live just as well with the dead
> As with the unborn
> Somewhat closer to the heart of creation than usual
> But far from close enough.

Notes

1. Paul Klee, *On Modern Art*, Jena, 1924, trans. by Paul Findlay, London, 1947, p. 51.

2. Paul Klee, *Notebooks, Vol. I, The Thinking Eye*, ed. Jurg Spiller, London, 1961, p. 4. This idea is further illustrated by a diagram on p. 44 showing the navel as the central point in Klee's "synthesis of body and space." A precedent for this drawing can, of course, be found in Leonardo's famous diagram of human proportions: "You must know that the center of the circle formed by the extremities of the outstretched limbs will be the navel." Edward MacCurdy, *Notebooks of Leonardo da Vinci*. Vol. I, New York, 1958. In its "Squaring of the circle" the Leonardo drawing also anticipates the "union of opposites" which we will see in the work of Kandinsky.

3. One definition of the *Omphalos* identifies it as the central part (containing the seeds) of the pomegranate. Liddel and Scott, *Greek English Lexicon*, 1229. It is of particular interest that Klee would choose the *Aphrodite of the Pomegranate* as a model. As an attribute of Proserpina, the pomegranate symbolized the return of spring—a new life. In Christian art this became the symbol of resurrection. As a container of seeds, it also signifies the womb and is thereby a symbol of fertility.

4. Many vase paintings illustrate the association between Apollo and the Omphalos. For example, a red-figured vase in the Naples Museum shows Apollo actually seated on the Omphalos. Jane Harrison, *Epilogomena to the Study of Greek Religion and Themis*, New York, 1962, p. 411, fig. 123.

5. Jane Harrison, *Epilogomena to the Study of Greek Religion and Themis*, New York, 1962, p. 384.

6. For example, Mount Gerezim in the center of Palestine, called *tabbur eres*—navel of the earth. Cf. Mircea Eliade, *The Myth of Eternal Return*, Princeton, 1974, p. 13. In the European world, a variation of this theme exists on the Capitoline Hill. As James Ackerman relates, "The ancient Romans moved the *umbilicus mundi* figuratively from Delphi to the Forum where it remained until medieval legend shifted it once more to the

Robert Knott

Campidoglio. Here it was permanently fixed in Michelangelo's pavement which combined its zodiacal inferences with its moundlike form." For a fuller discussion of this, see James Ackerman, *The Architecture of Michelangelo*, New York, 1961.

7. H.P. Blavatsky, *Collected Writings* (1877), *Isis Unveiled*, Vol. I, Wheaton, Illinois, p. xxxix.

8. James Joyce, *Ulysses*, New York, 1961, p. 38.

9. For a discussion of this imagery in *Ulysses*, see S. Gilbert, *James Joyce's Ulysses*, New York, 1952, p. 53.

10. *Ibid.*

11. T.H. Robsjohn-Gibbings, *Mona Lisa's Moustache*, New York, 1947, p. 177.

12. Wassily Kandinsky, *Concerning the Spiritual in Art*, New York, 1972, p. 32.

13. In a work such as *Accent in Pink*, 1926, all of the essentials are presented: concentric forms, the mandala representations of the whole universe of the One, from which all things emanate, and the quadrilateral and circle in which we find, in symbolic form, the purpose of this exercise, which is to unite opposites by meditation.

14. Paul Klee, *The Diaries of Paul Klee*, ed. Felix Klee, Berkeley, 1964, p. 215.

15. Paul Klee, *Notebooks*, Vol. I, p. 4.

16. Paul Klee, *Diaries*, p. 345.

17. For a more extended study of the relationship between esoterism and Surrealism, see Michel Carrouges, *Andre Breton and the Basic Concepts of Surrealism*, trans. Maurice Prendergast, Alabama, 1974, pp. 10ff.

18. André Breton, *Manifestoes of Surrealism*, trans. Richard Seaver and Helen R. Lane, Ann Arbor, 1962, p. 123.

19. Paul Eluard, *Defense de Savoir* 1 (218), from Eluard-Dausse collection of documents for the journal *Le Surrealisme au service de la Revolution*. New York. Reprinted in Mary Ann Caws, *The Poetry of Dada and Surrealism*, Princeton, 1970, p. 157.

20. André Breton, *Manifestoes*, p. 15, note 1.

21. Paul Klee, *Notebooks*, Vol. I, p. 4.

22. Erich Neumann, *Art and the Creative Unconscious*, New York, 1959, p. 135.

7

Surrealism and Modern Religious Consciousness

CELIA RABINOVITCH

In 1940, the central Surrealist group gathered in Marseilles under the auspices of the American Committee for Aid to Intellectuals. There, under the leadership of André Breton, they invented a new set of playing cards.[1] This seemingly irreverent statement had at its heart an intense seriousness of purpose, for it was a collective statement of hope by the Surrealists in the face of the devastation of World War II. The cards illustrated the cardinal points of Surrealist thought by replacing the four conventional suits with suits of Love, Dream, Revolution, and Knowledge, and portrayed in stylized and symbolic fashion some of the intellectual heroes of the movement, including Freud, Hegel, Baudelaire, and Lautréamont.

This playful invention reveals a central issue in understanding the spiritual dimension of Surrealism. What kind of attitude must we adopt in order to comprehend this elusive movement in all its subtle humor, idealism, despair, and hope? To understand Surrealism, we need to cultivate a sense of ironic sympathy, a willingness to be amused by the absurd antics of the Surrealists, while still recognizing the more significant contributions to modern culture by its members. The four major preoccupations of the group, expressed in the card deck as Love, Dream, Revolution, and Knowledge, demonstrate a search for new spiritual values that issue from a radical transformation of consciousness, a consciousness that was iconoclastic in character and that responded to the contradictions of the modern era.

This paper was given at the *XIV International Congress of the International Association for the History of Religions*, Winnipeg, Manitoba, August, 1980, under the title "Religious Phenomena in Surrealism," and is presented here in slightly revised form.

Surrealism championed chance over reason, the subconscious over the conscious, and the potent interior world of the imagination over the indifference of circumstance. Its purpose was to resolve the previously contradictory states of dream and reality into a kind of absolute reality, a "surreality."[2] It strove for the dislocation and derangement of all the senses, of which the poet Rimbaud spoke, that would reveal the "super-reality" that lies within mundane existence. The experience of the "surreal" transcends conventional, and hence restricted, ways of perceiving. The goal of Surrealism was to break open the boundaries between the conscious and subconscious, between the ordinary and the extraordinary, and to introduce unusual perceptions of the marvelous and magical into everyday life.[3]

The heightened perception sought after by the Surrealists was excited through various artistic, occult, meditative, and psychological practices that could arouse the dormant imagination. As the telescope to the infinite, the imagination was the only means through which the essential experience of the marvelous could be achieved. Methods such as pure psychic automatism, free association, trance, automatic writing or drawing, and the deliberate employment of chance were developed to excite the imaginative process and thereby to generate the metaphysical experience formerly denied to the rational, conscious mind. The Surrealists aimed for a revolution in art far beyond aesthetic concerns, for by altering our perceptions of reality, they hoped to change the very nature of reality itself.

It has been some sixty years since the beginning of the Surrealist movement in Paris in 1924, and since that time the movement has been subject to various art historical, literary, and philosophical approaches. Among these we may discern two prevailing trends: that is, to see Surrealism as but a step in the upward spiraling staircase of art, a program posited by the progressive ideology of modern art; or to see it as part of the increasing fragmentation and disorder that characterizes modern culture, an agenda proposed by the seemingly apocalyptic character of modern cultural history.[4] However, Surrealism resists the evolutionary lineage of most popular art histories; instead, it often has been categorized as an atavistic form of Romanticism, the last gasp of Romantic irrationality, moving against the currents of progressive abstraction in art and thought. The difficulty of easily understanding Surrealist art

is attested to by its current popular characterization as something uncanny, weird, or strange: in short, as a special quality of feeling, a sense of the extraordinary, that invades ordinary existence with a potent and disturbing presence. From the perspective of religious studies, the compelling feeling of the uncanny provoked by Surrealist art is precisely its most fascinating and perplexing aspect.

The spiritual aspirations of the Surrealists, seen in their belief in a supernatural reality—a "surreality"—must be understood in terms of modern religious consciousness. The sectarian social structure of the movement, its use of a manifesto or code of beliefs, its origins in a subterranean bohemian culture with a traditional attraction to the occult and heterodox, all suggest religion in camouflaged form. Even the blasphemy and iconoclasm deliberately employed by the Surrealists to challenge the hegemony of reason and the bourgeois morality ironically evoke the double-edged power of taboo, confirming its source, however inverted, in the Catholic tradition—in what sometimes has been called "la crise de la conscience Catholic."[5] Surrealism's transformation of archaic, occult, and pre-Christian elements reveals a heterodox profile that suggests an intentional reversal of traditional Western religious values. With this iconoclastic reversal, Surrealism creates a radically new orientation based on the power of psychological ambivalence.

The purpose of this paper is to show how the religious origins of Surrealism illuminate the entirety of the movement, and provide insight into the nexus of relations that comprise its significance for modern culture. Our focus is the Surrealist movement in France during its major period of ascendancy from 1924-40, a time sometimes called "the Age of Surrealism."[6] By studying Surrealism as religious phenomena, certain issues such as the origins of magic, the emotional quality of fetishism, and the nature of archaic religious experience are clarified. Similarly, the unusual imagery of these artists provokes questions concerning the relationship of myth to imagination, dream, and creativity.

Throughout this work, we will consider art and religion within a common context of the general systems theory.[7] Both art and religion can be understood as form-giving processes, constructs of the imagination, that frame an image or vision of the world for human culture. In this sense art and religion are symbolic systems that deal with qualitative experience, that is, with feeling.[8] We will apply to the study of art an approach derived from the history

and phenomenology of religions that allows a more inclusive frame of reference, encompassing the artist's experience of creativity as a spiritual or metaphysical process. This interdisciplinary approach provides a new lens through which we may see how the creative imagination is manifested in modern art and religious experience.

It is generally accepted that the symbolic expression of religious awareness is found in secular culture as well as in religion. Jungian theory in particular has explored how modern art discloses numerous and compelling parallels with universal religious symbolism. However, the Jungian approach tends to place art within explicit patterns or constellations called "archetypes"—a too literary interpretation implying that art illustrates rather than embodies meaning. By contrast, the extreme degree of ambivalence found in Surrealist art eludes archetypal classifications because of its intentional ambiguity of meaning. The Surrealists deliberately employ contradiction and paradox to create a peculiar mental *frisson* or shock, an utterly non-rational response that resonates with a sense of recognition in the mind of the beholder. Surrealist art spans such a wide spectrum that a single interpretation cannot do justice to its bizarre oscillations of meaning.

In previous eras the artist reinforced the established values; art was subservient to the system of patronage set up by the Church or state. Since the advent of Romanticism, the situation of the modern artist has changed. Freed from allegiance to doctrine, the modern artist presents an individual, unique vision that often opposes, criticizes, or offers an alternative to the dominant cultural norm. The modern imagination in the visual arts attempts to describe, in its own language, the nature of contemporary spiritual consciousness. While it may yet stutter as it talks, modern art does offer some iconographic clues as to the nature of modern religious consciousness.

The perception of the unusual and magical quality of everyday life is implicitly recognized in modern culture, concealed in popular language, and ironically held up as an ideal by the banalities of advertising, which so often employ the techniques of a Surrealist effect to promise an escape from ennui, uniformity, and discontent. The intrinsic power of these images to evoke religious phenomena seldom is acknowledged, because at this point the distinction between the secular and the sacred dissolves. But if we

are to understand the religious imagination as a living impulse, then its potential for new transformations and its continual effervescence in modern culture must be recognized.

To make visible the religious origins of Surrealism, we will concentrate on three major aspects of Surrealist expression that correspond roughly to the Knowledge, Dream, and Love of the Surrealist card deck. These aspects are:

1. The Surrealist mythos, or world-view
2. The Surrealist philosophy of immanence
3. The Surrealist cult of love, or images of the feminine.

1. The Surrealist Mythos

The Surrealist mythos is a mythology of the imagination, in which the imaginative process, expressed in dreams and creativity, is exalted as the medium through which an experience of the surreal is gained. In this way, the imagination is deified as a non-rational, sacred power.

Under the oracular tutelage of André Breton, the self-proclaimed magus of Surrealism, the Surrealists advocated a return to the origins of the mind. The movement's self-definition is given in the *First Manifesto of Surrealism* of 1924:

Surrealism: noun. Psychic automatism in its pure state, by which one pro-poses to express—verbally, by means of the written word, or in any other manner—the actual functioning of thought. Dictated by thought, in the absence of any control exercised by reason, exempt from any aesthetic or moral concern.

Philosophy: Surrealism is based on the belief in the superior reality of certain forms of previously neglected associations, in the omnipotence of dream, in the disinterested play of thought. It tends to ruin, once and for all, other psychic mechanisms and to substitute itself for them in solving all the principal problems of life.[9]

The Surrealist aim to "solve all the principal problems of life" forced the artist to reject all aesthetic and moral concerns, and to re-place ordinary conventions of thought with the pure freedom of the imagination granted by automatism. Through the method of psychic automatism, which is the free flowing of the imagination induced by various practices, the structure of thought itself would become manifest. Hence the Surrealists created a new definition of man as divinely inspired by the imagination.

"Pure psychic automatism" was inspired by Freud's work in dream analysis and free association. It was the mainspring from which other Surrealist methods of artistic creation drew their source. By using psychic automatism, the artist became a recording device for the unconscious; the rational faculty was suppressed, allowing thoughts to travel untrammeled from the unconscious mind through the hands to the brush or pencil. In order for the artist to become a "pure receptacle"[10] for the heightened consciousness of Surrealism, the mind had to be emptied of all preconceived notions of reality and thoughts allowed to arise spontaneously. A parallel may be drawn to Buddhist meditation, in which the mind is systematically detached and emptied of thought in order to be open to the existential state of emptiness. The Surrealists attempted a similar emptying of the mind in artistic creation, but they lacked the conscious discipline of forms such as religious meditation practice, and thus they experienced multiple levels of archaic, symbolic, or ideational religious perception.

After radically internalizing spirituality through psychic automatism, the Surrealists also became fascinated by dreams, childhood memories, trances, and by all types of psychic phenomena including psychotic experiences. In short, they pursued every type of perception suggestive of an otherness experienced in the midst of mundane life. Contrary to popular notions, they were not only inspired by the researches of Freud into the subconscious mind, but also by the poetic theory of the imagination found in the writings of the Italian artist Giorgio de Chirico. De Chirico's theory contributed a radical new mysticism to the Surrealist vision, but his considerable contribution to Surrealist philosophy has been obscured by time, neglect, and the politics of the art world.[11]

In de Chirico's early paintings a disquieting, premonitionary sense of doom precisely crystallized the Surrealist intimation of a preternatural power and immanence found in the insignificant and ordinary events and objects of daily life. His early self-portrait of 1913 prefigures the movement's transcendent aims. The artist inscribed it with the words, "And what shall I worship save the enigma?" De Chirico provided the movement with a type of poetic empiricism—a poetry of the ordinary—that proved an antidote to the scientific stance adopted by the high seriousness of the *Bureau des Recherches Surrealistes*.

De Chirico's writings appeared at a pivotal point in the development of Surrealism, paralleling the researches of Freud into

1 *Giorgia de Chirico,* Nostalgia of the Infinite,
1913. Collection, The Museum of Modern Art,
New York

the unconscious. His thought forms a bridge between the scientific approach of Freud, and the poetic intuition traditionally employed by visionaries. De Chirico's poetic theory of art, manifest in his insistence on the superiority of the imagination, dream, and childhood memory, established in large part the direction of Surrealism in its focus on the imagination. His ideas were familiar to the Surrealists through letters that the artist wrote to Apollinaire from 1911-1915, and from his later correspondence with André Breton and Paul Eluard. But while the Surrealists were systematizing their new theory of the imagination drawn from de Chirico's naive mysticism, the artist was experiencing an artistic and spiritual crisis that led to his adoption of a conservative style. The ensuing rift between de Chirico and the Surrealists has considerably obscured his role in modern art theory. However, the precise delineation and ominous clarity of de Chirico's early paintings such as *The Nostalgia of the Infinite* of 1913, (Fig. 1) exerted a vital influence on many Surrealist artists, who quickly adopted the artist's visual techniques to provoke an uncanny, disturbing effect. In this work the world is too still; the only moving objects are the flags adorning the lonely tower which dwarfs the insignificant, isolated figures that stand immobile below. The inspiration of de Chirico's early work thus shifted the emphasis of Surrealist artists from scientistic methods of creation to visionary, hypnotic images recalled from dreams or reconstructed from transient memory. His credo, issued in 1913,—"What I hear is worth nothing; there is only what I see with my eyes open, and even more, what I see with them closed"—affirms the interior world of the imagination, thereby prefiguring Surrealism's rejection of the world of appearance.[12]

The Surrealists aimed at a return to the origins of consciousness in order to find a significance and mystery therein that transcended reason. The mystical fixed point of their philosophy was the unconscious or dreaming mind. Mircea Eliade described the difference between sacred and profane space as one of quality: "Sacred space ... establishes a center, revealing absolute reality by founding the world from an absolute fixed point."[13] It is commonly accepted that most religions "found the world" or create sacred space at an actual physical place, church, or temple. Instead, by radically internalizing spirituality, the Surrealists found their world in the "terra intermedia" of dream and myth: in the imagination itself.

The Surrealist mythos is a "mythology of the imagination"

in which dream, reverie, and imagination act as sacred messengers heralding a perception of the divine. For them, the imagination was the avenue through which surreal perception was attained. In this way, they believed that they could reunite internal and external life, allowing a return to the original unity of the unconscious dreaming mind—what Freud and earlier philosophers called the "tabula rasa," the blank slate before the accumulation of experience constricted instinct and imagination. It is an artist's philosophy of art, an elevation of the creative process itself as the way to visionary insight, that answers the spiritual poverty of modern life with a new equation: art is religion.

2. The Surrealist "Philosophy of Immanence":

Consider a group of ordinary objects on a table. If you focus on just one object and concentrate on that alone, the surrounding objects may appear to vanish and fade into your peripheral vision. As the visual focus is intensified, the psychological importance and expressive character of the object is emphasized. When isolated, the object presents an "expression" to the mind of the beholder. By disregarding or nullifying the surrounding space, the impression of the size of the object varies, for no relative context defines its size or function. Isolating the object thus removes its conventional origin and introduces new perceptions of the ordinary, making it extraordinary.

The Surrealist philosophy of immanence, according to which surreality was embodied in reality itself, leads to an extraordinary perception of the object. Surrealism negates art as artifact; the purpose of the surreal art object is to manipulate perception in a revolutionary, religious, or metaphysical manner. The Surrealists wished to lose themselves in the perception of the object in the spontaneous and fluid manner of the child, or the obsessive and anxious manner of the psychotic. They attempted to attain, in a "poetic consciousness of objects," a sense of heightened significance and power that they sensed was available in psychotic, dream, and child experiences. This pervasive and diffuse sense of significance—a mysterious attraction and fear that Rudolf Otto has called the "numinous" or the holy—is the overriding quality of many Surrealist paintings.[14]

The Surrealist "crisis of the object" was ignited by the Dadaist

149

activities of Marcel Duchamp. Duchamp was engaged in the production of "readymades," which were mass-produced industrial objects such as the *Bottlerack* of 1914 (Fig. 2). The artist removed these readymades from their utilitarian context, remaking them with the addition of a new name and his signature. In exhibition, these banal objects acquired a bizarre internal life that contradicts their functional origins. They frequently elicit a peculiar fascination in the beholder because their alienation from a functional environment makes them symbolically ambiguous and hence disturbing. The perceptual emphasis is placed on the quality of the visual form, which is then perceived in all its uniqueness. A critic and contemporary of Duchamp's, Jean Bazaine, wrote at the time:

2 Man Ray photograph of Marcel Duchamp's Bottle Rack. *Collection, The Museum of Modern Art, New York, James Thrall Soby Fund*

This bottlerack, torn from its utilitarian context . . . is invested with the lonely dignity of the derelict. . . . Good for nothing, there to be used, ready for anything, it is alive. It lives on the fringe of existence its own disturbing absurd life. The disturbing object—that is the first step to art.[15]

Duchamp's enshrinement of the *Bottlerack*—an ordinary object that he placed on a pedestal so that it stands out of its usual context— creates a new perception of the object. By isolating the object on a pedestal, placing it within boundaries, Duchamp breaks the continuity of mundane space and introduces a point of psychological focus or absolute interest. In this way the object is charged with a mysterious potency, an obscure, unspecified sense of significance. In the words of Gerardus van der Leeuw, "The sacred is what has been placed within boundaries: its powerfulness creates for it a place of its own."[16] By distancing the object from its functional origins, a corresponding psychological distance takes place in the viewer, and a new thought for the object is born. The *Bottlerack*, with its deliberately elusive meaning, evokes a sense of the uncanny that is precisely the response engendered by archaic fetishism.

Similarly, Duchamp's *Fountain* of 1917 employs these same visual principles to remake the ordinary in an iconoclastic reversal of the banal and the holy. The *Fountain* was an inverted urinal that he entered in the 1917 *Salon des Independents* under the plebeian name of a "Mr. R. Mutt." Duchamp favored a kind of Buddhist non-discrimination to transform radically modern awareness. He advocated the "irony of affirmation" and put forward, with glacial wit, "absurd propositions intending to disturb rather than provoke laughter."[17] For the post-Victorian society in which he lived, his inverted urinal was indeed immoral. Not only did it refer to intimate body functions that were literally taboo in polite society, but it elevated this private domain to the status of a fetish which by association evokes the forbidden or the sacred. Duchamp's strategy is playful, ever puerile, but he has succeeded in making the ordinary object extraordinary. He thus fulfills his goal in creating "a new thought for the object."

The experience of an "unspecified power" is generally accepted as an essential part of archaic religious experience. Archaic man tends to perceive his environment as kinds of power. This numinous power is the original sense of the sacred, "a quality of existence separating the unusual and extraordinary from the usual and ordinary."[19] According to Ernst Cassierer, in archaic or mythic perception the object is taken as a pure presentation of the perceiver's

151

imagination, and thus becomes a vehicle for any unconscious knowledge or fear.[20] Similarly, in Surrealism the object assumes a new potency of meaning that is infinitely flexible. An ambivalent feeling of attraction and fear is associated with many Surrealist art objects such as the readymades or found objects—the *objet trouvé*. By positioning an object in an unfamiliar context, by visual isolation, or by unusual juxtapositions that break the conventional boundaries of thought, the Surrealist object accumulates symbolic and aesthetic power. This immanent or latent power of objects also is expressed in illusionistic painting by the precise delineation employed by certain Surrealists such as de Chirico or Dali.

The Surrealist altered object, an ordinary object transformed by the addition of one or more parts, also provokes a disturbing sense of the uncanny. Meret Oppenheim's uncomfortable *Fur-Lined Tea Cup* of 1936 is a cup, saucer and spoon covered with fur (Fig. 3). This combination creates a disconcerting sensation that denies its usual function. The prerequisite shudder of dread provoked by its potential use is created by breaking the boundaries between its vernacular and occult meaning.

In the magical view of the world, the fundamental principle is "the part suggests the whole." For example, in archaic magic, fur, toenails, or a piece of clothing evoke by association the entire person or animal. Sympathetic magic works through assumption that "things act on each other at a distance through a secret sympathy, the impulse being transmitted from one to another by invisible power."[21] When this power inheres in objects, it is manifested positively as *mana* and negatively as *taboo*. The Surrealist altered object similarly works by sympathetic association to animate the inanimate, industrial object with non-rational, inchoate power.

The Surrealists also felt that natural objects such as stone and wood attract power. These objects are portrayed both in the biomorphic forms of abstract Surrealist paintings by Miró, Matta, and Arp, and in the illusionistic works of Yves Tanguy and Salvador Dali. The muteness of these natural objects expressed for the Surrealists a mystery that they called the "Cult of Stones."[22] This was, in fact, a mysticism of the material world in which even the most ordinary or insignificant object enveloped an obscure, immanent power. In particular, the painter Yves Tanguy was drawn to the morphology of stone, which in his work assumes emotional connotations far beyond the genre of landscape. The illusionistic,

3 *Meret Oppenheim*, Object, 1936. *Fur covered
cup, 4⅜" diameter; saucer, 9⅜" diameter; spoon 8"
long. Collection, The Museum of Modern Art,
New York*

luminous space of Tanguy's work is made even more ambiguous by
the enigmatic lexicon of biological forms that are unrecognizable to
the rational mind. This imagery of stone may stem from the artist's
memories of his native Brittany, where archaic dolmens scatter
the landscape. His painting *Multiplication of the Arcs* of 1954 (Fig. 4)
depicts a mass of biomorphic forms whose scale is uncertain
and purpose unknown. The unnaturally sharp focus that icily
describes each object creates that same "sense of significance" that
imbues the readymade or altered object. The unusual effect of
spatial and psychological disorientation is achieved through the
obsessive precision of the artist's drawing.

 The profound internalization of spirituality by the Surrealists
is evident in the archaic nature of their perception of the object. The
presentiment of numinous power that resides in objects was a
response perhaps partially due to the breakdown of organized re-
ligious traditions, for there no longer were any "names" for things.
The Surrealists believed that the natural world was imbued with

a fluid, latent power that impelled the poetic imagination with incandescent visions of the marvelous. The sense of immanence in mundane reality is a projected symbolic sense manifested in the anxious or sublime perception of reality. According to the great phenomenologist Rudolf Otto, "Power awakens a profound feeling of awe which manifests itself as both fear and attraction. There is no religion whatever without terror, but none equally without love . . . or attraction."[23]

3. The Surrealist Cult of Love

While the Surrealist object is markedly similar to the fetish in archaic religion, Surrealist iconography develops according to the principle of metaphor also found in other traditional religious iconography. What occurs in Surrealism is not simply a meditative world-view recalling that of Zen Buddhism or Hinduism—traditions which practice forms of psychological transformation to

4 Yves Tanguy, Multiplication of the Arcs, *1954. Oil on canvas, 40 x 60". Collection, The Museum of Modern Art, New York. Mrs. Simon Guggenheim Fund*

which psychic automatism may be compared. Indeed, there are
many commonalities between Surrealism and Zen Buddhism,
particularly in the use of meditative practices such as automatism or
zazen, in the mutual negation of ideologies as a viable existential
position, or the use of the irrational to communicate, teach, and ex-
plain. The Surrealists often seem like sly Taoist or Zen masters
in their methodless madness. What emerges, however, with
increasing insistency in Surrealism is a new cult of the feminine: the
feminine as powerful, dangerous, procreative, and inspirational.

The feminine is linked to the fertility and potency of the imagina-
tion in Surrealist thought. The plethora of Surrealist art which
presents the feminine as a powerful entity strongly suggests that
these images transcend representations of female sexuality,
focusing instead on the procreative power of the feminine principle
itself. Female creativity became, for the Surrealists, a metaphor for
the creative process.[24]

Surrealism's attitude towards the feminine was ambivalent and
complex, fluctuating between levels of erotic attraction—seen
in the cult of romantic love or *amour fou*—to a more negatively
ambivalent attitude of fear of woman, who comes to represent a
symbol of uncontrolled nature. These ambivalent attitudes are ex-
pressed in Joan Miró's *Head of a Woman* of 1938 (Fig. 5), which
portrays a primordial beast, half insect and half human, flailing
its arms in an aggressive embodiment of emotional rage. Painted in
colors of black, red, and yellow, the creature gesticulates ferociously,
calling forth the image of woman as a daemonic, destructive entity.
Recent research has shown that for Miró, this image was in-
tended not only as a fertility figure but as a sign for a state of psychic
menace:

When I make a large female sex image it is for me a goddess, as the birth of
humanity. . . . It is a fecundity figure, but all the same it is menacing, on
the right and on the left, above and below, we are menaced.[25]

This image, like the goddess Kali of Hinduism, presents the feminine
in its daemonic, destructive aspect. It is the polar opposite of the
languid, passive figures created by Surrealist painters such as
Paul Delvaux. These images of the feminine are portrayed with vary-
ing degrees and nuances of meaning in Surrealist art, from explicit
and erotic sexuality, to the presentation, in Miró's *Head of a Woman*, of
the feminine as an abstract, destructive force.

The Surrealist mythology in which the imagination was exalted

as the opening to the surreal was an abstract one, but most of the movement's members were artists, writers, and poets—people whose creative expressions had a decidedly concrete, imagistic slant. Historically, the imagination has traditionally been represented as feminine, not only in the ideal of the classical muse adopted and revised by nineteenth-century Romanticism, but also in archaic myth, where the realm of the irrational and the underworld has often been associated with feminine powers such as the Greek Demeter-Persephone. Considering that the use of female images to convey abstract ideas dominates European iconographic traditions, it follows that the Surrealists would also be drawn to the image of woman to express their understanding of the imagination. Similarities to the classical muse, that ancient genie of the imagination, may be drawn; but the muse is a ghostly asexual voice-in-the-ear, whereas the Surrealist woman is angry, aggressively sexual, both dangerous and essential to man. Her most obvious characteristic in artistic depiction is her sexuality, her connection to earth, matter, and the underworld, and she is definitely not the airy, sweet sprite of classical thought.

In Surrealism the image of woman is exalted as a symbol of the procreative power of the imagination. Expressed iconographically, the many incidences of female representation resemble characteristics of fertility goddesses in archaic religions. In numerous works by Surrealist artists such as Paul Delvaux, Max Ernst, and Magritte, images of women are erotically explicit and often deliberately shocking; their bodies are full and obviously sexual, the figures idealized, no longer specific individuals but abstract, powerful entities. Like the chthonic goddesses of Asia Minor, their faces often are masked, obscured, or idealized out of a specific personal identity. Their connection to earth and matter is expressed in Surrealism by images of stone or *prima materia*, primal matter that is related psychologically and etymologically to the term "mater" or mother, and hence to the feminine principle.

The Cult of Stones is linked thematically to the personage of the Great Mother, or *Magna Mater*, for stone is the basic image of mute matter and substance in most archaic thought. The *Magna Mater* or the goddess Cybele was originally worshipped in the form of an uncut black bethel stone, of meteoric origin. This stone was apparently embedded in the statue of Cybele where the face ought to be, in the statue brought to Rome in the first centuries A.D.

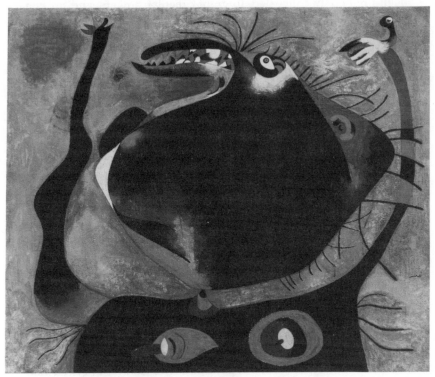

5 *Joan Miró*, Head of a Woman, *1938. Oil on canvas, 18 x 21⅝". Minneapolis Institute of Arts. Gift of Mr. and Mrs. Donald Winston*

Hence matter or stone is linked with the fertility deities of Asia Minor, such as Cybele, and with the principle of regeneration in general.[26] In traditional folk religion, stones were often used for their power to grant fertility, a phenomenon most obvious in the abstract *lingam* and *yoni* representations of Hinduism. By extension, the fertilizing principle of stone is linked to the fecundity of the earth itself, especially in the alchemical idea of *prima materia* or formless, primal matter.

The philosopher's stone, employed by the alchemist to transmute raw matter into precious gold, was formed from the original substance or *prima materia* from which the world was created. The philosopher's stone had the magical property to reveal what had

been previously concealed, to grant oracular powers, and to "convey a spirit into an image."[27] Like the formlessness of the imagination, the philosopher's stone was of a mutable substance that had the potential to create all things. Titus Burkhart observes, "of *materia prima*, the primordial substance, one can only say that it is purely receptive with regard to the form-giving cause of existence, and that at the same time it is the root of "otherness" for it is through it that things are limited and multiple."[28] In Surrealism the preoccupation with an original unity before the beginning of time is reflected in the biomorphic forms of works such as Yves Tanguy's *Multiplication of the Arcs*. Its timeless, organic forms suggest a search for origins in biological as well as in mythical time.

The intense ambivalence of the Surrealist attitude towards the feminine is seen in her portrayal as both procreative and destructive, a source of nature and regeneration and a bringer of chaos and death. In this way the Surrealist depiction of woman was identified with the imaginative unconscious: these ambivalent emotions relate the feminine to the underworld of the unconscious with its chaotic energy. This is the realm of ghosts, memories, and dreams—fossils of lived experience which remain to irritate the imagination. The ambivalence which attends the image of woman expresses a fundamental tension directed against the primal energy of the unconscious mind itself. Not surprisingly then, many Surrealist artists did experience forms of psychic disorientation and even madness that stemmed from the tensions of their situation, generated by the deliberate provocation of the creative unconscious, a provocation that at times must have been overwhelming.

Various interpretations may be posited concerning images of the feminine in Surrealism. Historically, Surrealism is a psychological reversal of the predominantly patriarchal Judaeo-Christianity of the era. In particular, it is an intentional inversion of the traditional Catholicism that has dominated France over the centuries, with its concomitant antithesis of French anti-clericism since the time of the *philosophes*. This deliberately shocking reversal of accepted tradition is strikingly apparent in Max Ernst's painting, *The Virgin Mary Spanking the Infant Jesus before Three Witnesses, André Breton, Paul Eluard, and the artist, Max Ernst*. As the title so aptly suggests, the work depicts an enraged Virgin spanking the infant Christ, whose halo has fallen to the floor. Far more than just a jab at the bourgeoisie, the work punctures major religious, artistic,

and psychological conventions related to a cultural icon. Hence Ernst's iconoclasm does not merely break established rules or genres; it contains a blasphemous potential that is derived from its source in religious traditions. It has power of a special order—the power of taboo.

The symbol of the feminine in Surrealism carries an intensely emotive aspect that characterizes the breaking of taboo. In Freud's view, "Taboo is a command of conscience, the violation of which causes a corresponding sense of uncovery and impending doom."[29] Taboo generates both power and danger when broken. As shown earlier, the ominous clarity and extreme delineation of many Surrealist paintings has a strong element of doom and apocalyptic feeling. This remarkable phenomenon of omen and doom suggests that the apocalyptic feeling in Surrealism arises from its rejection of prevailing sexual taboos, and its concurrent evaluation of the feminine as powerful. The iconoclastic attitude of the movement allowed for the uncovery of previously unacceptable emotions and ideas, and perverse or daemonic aspects of the feminine principle could be revealed. Considering that the Greek root of the word "apocalypse" is "uncovery," then the connection between feelings of omen and doom and the breaking of socio-sexual taboos becomes clearer. The reactionary symbolism of the feminine principle in Surrealism indicates a type of forbidden emotion that exults in a newly found freedom, hampered by feelings of fear, guilt, and danger. The sensation of presentiment so strongly depicted by the startling juxtapositions of Surrealist art thus stems from the delight of *uncovery* in the breaking of taboo, and its concomitant fear of retribution in the coming apocalypse.

Conclusion

The currently popular connotations of the word "surreal" bring to mind terms such as, "bizarre, uncanny, disturbing, and weird." Ironically, the term "weird," so often applied to surrealistic effect, is perhaps curiously appropriate. "Weird" derives from the Old English *wyrd*, which signifies fate, destiny, or events. *Wyrd* is in this sense a vast amorphous force, associated with absolute otherness and predestination. In its broadest aspect, "wyrd is the destiny of all human life and civilization: death itself."[30]

Assimilated by contemporary advertising, and exploited by the

trite visual tricks of psychedelic packaging, the techniques of a sur-
realist effect are well known, and well worn. The movement has
thus lost much of its original impact, and the term "surreal" has de-
generated to common adjectival usage. As a historical movement,
however, Surrealism is characterized by the courage and honesty to
experiment, to attain new perceptual states, regardless of artistic
or financial consequences. That the movement was above all
successful attests to its immense appeal on the popular level to
excite the collective imagination of its time.

Notes

1. Sarane Alexandrian, *Surrealist Art*, (New York: Praeger Publishers, 1975),
p. 160.

2. Andre Breton, *Manifestoes of Surrealism*, trans. by Richard Seaver and
Helen R. Lane, (Ann Arbor: University of Michigan Press, 1974), p. 14. "I
believe in the future resolution of these two states, dream and reality,
into a kind of absolute reality, a 'surreality,' if one may so speak."

3. The "marvelous" is a central concept in Surrealist thought. In Breton's
words, "Let us not mince words: the marvelous is always beautiful, anything
marvelous is beautiful, in fact only the marvelous is beautiful." Andre
Breton, *Manifestoes of Surrealism*, pp. 14-16.

4. A "fragmentation theory" of modern culture is particularly apparent in
Nathan Scott, *The Broken Center: Studies in the Theological Horizon of Modern
Literature*, (New Haven: Yale University Press, 1966).

5. Robert Bessede, *La crise de la conscience Catholique dans la littérature et la
pensée française à la fin du xix siècle*, (Paris: Editions Klincsieck, 1975).

6. Roger Shattuck, "Love and Laughter: Surrealism Reappraised," introduc-
tion to Maurice Nadeau, *The History of Surrealism*, (Middlesex: Pelican
Books, 1973), p. 11.

7. See Ludvig Von Bertalanffy, *General System Theory*, (New York: George
Braziller, 1968); also "Cultures as Systems: Towards a Critique of Historical
Reason," *Phenomenology, Structuralism, Semiology*, (Lewisberg: Buchnell
University Press, 1976).

8. This approach is derived in particular from the philosophy of Susanne K.
Langer, who states that all art is the objectification of feeling. Susanne
K. Langer, *Problems of Art* (New York: Charles Scribner's Sons, 1957), p. 15.
"A work of art is an expressive form created for our perception through
sense or imagination, and what it expresses is human feeling."

9. André Breton, *Manifestoes of Surrealism,* p. 26.

10. André Breton, *Manifestoes of Surrealism,* p. 27. "But we, who have made no effort whatsoever to filter, who in our works have made ourselves into simple receptacles of so many echoes, modest 'recording instruments' who are not mesmerized by the drawings we are making, perhaps we serve an even nobler cause."

11. I have explored the relationship of Giorgio de Chirico and the Surrealists and the extent of his influence on Surrealist art theory in "The Surreal and the Sacred: Archaic, Occult, and Daemonic Elements in Modern Art, 1914-40," (Doctoral Dissertation, McGill University, Montreal, 1984), pp. 204-233. Currently under consideration for publication.

12. Giorgio de Chirico, cited in André Breton, *Surrealism and Painting,* (France: Editions Gallimard, 1965), pp. 16-17; also cited in James Thrall Soby, *Giorgio de Chirico* (New York: Museum of Modern Art, 1966), p. 245.

13. Mircea Eliade, *The Sacred and the Profane,* (New York: Harcourt, Brace, and World, 1959), pp. 21, 30.

14. Rudolf Otto, *The Idea of the Holy* (New York: Oxford University Press, 1973), p. 6. Otto refers to the numinous as something ethically neutral: " 'Holy' means something quite other than good. 'Omen' has given 'ominous' and there is no reason why from 'numen' we should not similarly form a word 'numinous.' He defines the numinous as 'mysterium tremendum et fascinans.' "

15. Jean Bazaine, *Notes sur la peinture d'aujourd'hui,* (Paris: Editions du Seuil, 1953), p. 124.

16. Gerardus Van der Leeuw, "Religion in Essence and Manifestation" from *Phenomenology of Religion,* (New York: Harper and Row, 1969), p. 80.

17. Marcel Duchamp, cited in Sarane Alexandrian, *Surrealist Art,* p. 34.

18. Marcel Duchamp, cited in Marcel Jean, *History of Surrealist Painting,* (New York: Grove Press, 1960), p. 36.

19. J.D. Bettis, ed., *The Phenomenology of Religion,* (New York: Harper and Row, 1969), p. 54.

20. Ernst Cassirer, *Language and Myth,* (New York: Dover, 1945), p. 56.

21. James G. Frazer, "Sympathetic Magic," *Reader in Comparative Religion,* William Lessa and Evon Vogt, ed., (New York: Harper and Row, 1958), pp. 415-425.

22. André Breton, *Surrealism and Painting,* (France: Editions Gallimard, 1965), p. 280. See also Celia Rabinovitch, "The Surreal and the Sacred: Archaic, Occult, and Daemonic Elements in Modern Art, 1914-40" (Doc. diss., Montreal: McGill University, 1984), pp. 300-324.

23. Rudolf Otto, *The Idea of the Holy.*

24. This idea has been examined in Whitney Chadwick, "Eros or Thanatos—The Surrealist Cult of Love Reexamined," *Artforum*, 14 (Nov., 1975), pp. 45-56.

25. Cited in Sidra Stitch, *Joan Miró: The Development of a Sign Language*, (St. Louis: Washington University, 1980), p. 30.

26. Celia Rabinovitch, "Cybele: Myth, Cult, and Iconogenesis," research paper, McGill University, 1981.

27. Elias Ashmole, ed., "Theatrum Chemicum Britannicum," a reprint of the London Edition, 1652, with a new introduction by Alan Debus (Johnson Reprint Corporation, New York and London), 1967. Cited in Edward Edinger, *Ego and Archetype*, (Baltimore: Penguin, 1973), pp. 262-263.

28. Titus Burckhardt, *Alchemy: Science of the Cosmos, Science of the Soul*, (Baltimore: Penguin, 1974), p. 63.

29. Sigmund Freud, *Totem and Taboo*, (New York: W.H. Norton and Co., Inc., 1950), p. 90.

30. B.J. Timmer, *"Wyrd in Anglo Saxon Prose and Poetry," Neophilologus XXVI*, (New York: Johnson Reprint Corporation, 1940), pp. 24-33, 213-228.

8
Mondrian and Theosophy

ROBERT P. WELSH

Mondrian's membership in the Theosophical Society, although invariably cited in accounts of his career, in general has been treated merely as an intellectual interest which helped to clarify his thinking about art, especially during the period of World War I which he spent in The Netherlands. By 1917, along with other members of the De Stijl group, he had arrived at a form of geometrizing abstract art so radically novel that some theoretical justification seemed called for in printed form. Thus, in October 1917 he joined in founding, under the editorship of Theo van Doesburg, the periodical *De Stijl*, which immediately began to carry his own series of articles, "Die Nieuwe Beelding in de Schilderkunst" ("The New Plasticism in Painting").[1] As an influence on these essays, most critics have singled out the Dutch "Christosoph," Dr. M.H.J. Schoenmaekers, whose books *Het Nieuwe Wereldbeeld* (1915) and *Beginselen der Beeldende Wiskunde* (1916) Mondrian is known to have admired.[2] Indeed, although translated into English as *The New Image of the World* and *Principles of Plastic Mathematics*, like Mondrian's own Franco-Anglicized term "Neo-plasticism," these titles all rely upon the significance of the Dutch word "beelding." This is best translated as "form-giving" and closer in definition to the German "Gestaltung" than to the English "image" or "plasticism." In any case, both the art theory of Mondrian and the philosophical system of Schoenmaekers adopt the concept *beelding* as a fundamental principle in viewing the world, and there can be no doubt that the personal contact between the two men was a mutually fruitful one. Doubtless, too, Professor H.L.C. Jaffé is correct in finding an affinity between the "abstract" thought patterns of Mondrian and Schoenmaekers, which, in turn, share in Dutch Calvinist

traditions of precise and logical intellectual formulation.[3] Nonetheless, the general tendency to grant such emphasis in Mondrian's art theory development to the role of Schoenmaekers has helped to obscure two essential facts; namely, the importance of Theosophy to Mondrian at a date previous to his contact with Schoenmaekers, and the incorporation of Theosophic ideas into his actual style of painting.

It was, in fact, as early as May 1909 that Mondrian officially joined the Dutch branch of the Theosophical Society. Shortly thereafter, an approving critic, the Amsterdam writer Israël Querido noted Mondrian's use of Theosophic terminology in a letter received from the painter which contained art theoretical observations, and which Querido published in lieu of comment by himself.[4] In exhibition reviews from both 1910 and 1911[5] another critic cited the artist's Theosophic interests, in the latter year with specific reference to the monumental *Evolution* triptych, a work which, as will be shown below, eminently deserved this special mention. By the winter 1913-14, Mondrian's attachment to Theosophy was so well appreciated that, although then living in Paris, he was asked to write an article upon the subject "Art and Theosophy" for *Theosophia*, the leading organ of the Dutch Theosophical movement.[6] Although this essay remained unpublished, it very likely reflected the thoughts about art with which Mondrian annotated two sketchbooks from approximately the same period[7] and which are also summarized in several extant letters from early 1914.[8] In sum, there is adequate documentation that Mondrian's involvement with the Theosophic movement predated his contact with Dr. Schoenmaekers and from the first related directly to his own activities as an artist.

Significantly, in none of his surviving texts from before the De Stijl period does the artist as yet advocate the exclusive use in painting of either straight vertical and horizontal lines, rectilinear planes or the three primary colors: red, yellow and blue. Nonetheless, whereas the basic color triad is mentioned by Dr. Schoenmaekers for the first time in his *Het Nieuwe Wereldbeeld*, it is apparent that the combination of ochre (for yellow), blue and red/pink hues already occurs in a number of major paintings which Mondrian executed previous to his return from Paris to The Netherlands in mid-1914 when the book in question was datelined. Similarly, in his *Mensch en Natuur (Man and Nature)* of 1913,[9] a work until now

unnoticed in the literature on Mondrian, Schoenmaekers discusses such abstract geometric forms as vertical and horizontal lines, crosses, circles and ovals in a manner which might seem to explain their occurrence in compositions by Mondrian. Indeed, the oval-shaped, so-called plus and minus grid, which is expressed overtly in the "pier and ocean" theme of 1914-15 and a number of related compositions, embodies the same range of linear configurations emphasized in the three above-mentioned volumes by Schoen-maekers. Yet, a closely related grid conception occurs as the underlying structural basis for several tree and still life paintings executed by Mondrian as early as 1912.[10] These chronological considerations make clear that the structural character of Mondrian's painting during his Cubist and proto-De Stijl phases of 1912-early 1917 was determined by precepts which antedate the occurrence of related formulations in the writings of Dr. Schoenmaekers. In fact, although the founder of *Christosophie* in particular was reluctant to acknowledge his intellectual dependence upon standard Theosophic doctrine, preferring to credit personal intuition and mystical insight instead, both he and Mondrian maintain a world-view and employ a critical jargon patently derived from earlier texts fundamental to the international Theosophic movement. In Mondrian's case, the principal debts are to no lesser personages than Mme H.P. Blavatsky and Rudolf Steiner, whose writings appear to have influenced his painting most directly during the pre-Cubist or "coloristic" period of circa 1908-11.

The gradually increasing and self-transforming debt to Theosophic belief found in the pre-Cubist work of Mondrian is summarized in, though scarcely encompassed by, an analysis of three figural compositions. The *Passion Flower* (Fig. 1), a watercolor executed as early as circa 1901,[11] already manifests the basic iconographic format which would be used in all three works; namely, the combined image of a profoundly meditative female torso with upturned head and accompanying heraldic flower blossoms. The *Devotion* (Fig. 2) of 1908[12] summarizes essentially the same iconographic nomenclature by means of a profile view of a girl seen contemplating a single chrysanthemum blossom. This latter work nonetheless adds a novel element by its bright blue and red coloration. Such hues are lacking in the dullish tones of the earlier example and doubtless are symptomatic of the artist's new appreciation for Post-Impressionist and Fauve traditions.

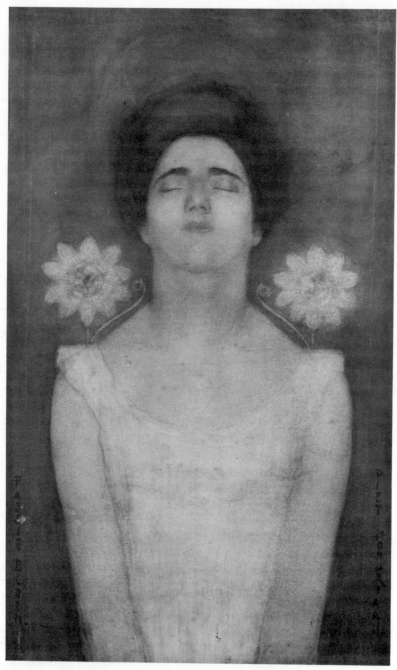

1 *Piet Mondrian,* Passion Flower, *c. 1901.*
Watercolor 28½ x 18¾". Haags Gemeentemuseum,
The Hague

Finally, by late 1911, Mondrian had produced his *Evolution* (Fig. 3),[13] a work which thrice employs a frontally posed figure with flanking "flower" attributes as found in *Passion Flower* and which yet surpasses the color intensity of even the *Devotion* through the use of a deeply resonant blue background and a radiant yellow ambiance for the head of the central figure. The general debt to Symbolist and Art Nouveau tradition which informs all three of these works is indisputable and has been discussed in some depth already by Martin S. James.[14] Therefore one need only to emphasize here those aspects which differentiate Mondrian's approach from that contained in his presumed models and to elucidate where, if at all, Theosophic thinking performed an innovative function.

Such an influence, of course, is not very likely to have affected the *Passion Flower*, which was produced at least several years before the artist officially registered as a Theosophist. Moreover, the title alludes to the inherited Christian symbolism of a particular flower, since its three stamens and its tendrils were popularly equated with respectively the three nails and the crown of thorns from the Crucifixion.[15] At the same time, Mondrian's female may be thought to suffer as much from the torments of her own earthly passions as from contemplation of her Savior's sacrifice on the cross. Hence, the artist's close friend and the watercolor's former owner, the late Mr. A.P. van den Briel, preferred to stress the mundane circumstances in which the work had its origin.[16] Having heard that his model might be infected with venereal disease and possessing some dubious medical advice that one symptom of such illness was a greenish discoloration of the throat, Mondrian incorporated this information in the pose of the upturned head with its suggestion of "longing for release" and the somber, earthen tonalities of his palette. Apart from providing an early instance of Mondrian's frequently recorded mistrust of the hue green as "too close to nature," this story illustrates the still basically ethical or Christian content with which his iconography was preoccupied. The *Passion Flower* thus remains closer in conception to the example of Jan Toorop and other Dutch *fin-de-siècle* Symbolists than to the teachings of an esoteric Theosophy, which was little concerned with specific instances of terrestrial woe.

In a brief biographical sketch from 1907, Mondrian stated that in 1901 he had ceased doing "portraiture" in order to concentrate upon landscape painting.[17] But with the *Devotion* of 1908, he

once again employed figural content in a manner which attracted immediate critical attention. After seeing this painting when exhibited in January 1909, Querido, believing himself to be reiterating the painter's own analysis, described it as representing a praying girl.[18] Yet Mondrian reacted immediately and insistently against this interpretation, stating in effect that the girl was not viewed in an act of prayer but as representing the concept "devotion." The painter also explained his use of an unnatural red color as a means by which the viewer's attention was distracted from thoughts about the girl's material reality. In the same account he admitted his wish to obtain "knowledge of the occult spheres" and claimed that progress in this pursuit was accompanied by the attainment of greater clarity in his art, which nonetheless still was produced "in the normal way." While one may in fact understand the basis of Querido's traditional manner of interpretation, it is even more important to investigate the additional levels of meaning which were intended by Mondrian.

The most relevant explanation of the artist's own content can be found in the writings of Rudolf Steiner. Among the handful of books which Mondrian kept until death was a collection of lectures, paraphrased in Dutch, which the then German Secretary of the Theosophical Society had given in various Dutch cities during March 1908.[19] A number of passages in these *Dutch Lectures* were pencil marked by Mondrian. In one such passage Steiner explains how certain occult ". . . impulses, which time and again must work themselves into the Etheric Body, can be awakened by devotional religious feelings, *true* art, music."[20] In numerous related texts,[21] Steiner elaborates on how an esoteric capacity for devotion can be developed in the Theosophic initiate through recourse to meditative exercises. For the attainment of this goal the "positive mystical" observation of various forms of mineral, animal and, especially, plant life is particularly recommended and is described in great detail. In reference to Mondrian's paintings, it is noteworthy that Steiner mentions young girls as sometimes gifted with natural feelings of devotion and describes how the mystical experience of devotional feelings is to be sought with eyes open and in full mental alertness, rather than by turning away from the world of nature as had earlier practitioners of "negative mysticism."

Nonetheless, this devotional contemplation of natural objects is accompanied, whenever fruitful, by clairvoyant visions of the

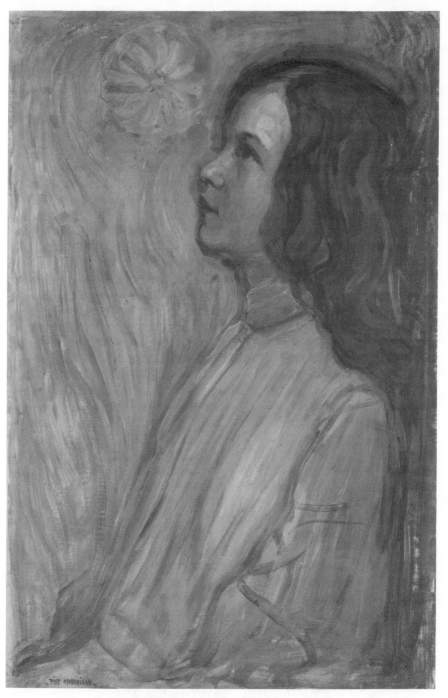

2 Piet Mondrian, Devotion, *1908. Oil on canvas,*
37 x 23⅞". Haags Gemeentemuseum, The Hague

"higher spheres" in which color manifestations not visible to the normal, untrained eye play a fundamental role. Such manifestations radiate from the objects viewed, constituting their "aural shells," and represent the supramundane "astral" or "etheric" levels of being. Although the exact meaning of specific hues and tints sometimes is disputed within Theosophic circles (and single hues may assume variant shades of both honorific and derogatory connotation), Steiner definitely associates the appearance of blue with the experience of devotion, and this sometimes in combination with certain forms of red which can be interpreted to signify deeply felt affection. It is important to note that these color auras are not to be thought of as symbols for something else, but as indications of spiritual states of being. This attitude in itself would explain why Mondrian objected to the conventional interpretation of his painting as a symbolic action.

Unfortunately, neither Mondrian's own references to *Devotion* nor any single Theosophic text adequately explain the exact relation of Mondrian as creative artist to the clairvoyant experience of devotion. One may wonder, for example, whether the artist either was attempting to reproduce in paint some form of remembered vision, had actually combined his working procedure with devotional meditative exercises, or otherwise sought through his activity as painter to gain a knowledge of the higher spheres. The question, as intriguing as it is, for lack of further evidence, is unanswerable. For, whatever attitude one maintains in reference to supra- or extra-sensory perception and spiritualism in general, only a first-hand account by Mondrian could provide the basis for serious discussion of this complex issue. It can be stated, however, that by 1908 when *Devotion* was executed Mondrian was profoundly concerned with the possibility of clairvoyant experience in relation both to his creative and to his personal life.

A second aspect of the *Devotion* which can be illuminated by reference to the writings of Steiner is the significance of the flower blossom included in the upper left. In fact, this blossom was meant to serve an iconographic function which may be extended equally to other major flower studies from the same period. These include several treatments of the sunflower theme and numerous depictions of chrysanthemums, particularly the well known *Dying Chrysanthemum* of 1908 (Gemeentemuseum, The Hague). Steiner's analysis of plant life depends heavily upon his

esoteric reading of the scientific theories of Goethe and comprises in essence a Theosophic reinterpretation of German Romantic nature philosophy.[22] Like human and animal bodies, plant forms, especially flower blossoms, radiate "auras" of color which can be perceived by all properly trained clairvoyants.[23] As part of the function which they serve in devotional exercises, flowers may be said to re-capitulate in microcosm the eternal processes of birth, life, reproduction, decay, material death, and regeneration which Theosophy sees as the ruling principle of the universe, and which is summed up in the term "evolution." For Steiner in particular, the flower illustrates this process with unmistakable clarity. Like the human or animal eye, the flower blossom stands as proof of the primal efficacy of light as a cosmic force. In reference to the evolution of animal organisms, Steiner considers it unthinkable that the material

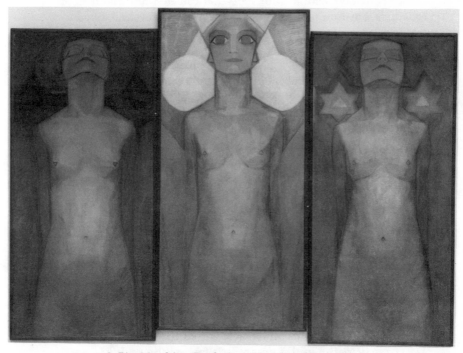

3 Piet Mondrian, Evolution, *1910-11. Oil on canvas, triptych. Two panels, each 70 1/16 x 33 7/16 in. One panel 72 1/16 x 34½ in. Haags Gemeente-museum, The Hague*

organ of the eye would have developed except for the omnipotence of light, which, as the purest manifestation of spirit, called the physical eye into being.[24] Steiner's favorite metaphor for spiritual awakening is the man born blind who suddenly is enabled to see. As does physical vision, so does the flower depend upon light for its very existence, not to mention the beauty of its color, which phenomenon is treated wholly as a function of light. The power of light is said to be directly operative in every phase of the life cycle of the plant, since from germination of the seed to withered decay the life of plants responds to the warmth and rays of the sun and to the "etheric" and "astral" principles which govern all organic growth. What is the significance of these theories for Mondrian's flower pieces?

First, the blossoms both of the chrysanthemum in *Devotion* and of numerous independent flower studies from a comparable date are embellished with a color halo that can be interpreted as an artistic re-creation of the flower's etheric or astral shell. Even as the material body of the plant decays, this astral phenomenon survives, which concept would seem to explain the vibrant ebb and flow of color surrounding the many dying blossoms produced by Mondrian during the years circa 1908-09. Second, Steiner insists that the individual species of a flower is of little importance, since only the cosmic process in which *all* flowers participate provides a sound guide to esoteric knowledge. Here, too, the intellectual bias is anti-Symbolist, and associations of ethical virtues with specific flowers are notably absent from Steiner's analysis, except as historical illustration. By analogy, one should not casually associate the flowers chosen by Mondrian for his paintings with the various accretions of meaning inherited from Symbolist art. It is in this respect that the *Devotion*, iconographically interpreted, is further removed from the *Passion Flower* in which such associations are paramount.

Third, even the contrast between healthy, upright flowers and withering alternative forms so graphically illustrated within Mondrian's oeuvre by the *Upright Sunflower* of circa 1908 (Private Collection Hengelo, The Netherlands) and the *Dying Sunflower* of 1908 (Collection Mr. & Mrs. David Lloyd Kreeger, Washington, D.C.), participated in the *fin-de-siècle* fascination with life-death polarity, chiefly thanks to the power of tradition. In keeping with the basically Utopian and transcendental optimism of the whole

Theosophic movement, Steiner, for example, encourages the Theosophic initiate to discover in a dying blossom the expectation of regeneration and in the healthy flower the inevitability of decay. In this respect Steiner's esoteric pedagogies reflect the adoption by Theosophy of oriental religious doctrines regarding transmigration of the soul. It is therefore very likely not by accident that in 1909 Mondrian exhibited a flower piece, probably the *Dying Chrysanthemum*, under the title "Metamorphosis."[25] Though usually described not only as indebted to Art Nouveau style, which it is, but also as containing a Symbolist allusion to death, this work was explained by Mondrian himself, when writing in 1915,[26] as limited merely by an excess of "human emotion." This limitation, moreover, was contrasted to a somewhat later flower painting, which was very likely the *Arum Lily* of 1909-10 (Gemeentemuseum, The Hague) and which in its frontal, upright positioning, promised more of "the immobile." In all those works, Mondrian clearly was concerned more with thoughts of perpetual life than with premonitions of death. Of course, flowers, like other subjects based on nature, gradually would disappear behind the veil of Mondrian's adoption of the Cubist style during the winter 1911-12. In this historical context, the adoption of Cubist style involved for Mondrian the abandonment of all residual attachment to particular instances of natural beauty. Thereafter, only in the stylistically retardataire, yet exquisitely subtle flower pieces with which Mondrian, especially during the early 1920s, ensured his material survival can one believe that he continued to practice a form of artistic "devotion" which related intimately to his Theosophic preoccupations of circa 1908.

If the *Devotion* comprised an attempt by Mondrian to give artistic expression to an esoteric, clairvoyant experience of "astral" colors appropriate to the preliminary stages of Theosophic initiation, then the *Evolution* triptych transports us to more exalted realms of occult knowledge. Above all, it is the title of this composition which betrays the "higher spheres" to which its content relates. Evolution is no less than the basic tenet in the cosmological system predicated by Mme Blavatsky and, as such, replaces the Christian story of Creation as an explanation for how the world functions. This cosmology is analogous to Hindu and other mythologies which stress a perpetual cosmic cycle of creation, death, and regeneration. It also has much in common with the Darwinian

scientific theory of evolution. Darwin's only essential mistake, in Blavatsky's opinion, was to substitute matter for spirit as the motivating force in the universe. In her own world view, matter, though constituting a necessary vehicle through which the world of spirit was to be approached, clearly stands second in importance to the latter phenomenon, from which, to be sure, matter is said to have been born. The resulting concept of spirit as the active and matter as the passive force in the world is, of course, deeply rooted in a wide range of mystical tradition reaching far back into the past, as the writings of Blavatsky profusely attempt to illustrate.[27] More to the point, this conceptual polarity was universally accepted as a cardinal doctrine throughout the Theosophic and other intellectually related late nineteenth century spiritualist movements and also is present within the subsequent Anthroposophy of Steiner and the *Christosophie* of Schoenmaekers. The same polar conception pervades the art theoretical writings of Mondrian, beginning with his letter to Querido of 1909, and is epitomized in his *Sketchbooks* of circa 1912-14. In the latter text he specifically alludes to the Theosophic Doctrine of Evolution as a determining factor in the history of art.[28] In short, Mondrian could not have chosen as the theme of his monumental triptych a doctrine which was more central to Theosophic teaching than this.

In terms of compositional format the *Evolution*, like the *Devotion*, derives from Symbolist precedent. Jan Toorop's *Three Brides* (Fig. 4) of 1893, a work doubtless known to Mondrian, comprised an example of an hieratically tripartite composition based upon three frontally posed female figures which was inherently suggestive of sacerdotal tradition.[29]

Nonetheless, one should not be satisfied to interpret Mondrian's triptych merely as a late example of Dutch Symbolism. Toorop's *Three Brides*, like comparably symbolic figures in the art of Edvard Munch which are sometimes also said to have influenced Mondrian,[30] constitute ethical and psychological archetypes which relate essentially to the mundane world of human joy and woe. The physically undifferentiated figures of the *Evolution*, in contrast, are expressively devoid of human emotion and appear to participate in a transcendental ambiance which exists beyond any concrete earthly setting. Similarly, the crimson flower forms which accompany the figure at left defy identification with any particular species and hence with any well-established Symbolist flower

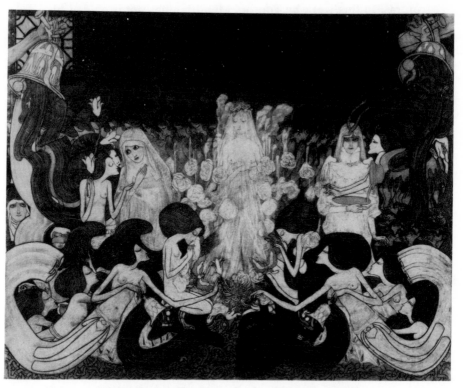

4 *Jan Toroop,* The Three Brides, *1892/93. Pencil
and black crayon on paper, 30 11/16 x 39 9/16".
Rijksmuseum Kröller-Müller, Otterlo, Netherlands*

iconography. To the extent that a reference to another flower
representation can be supposed, this image, because of its similar
color and triangulated petal shapes, relates to the artist's own
Amaryllis, a watercolor quite close in date and style of execution to
the *Evolution*.[31] The six petals of the amaryllis, if viewed frontally, can
be thought to form a six-pointed star, which is the insignia of
the Theosophic movement and is to be found with the figure at right
in the *Evolution*. The positive meaning for Theosophy and
Mondrian's triptych of these geometrizing elements will be dis-
cussed in greater detail below. Here one merely needs to note
their negative function of obviating the kind of orthodox Symbolist
floral associations which inform the content of the *Three Brides*.[32] In

175

contrast to this work by Toorop, Mondrian has not provided his
figures with attributes which are explicable exclusively in reference
to any established iconographic tradition, Christian or otherwise.
Thus, while his imagery may bear a formal resemblance to his
own earlier *Passion Flower*, the intended content is substantially dif-
ferent. On one level, his three starkly upright nudes further expand
the idea of clairvoyant visionary experience found in *Devotion*.
Theosophic writings couple supersensory perception with either
open or closed eyes according to specified conditions, and the blue
and yellow colors used by Mondrian in *Evolution* can be in-
terpreted as suggesting "astral" shells or radiations of the figures.[33]
However, the visionary spheres in which these figures participate
clearly relate to a stage of Theosophic initiation considerably
more advanced than that appropriate for the cultivation of devo-
tional feelings. Indeed, as a consequence of the exalted level of
spiritual activity in which Theosophy conceives "evolution" to have
its origin, the implied setting of the triptych may be described
not only as supra-mundane, but as transcending the limits of
particular time and space.

It is in reference to this occult metaphysical sphere that the
three figures of Mondrian's triptych and their accompanying
emblems must be analyzed. As the similar, somewhat androgynous
physical appearance of the figures implies, one should view them
not merely as personifications of three separate ideas, but as
the same person viewed in three complementary aspects. Indeed,
another Dutch artist who was a Theosophist wrote in 1906 that "For
Theosophy man himself is a living temple of God,"[34] or, in other
words, represents within himself a microcosmic instance of the
universal principles which govern his existence. Thus, Mme
Blavatsky, in paraphrasing a text from the mystic Paracelsus,
explains:

Three spirits live and actuate man, . . . three worlds pour their beams upon
him; but all three only as the image and echo of one and the same all-
constructing and uniting principle of production. The first is the spirit of the
elements (terrestrial body and vital force in its brute condition); the
second, the spirit of the stars (sidereal or astral body—the soul); the third is
the *Divine* spirit. . . .[35]

Of course, this statement permits an identification of the three
figures as generalized personifications, since if read in the order left,
right, and center, we have the classic mystic progression from matter

through soul to spirit. To this extent the *Evolution* still reflects Symbolist thinking. Yet Blavatsky's writings also contain a more profoundly syncratic idea which is as relevant for Mondrian's background as for his figures. This idea is inclusively defined in another statement by Mme Blavatsky, which comprises one of her most essential pronouncements upon the nature of man:

Man is a little world—a microcosm inside the great universe. Like a foetus, he is suspended, by all his *three* spirits, in the matrix of the macrocosmos; and while his terrestrial body is in sympathy with its parent earth, his astral soul lives in unison with the sidereal *anima mundi*. He is in it, as it is in him, for the world pervading element fills all space, and is space itself, only shoreless and infinite. As to his third spirit, the divine, what is it but an infinitesimal ray, one of the countless radiations proceeding directly from the Highest Cause—the Spiritual light of the world. This is the trinity of organic and inorganic nature—the spiritual and the physical, which are three in one. . . .[36]

According to this principle, not merely the figure at left but all three females participate as physical beings in the world of matter, while the astral colors in which each is shrouded suggest the "sidereal *anima mundi*," which as "the world-pervading element fills all space, and *is* space itself." Finally, at least the center figure may be considered representative of mankind's "third spirit, the divine," conceived as "one of the countless radiations proceeding directly from the Highest Cause—the Spiritual light of the world." As such, these figures embody what Blavatsky described as "the same all-constructing and uniting principle of production," which is no more than to say the idea of Evolution as defined by Theosophy.

It is in this same exalted metaphysical context that one must analyze the various geometric figures, particularly triangles, which occur within the composition. These Mondrian attached to the navels and breast nipples of the figures (most probably through Theosophic identification of such body parts with the *anima mundi*), but also to the "flower" images which are placed with heraldic symmetry near the figures' heads. Here, too, a progression from matter to spirit is operative. At left the triangles, including that at the center of the flower image, point downward, at right overlapping downward and upward pointing triangles form a six-pointed star, the emblem of the Theosophical Society;[37] and at center upward pointing triangles are inscribed in circles. As any seriously interested student of Theosophy would know, the

respectively downward and upward pointing triangles basically indicate the opposing principles of matter and spirit which sometimes interpenetrate and achieve balance in the "sacred hexagram."
This abstract imagery thus derives from those same metaphysical principles with which Blavatsky described the nature of man. This philosophy is perhaps best described as a kind of "tripartite dualism" since even the triangle itself participates in a related dualist principle. As Blavatsky writes:

The triangle played a prominent part in the religious symbolism of every great nation; for everywhere it represented the three great principles—spirit, force and matter; or the active (male), passive (female), and the dual or correlative principle which partakes of both and binds the two together.[38]

This latter "dual or correlative principle," incidentally, frequently is identified within Theosophic writings as androgynous, an idea which may help to explain the expressively masculine aspect of Mondrian's ostensibly female figures. In any case, in her exegesis of the Theosophic hexagram, Blavatsky identifies the significance of triangles with a basically dualist philosophy:

In the great geometrical figure which has the double figure in it [*i.e. a double hexagram, as that accompanying the figure at right in the Evolution*] the central circle represents the world within the universe. . . . The triangle with its apex pointing upward indicates the male principle, downward the female; the two typifying, at the same time, spirit and matter.[39]

In reference to the *Evolution*, this text explains not only the presence and meaning of the Theosophic hexagram, but also why Mondrian chose to inscribe within circles the upward pointing triangles which occur with the figure at center. For Blavatsky the circle, too, comprises a profoundly meaningful spiritual essence. Its use by Mondrian thus elevates the center figure to a mystical status identified with the "worlds within the universe," or with the force of cosmic creation and evolution itself. In fact, both her triangular emblems of spirit and the head of this center figure appear embedded in radiating auras of white and yellow light in striking similarity to the diagrams used by Blavatsky to explain the first principles of the cosmos.[40]

However, it is not only as a refined distillation of Symbolist and Theosophic thinking that the *Evolution* was important in the career of Mondrian. The ideas it embodied proved of equal importance to his future stylistic development, especially during the

Cubist and immediately post-Cubist periods of circa 1912-17.
During these years, as mentioned above, virtually all Mondrian's
major compositions employed some form of underlying or overt
grid of vertical and horizontal lines. Frequently the dispersion
of linear elements was contained within a circular or oval perimeter,
which nonetheless allowed for a varied play of curvi- and rectilinear
forms. In fact, for Blavatsky, who introduced into Theosophic
literature the alleged quotation from Plato, "God geometrizes,"
all basic geometric shapes bear witness to the same doctrines which
she discusses in reference to the triangle. The triangle, with its
three-in-one character, comprises for her at the same time the
"mystic four," which concept also is "summarized in the unity of one
supreme Deity." In reference to the Greek cross, which she calls
the Egyptian cross and places at the very center of her hexagram and
inscribes within a circle,[41] this too embodies the same unitarian,
dual, tripartite, and quadripartite concepts elsewhere associated
with the triangle. As well as speaking of "the celestial perpendicular
and the terrestrial horizontal base line," she observes that "the
vertical line being the male principle, and the horizontal being the
female, out of the union of the two at the intersection is formed
the *cross*." Far transcending in significance its historical occurrence
within any particular religion, the cross, like other geometric
figures, expresses a single mystical concept of life and immortality.
Blavatsky summarizes this concept conveniently in another and our
final quotation:

The philosophical cross, the two lines running in opposite directions, the
horizontal and the perpendicular, the height and the breadth, which the
geometrizing Deity divides at the intersecting point, and which forms the
magical as well as the scientific quaternary, when it is inscribed within
the perfect square, is the basis of the occultist. Within its mystical precinct
lies the master-key which opens the door of every science, physical as well
as spiritual. It symbolizes our human existence, for the circle of life cir-
cumscribes the four points of the cross, which represent in succession birth,
life, death, and IMMORTALITY. Everything in this world is a trinity
completed by the quaternary, and every element is divisible on this same
principle.[42]

Such was the weight of philosophical meaning borne by the mystical
cross of Theosophy and by the other geometric forms which relate
to it. Considering the importance of simple, two-dimensional
geometric forms to Theosophic teaching, it is not surprising that

shortly after completing the *Evolution* triptych, Mondrian intro-
duced and increasingly emphasized a free play of often crossing
vertical and horizontal lines as the basis for his evolving com-
positional experiments.[43] Indeed, since "the four points of the cross
. . . represent in succession birth, life, death, and IMMORTALITY,"
the cross, too, may be thought emblematic of those cosmic processes
which Theosophy sums up in the term "evolution."[44]

In similar fashion, although concomitantly inspired by models
in the work of Braque and Picasso, Mondrian's adoption in 1913 of a
well defined oval compositional border also very likely carried
with it an iconographic meaning derived from Theosophy. The oval
is viewed within Theosophy as a variant form of the circle and was
identified by Mme Blavatsky and her followers[45] with the "world
egg" of Hindu mythology, which concept, therefore, also relates
directly to the theme of cosmic birth and evolution. Finally, even
Mondrian's use beginning circa 1918 of the lozenge compositional
format probably owes some carried-over debt to an esoteric in-
terpretation of geometric form. His diamond-shaped canvases in
fact comprise perfect squares turned to stand upon a corner
point, which shape, as such, can be thought to circumscribe an
imaginary upright Greek cross. At the same time, this format also
may be read as an alternative form of the Theosophic double
triangle, which is to say, as two triangles joined at a horizontal line
bisecting the lozenge.[46] These are only a few salient possibilities,
limited to the plastic or *beeldend* element "line," in which the
artist's use of geometric elements of expression can be associated
with the cosmological theories of Mme Blavatsky. In each instance,
the Theosophic concept which justifies in iconographic terms the
diagrammatic shapes found in the emerging abstract art of Mondrian
relates to the movement's cardinal Doctrine of Evolution. It is
thus not by chance that the artist chose this doctrine to com-
memorate in his triptych of 1911, nor that it is cited specifically,
indeed provides the underlying theme, in the two annotated sketch-
books which he produced during the Cubist years circa 1912-14.

The early intrusion of Theosophic beliefs in Mondrian's art was
of profound meaning to his development of a fully abstract style.
Above all, his precipitate adoption of Cubist style during the winter
of 1911-12 and his immediate enthusiasm for the writings of
Schoenmaekers may now be interpreted to have resulted from his
previous deep involvement with Theosophic teachings. Not that this

fact diminishes the importance of either the Cubist or Schoen-
maekers' influence upon the art of Mondrian. The writings of
Blavatsky and Steiner by no means constituted an exclusive source
of inspiration during his periods of transition to abstract art.
Indeed, throughout the years 1908-17, virtually every major paint-
ing within his numerically restricted oeuvre deserves special
attention for the idiosyncratic fusion of natural subject, esoteric
iconography and employment of style which it contains. While
typically unorthodox in approach Mondrian's successive use of the
Art Nouveau, Pointillist and Cubist styles was invariably inventive
and aesthetically satisfying. Consequently, whereas many viewers
of the present, unprecedentedly complete showing of his mature
work will have little interest in Mondrian's Theosophic iconog-
raphy, they will respond readily to the extraordinary quality
of his handling of color, brushwork and compositional structure.
In this respect, the *Evolution* and such related works as the *Church
at Domburg* from 1910-early 1911 (Gemeentemuseum, The Hague)
and *The Red Mill* of circa 1911 (Gemeentemuseum, The Hague)[47]
may appeal to a present-day audience chiefly for the optical
phenomena of intense color luminosity and irradiation which they
contain and which so clearly anticipate contemporary artistic
trends. Similarly, no one who seriously studies Mondrian's abstract
work in the original will confuse his paintings—enlivened as they
are by subtle tensions of line, color, implied movement and
generated space—with the theoretical preoccupations which
inform his iconographic content. Nonetheless, it was with the aid of
such preoccupations that Mondrian achieved his artistic results.
If for no other reason than this, one may feel grateful for the con-
tribution made by Theosophic doctrine to the art of one of the
major painters of the present century.

Notes

1. I.e. *De Stijl*, I-II, 2 Oct. 1917-Oct. 1918.

2. See M. Seuphor, *Piet Mondrian, Life and Work*, New York, Harry N.
Abrams, Inc., 1956.

3. See H.L.C. Jaffé, *De Stijl 1917-31: Dutch Contribution to Modern Art*,
London, Alec Tiranti, 1956, pp. 53-62. See also L.J.F. Wijsenbeek,

Robert P. Welsh

"Introduction," *Piet Mondrian 1872-1944*, New York, The Solomon R. Guggenheim Museum, 1971.

4. Translated in *Sketchbooks*, pp. 9-10.

5. M.D. Henkel, "St. Lucas-Ausstellung," *Kunstchroniek*, June 6, 1910, and "Ausstellung der Kubisten in dem 'Moderne Kunstkring' zu Amsterdam," *Kunstchroniek*, Dec. 22, 1911.

6. See "Documentatie 1," letters 7, 8, 10.

7. *Sketchbooks*, p. 13.

8. "Documentatie 1," esp. letter 5.

9. Published in Bussum, The Netherlands, by C.A.J. van Dishoek.

10. See R.P. Welsh, "Mondrian," *Revue de l'Art*, no. 5, 1969, pp. 99-100.

11. The original owner, Mr. A.P. van den Briel, repeatedly advised the present writer that this watercolor was in his possession by 1904 at the latest and, according to his memory, had been executed several years earlier.

12. Exhibited Amsterdam, January 1909, at the Stedelijk Museum, no known catalogue.

13. Exhibited Amsterdam, Oct.-Nov. 1911, *Moderne Kunstring*, no. 97.

14. In "Mondrian and the Dutch Symbolists," *The Art Journal*, vol. XXIII, no. 2, winter 1963-64, pp. 103-11.

15. *Ibid.*, pp. 105-06.

16. In conversation with the present writer.

17. See F.M. Lurasco, ed., *Onze Moderne Meesters*, Amsterdam, C.L.G. Veldt, 1907, under "Piet Mondriaan," n.p.

18. *Sketchbooks*, p. 10.

19. Known in the literature on Mondrian from the title of the first recorded lecture, "Mystiek en Esoterik," since the title page of the artist's copy is missing. Hereafter: *Dutch Lectures*.

20. *Ibid.*, p. 32. Though unacknowledged, Steiner's concept of "devotion" owes much to the *Thought Forms* of A. Besant and C.W. Leadbeater (trans. in Dutch, 1905) and, through these writers, to Mme H.P. Blavatsky, the founding spirit of modern Theosophy. The source of Mondrian's interpretation is therefore not necessarily limited to the writings of Steiner.

21. Esp. in the popular introductory texts, *Theosophy* and *Knowledge of the Higher Worlds*, which Mondrian could have known in the German original versions (Dutch trans. 1909 and 1911 respectively).

22. Steiner had begun his career by editing the scientific writings of Goethe.

23. Here, too, Steiner was reiterating standard Theosophic doctrine. For the general teachings of Theosophy and their relation to the development

of abstract art, see Sixten Ringbom, "Art in the 'Epoch of the Great Spiritual,' " *Journal of the Warburg and Courtauld Institutes*, XXIX, 1966, pp. 386-418.

24. *Dutch Lectures*, p. 2. The following discussion of Steiner's theories is based on statements found in this same text.

25. *Sketchbooks*, p. 9 and note 10.

26. I.e. letter to Mrs. Aug de Meester-Obreen, "Documentatie 2," p. 267.

27. The ideas relevant to the present discussion were proliferated in numerous texts, lectures and discussions undertaken by Mme Blavatsky and her followers. However, for the sake of convenience and because its role as a source for other quotations often has been overlooked, the monumental two volume *Isis Unveiled* of 1877 (New York: J.W. Bouton) and esp. its discussion of two cosmological diagrams (II, pp. 266-71) will provide the exclusive text upon which our discussion is based. In the original Dutch translation, vol. I is dated to 1911 and vol. II to 1914, but, in fact, both vols. were available through serialized installments (published resp. 1908-10 and 1911-14).

28. *Sketchbooks*, p. 64.

29. Toorop had anticipated essential features of the *Evolution* in a minor crayon drawing of circa 1893, the *Two Sylphs Ringing Bells* (Rijksmuseum, Amsterdam).

30. E.g. James, *op. cit.*, pp. 106-7. However, the present writer has found virtually no evidence that the work of Munch was either exhibited in The Netherlands or illustrated in Dutch art journals by the date that the *Passion Flower* or even the *Evolution* was executed. In any case, such an influence would have been a formal one at most.

31. Either this or a second version (now priv. coll., France) was exhibited Amsterdam, April-June 1910, at St. Lucas, no. 490.

32. E.g. the virginal symbols of lilies at left and rose garden at center.

33. In *De Stijl*, I: 3, p. 30, note 3 (1968 edition, p. 46) Mondrian rejects the "imitation of astral colours" as incompatible with his approach to painting which he then described as "abstract-real." See Miss Charmion von Wiegand's remarks on this subject in *Piet Mondrian 1872-1944*, New York, The Solomon R. Guggenheim Museum, 1971, p. 81.

34. I.e. the Dutch architect and Theosophist, J.L.M. Lauweriks, writing on "Rembrandt and Theosophy" for *Theosophia*, XV, July 1906, p. 136.

35. *Isis Unveiled*, vol. 1, p. 212. James, *op. cit.*, p. 107, was the first to discover in a similar quotation from Ed. Schurés, *Les Grand Initiés* (Dutch trans. 1907), an essential iconographic aspect of Mondrian's triptych. However, apart from documenting the availability of Mme Blavatsky's ideas in this popularized secondary source (see note 27 above), the quotation does not

Robert P. Welsh

prove equally applicable to the *Three Brides* according to the strict form of James' analysis.

36. *Ibid.*

37. As found, for example, on Mondrian's membership certificate preserved by the artist's heir, Mr. Harry Holtzman.

38. *Isis Unveiled,* vol. II, p. 269 (i.e. in reference to the "Chaldean" diagram which follows p. 264).

39. *Ibid.,* p. 270, in reference to the Hindu diagram placed adjacent to the "Chaldean."

40. A variant use of this same abstract iconography can be found in a paradigmatic example of Dutch Symbolist art, a woodcut from 1894 known as *The Marriage* by the architect and Theosophist, K.P.C. de Bazel (Rijksprentkabinett, University of Leiden). No. 12 in *De Houtsneden Van K.P.C. de Bazel,* Amsterdam. S.L. van Looy, 1925, whose editor, J.L.M. Lauweriks (see note 34 above) in his introduction refers to de Bazel's wish with his woodcuts "to make visible the supersensory world."

41. I.e. in her "Hindu" and "Chaldean" diagrams, *Isis Unveiled* (see notes 38 and 39), to which the shorter quotations given in the present text also allude.

42. *Isis Unveiled,* I, p. 508.

43. See note 10.

44. Mondrian's drawing from 1913, the *Circular Composition: Church Facade* (Sidney Janis Gallery, New York) can be interpreted iconographically as a tribute to all the abstract geometric configurations, the meaning of which is summarized in the philosophical cross of Blavatsky.

45. I.e. including by the Theosophist-Christosoph Dr. Schoenmaekers, beginning with his *Mensch en Natuur* of 1913, which may be considered a personal interpretation of standard Theosophic doctrine.

46. This alternate usage is found in the hexagram and body emblems of the figure at right in *Evolution,* and may already have been incorporated into the *Arum Lily* of the previous year.

47. These works also contain triangulated design elements which relate to the iconographic content found in *Evolution.*

9
Kandinsky's
"Woman in Moscow"

KATHLEEN J. REGIER

By 1912, Wassily Kandinsky had extracted the subliminal from
representational elements. In many of his compositions, form and
space had become dematerialized, and the expressive power
of diaphanous color ruled paramount. It is also interesting to note
that he still continued to complete "representational" images even
though he had established that various intensities of feeling could
be achieved in non-objective works. When considered in con-
junction with his dynamic explosions of color, the more representa-
tional compositions take on an immediate arresting quality.
One such image is his *Woman in Moscow*, 1912. The importance of
the subject to Kandinsky is demonstrated by the fact that he com-
pleted three versions of the image, a watercolor, a glass, and an
oil, all within the same year.[1]

This paper has several purposes, all of which center around
Kandinsky's well established knowledge of and involvement with
mysticism. First, the mystical symbolism of a few heretofore
unnoticed details in the *Woman in Moscow* will be established.
Second, the central theme of the image will be traced directly to
Kandinsky's book *Concerning the Spiritual in Art*, which was published
approximately five months prior to the completion of the oil
version. Lastly, the work should be interpreted as a tribute to a
woman whose writings he ardently admired, Mme Blavatsky.

The large oil version contains a woman with reddish hair stand-
ing in front of a relatively empty street scene. She is well dressed and
appears before us in a pose reminiscent of the so-called Minoan
snake goddesses. Her right hand is around a small white dog
on a table, and she holds a red rose in her left hand. In the loosely
triangular shape which frames this woman, we find a Russian

1 *Wassily Kandinsky,* Woman in Moscow, *1912.*
42⅞ x 42⅞". Oil on canvas. Städtische Galerie
im Lenbachhaus, Munich

peasant appearing to be almost standing on the table, a running dog, a horse-drawn carriage, three street lamps "framing" her head, and a distinct abstract shape on each side of her: a rose and red circular form at the right and a blue triangular shape at the left. A large black shape covers part of the sun.[2] Churches, walls, a watch tower with a guard, and threatening skies appear in the background.

Although commentary on the *Woman in Moscow* has not been abundant, several writers have mentioned the mystical nature of the painting. Will Grohmann wrote that the woman is "surrounded by a halo or Mandala, a magic circle," and the nebulous form at the lower right "must surely be connected with Kandinsky's theosophic ideas, with the ethereal creative forces, perhaps also with Annie Besant's 'thought forms.' " He concluded that the image was "a psychoanalytic or parapsychological painting, quite unlike Kandinsky's other works."[3] Johannes Eichner noted that both Kandinsky and Gabriele Munter were silent about the motives for the picture, and concluded that the meaning of the painting was a riddle.[4] Sixten Ringbom established that the mystical aura which surrounds the woman is an etheric double derived from Annie Besant's and C.W. Leadbeater's *Thought-Forms,* and he linked the looming black shape with negative forces and disturbing childhood experiences. He set forth the following as the painting's central theme: "Whatever the exact relationship between the black spot and the figural motifs of *Dame in Moskau,* the struggle between blackness and light, hate and love, remains the central theme of the image."[5]

The most extensive and persuasive interpretation of this work was written by Fred Gettings, who concluded that the painting proves "to be a philosophical reflection on the relationship which humanity holds to the visible and invisible worlds: it is a sermon on the occult nature of man." He convincingly established that solar forces are absorbed by the changing etheric double and distributed throughout the body along a series of wheeling centres. These centres are called *chakras* and are represented in the image as the intertwined pattern on the dress. He summed up the essential qualities of the work in the following way:

Kandinsky's picture deals not only with the past and present, but also with the future. It indicates that man is not merely composed of a physical body, rooted in the fourfold elemental kingdom, but that he stands astride the vegetable and animal kingdoms, toward which he holds responsibility,

through his higher mentality. In terms of the future, the imagery is so arranged as to point to man's cosmic function as a meeting point between the two conflicting polarities of the spiritual world which must be reconciled by man [the swirling red spiral, love and affection, and the mass of black, malice].[6]

The *Woman in Moscow* is a uniquely representational work by Kandinsky when considered in conjunction with his accomplishments in the direction of non-objective paintings. By 1912 he had moved beyond his "melodic" category of painting, which he described as being "regulated according to an obvious and simple form," and had developed his "symphonic" compositions. In this latter category, he had set forth three sources of inspiration: an impression of nature (resulting in works he called "an Impression"), a largely unconscious spontaneous expression of inner character ("Improvisation"), and those compositions which came about through a slowly formed inner feeling ("Composition"). Examples of these works include: *Impression: Pastoral*, 1911, *Improvisation 19*, 1911, and *Composition V*, 1911. All these works show a symbiosis between figures and nature and a distant world far removed from the realities of modern materialism.

The large oil version of *Woman in Moscow* measures 108.8 x 108.8 cm. Of immediate interest is the fact that it is perfectly square, while the other two versions are not. It is well known that Kandinsky had heard lectures by the founder of Anthroposophy, Rudolf Steiner, and had read Mme Blavatsky's writings on Theosophy. He may have even practiced spiritual meditation himself. In Mme Blavatsky's *Isis Unveiled*, we find that the square in esoteric terms is symbolic of "divine equity geometrically expressed. All the powers and great symphonies of physical and spiritual nature lie inscribed within the perfect square."[7] Furthermore, the woman is framed within a loosely defined triangular shape. In Mme Blavatsky's *Secret Doctrine*, we find that "a triangle and a quaternary (square), [represent] the symbol of Septenary man."[8] In esoteric beliefs, man is composed of a threefold spiritual nature and a fourfold material nature.

One further geometrical aspect of the painting should be considered for its mystical symbolism, the center point of the square which is located on the left arm. When a line is drawn across the woman from this point, we find that it intersects the upper pattern of her dress, more specifically, the area of the heart chakra (one of the centers of the body which receives solar forces and is involved

with spirituality and love). The heart chakra is also symbolic of the "mystic rose," the flower she is holding in her hand.

In the lower left of the painting, there is a blue spire or triangular shape which has not been discussed in previous literature on the painting. The swirling red shape at the lower right has been correctly identified as a thought-form of love and affection derived from Annie Besant and C.W. Leadbeater's *Thought-Forms*.[9] The blue shape can also be traced to the same text, where we find that a blue spire shape is associated with devotion. "The determination of the upward rush points to courage as well as conviction, while the sharpness of its outline shows the clarity of its creator's conception and the peerless purity of its color bears witness to his utter unselfishness."[10] Thus the woman is flanked by two thought-forms: the swirling red shape symbolizing love and affection and the blue spire symbolizing significantly "developing" spiritual devotion.

This *Woman in Moscow* is no ordinary woman, but rather someone who possesses an understanding of the vegetative world (the mystic rose) and the animal world (the dog). She stands before this scene as if she has the foreknowledge of what will happen to this city. Her mesmerizing eyes and etheric aura enforce her clairvoyant character. Her size with respect to the cosmopolitan background is completely out of scale, and yet no one is aware of her "presence."

The source for the destiny of the scene depicted can be found in Kandinsky's *Concerning the Spiritual in Art*. In part III, entitled "Spiritual Turning Point," he wrote of the spiritual triangle that "moves slowly forward and upward," and that the inhabitants of the largest of the lower divisions

have never managed to solve a problem for themselves and have always been pulled along in the cart of humanity by their self-sacrificing fellow men standing far above them; they know nothing of the effort of pulling, which they have never observed except from a great distance. For this reason, they imagine this effort to be very easy, believing in the infallible remedies and prescriptions of universal application.

Kandinsky then continued to tell us what happens as we systematically proceed upward into the higher compartments of the triangle, a passage which describes this Moscow scene:

And if we climb still higher, we see even greater confusion, as if in a great city, built solidly according to all architectural and mathematical rules, that

189

is suddenly shaken by a mighty force. The people who live in this division indeed live in such a spiritual city, where such forces are at work, and with which the spiritual architects and mathematicians have not reckoned.

Significantly, Kandinsky then described what this "spiritual city" will look like after a "mighty force" occurred, a city with "old, forgotten graves" and "ghosts," (depicted by the ghost-like shape before the wall in the upper left) and "spots on the sun":

Here, part of the massive wall lies fallen like a house of cards. There, an enormous tower that once reached to the sky, built of many slender, and yet 'immortal' spiritual pinnacles, lies in ruins. The old, forgotten cemetery quakes. Old, forgotten graves open, and forgotten ghosts rise up out of them. The sun, framed so artistically, shows spots and darkens, and what can replace it in the fight against darkness?

Of the people in the city, Kandinsky wrote that they are "deaf people, deafened by unfamiliar wisdom, who cannot hear the collapse, blind people also—for unfamiliar wisdom has blinded them, and they say, 'Our sun gets brighter and brighter—soon we shall see the last spots disappear.' " Kandinsky projected, however, that one day "they too will hear and see."

As we move still higher in Kandinsky's spiritual triangle,

we find that there is no more fear. The work done here boldly shakes the pinnacles that men have set up. Here, too, we find professional intellectuals who examine matter over and over again and finally cast doubt upon matter itself, which yesterday was the basis of everything, and upon which the whole universe was supported.

and,

the number of people who set no store by the method of materialistic science in matters concerning the "nonmaterial," or matter that is not perceptible to our senses, is at last increasing. And just as art seeks help from the primitives, these people turn for help to half-forgotten times, with their half-forgotten methods.

Kandinsky then mentioned Mme Blavatsky and the Theosophical Society, calling the latter "one of the most important spiritual movements," being synonymous with "eternal truth." "Mme Blavatsky was the first person, after a life of many years in India, to see a connection between these 'savages' and our 'civilization.' " Quoting from her book *The Key to Theosophy*, he added,

A new emissary of truth will find the human race prepared for his message through the Theosophical Society: there will exist a form of expression in

which he will be able to clothe the new truths, an organization which, in a certain sense, expects his coming, and exists for the purpose of clearing away material hindrances and difficulties from his path.

As we look at this *Woman in Moscow,* this unique lady with mystical powers, perhaps we are seeing Kandinsky's tribute to Mme Blavatsky. He wrote in a few passages prior to mentioning her that a "mighty force" might destroy cities, a force which, although unknown to the present inhabitants, will be seen and heard in the future. He momentarily deviated from his abstract style in order to create a representational work showing his belief in the importance of the occult. The significance he placed on this image carries the implication that later representational works also have mystical symbolism. The painting is more than a statement on "blackness and light, hate and love." It reinforces his belief in the expansion of mystical and transcendental ideas and announces a spiritual change. We are viewing a city in the process of mystical transition and development. The sky is darkening, the sun is being obliterated, there is a call for love and affection reflected in the swirling rose shape, and a reference to developing spiritual devotion symbolized by the blue spire. Significantly, Kandinsky also told us what this city will look like after this mystical change has occurred by quoting the last lines of Mme Blavatsky's *Key to Theosophy:* "... the twenty-first century would be heaven by comparison to what ... is now."[11]

Notes

1. I agree with Sixten Ringbom in regard to the suggested order of completion of these three works. The watercolor was probably completed first, being followed by the reversal of the image in the *Hinterglas* painting. The large oil became the definitive statement on the subject. The watercolor contains the most variation of detail when compared to the oil versions. The lower portion of the woman's dress has a more intricate patterning; the man walking in the street is seen from the side and carries a large item of food on his head; and the swirling form in the lower left contains an inverted heart shaped form. See Sixten Ringbom, *The Sounding Cosmos: A Study in the Spiritualism of Kandinsky and the Genesis of Abstract Art,* (Åbo, Finland: Åbo Akademi, 1970), vol. 38, no. 2, pp. 94-108; and "Kandinsky und das Okkulte," in Armin Zweite, ed., *Kandinsky und München: Begegnungnen und Wandlungen 1896-1914,* Munich, 1982, pp. 85-101.

2. For a discussion of this shape in another work from 1912, *Black Spot I*, see S. Ringbom, *The Sounding Cosmos*, op. cit., pp. 100-102, and Rose-Carol Washton Long, *Kandinsky: The Development of an Abstract Style* (Oxford: Clarendon Press, 1980), p. 132.

3. Will Grohmann, *Wassily Kandinsky: Life and Work* (New York: Abrams, 1958), p. 107.

4. Johannes Eichner, *Kandinsky und Gabriele Munter* (Munich: F. Bruckmann, 1957), p. 138.

5. S. Ringbom, *The Sounding Cosmos*, op. cit.

6. Fred Gettings, *The Occult in Art* (New York: Rizzoli, 1979), pp. 138-144.

7. H.P. Blavatsky, *Isis Unveiled* (Wheaton, IL: Theosophical Publishing House, 1972), Vol. I, p. 9.

8. _____, *The Secret Doctrine: The Synthesis of Science, Religion, and Philosophy* (Pasadena: Theosophical University Press, 1952), pp. 625-26.

9. S. Ringbom, *The Sounding Cosmos*, op. cit., p. 98.

10. Annie Besant and C.W. Leadbeater, *Thought-Forms* (Wheaton, IL: The Theosophical Publishing House, 1969), p. 36 and Figs. 15 & 16.

11. Kenneth C. Lindsay and Peter Vergo, eds., *Kandinsky: Complete Writings on Art* (Boston: G.K. Hall, 1982), pp. 139-145.

10

Jackson Pollock's "The White Angel" and the Origins of Alchemy

JONATHAN WELCH

Jackson Pollock's *The White Angel* of 1946 (Fig. 1), a small and heretofore unfamiliar work, deserves more attention than it has received.[1] An analysis of this figure composition indicates that its subject is probably based on a myth concerning the origins of alchemy. Evidence in connection with *The White Angel* regarding Pollock's exposure to ideas about alchemy allows not only for additions to Judith Wolfe's interpretation of Pollock's *Alchemy* (1947),[2] but offers new insight into his breakthrough to the drip technique.

A detailed description of the several motifs and their derivation in *The White Angel* will help orient the reader to its somewhat hidden figuration. Pollock depicted a male angel on the left and a female figure on the right. An ellipse with four dots in the upper left represents the angel's head and facial features. The long narrow white passage is the neck, and the white triangular area at left center is the torso or lower abdomen. Male genitalia are prominently represented below this triangular shape. The long vertical white area below the triangle is the angel's leg terminating in a hoof-like foot. The two large dark areas to the left and right of the angel's neck and torso appear to be wings, and an arm and a hand are seen at the extreme left.

Pollock's figurative vocabulary was often based on motifs seen in European paintings of the previous decades, especially those by Picasso and Miró. The triangular torso, the genitalia, and the leg of the angel described above recall somewhat Picasso's depiction of Franco in *The Dream and Lie of Franco* (1937), though the two works are quite different in expression. Forms similar to those found in the male angel are also evident in Pollock's own work, for example *Sun-Scape*, also of 1946 (Sidney Janis Gallery, New York).

193

1 Jackson Pollock, The White Angel, 1946. Oil
and enamel on canvas, 43½ x 29⅝". From the
collection of Betty and Stanley K. Sheinbaum, Los
Angeles

The partial representation of the female figure on the right is composed of forms that are more symbolic than descriptive. The configuration at the upper right appears to represent a plant, but the tiny round form above it has two black dots and a slight slit suggesting eyes and mouth. This tiny head recalls certain works by Picasso of the 1930s such as the pencil drawing *An Anatomy* of 1933 (reproduced in *Minotaure*, no. 1:33-7, 1933). The similar configuration that rises over the body of a woman in Pollock's drawing *Sleeping Woman* of 1941 strongly suggests that he associated this pattern with a female figure. The two "leaves" in the painting, which also suggest lungs, may not have an exact correlation with human anatomy but are in any case biomorphic. The configuration resembles organic forms in, for example, *Harlequin's Carnival* of 1924 (Albright-Knox Art Gallery, Buffalo, New York) by Miró, for whom Pollock openly expressed his admiration.

Extending downward from this plant form to the large lozenge at the lower right is a line or axis. The small circular form to the right of and tangent to the midpoint of this axis suggests a breast, and the small curving form adjacent to this but left of the axis may be a shoulder or a stomach in profile. Similar representations of breast and stomach can be found in Pollock's *Male and Female* (Collection Mrs. H. Gates Lloyd, Haverford, Pennsylvania) of 1942.

While the patterns inside the lozenge are not decipherable, perhaps they embody some cryptic reference to American Indian art—the lozenge itself would seem to symbolize female genitalia. Use of the symbolic lozenge occurs earlier in Pollock's work. In a drawing of c. 1939, Pollock created a schematic figure with a central axis that intersects a lozenge located much like that in *The White Angel*; and in *Night Mist* of 1945 (Norton Gallery and School of Art, West Palm Beach), the stick figure with a figure-eight form suggesting breasts features a lozenge at the parting of the legs. Thus *The White Angel* seems to be a representation of a male angel on the left confronting a female figure on the right. The proximity of their genitalia, the angel's possibly represented as erect, suggests imminent copulation.

A striking parallel of subject matter is to be found between this painting and a short article by the Surrealist painter Kurt Seligmann, "Heritage of the Accursed," published in the December 1945 issue of *View*. The article consists of excerpts from Seligmann's book *The Mirror of Magic*, which would be published in 1948. He

quotes from Genesis 6:2: "The sons of God saw the daughters of men, that they were fair," and he further states, "The fathers of the Church have declared that the sons of God were fallen angels who mated with mortal women of antediluvian times."[3] In the book of 1948 Seligmann explains that according to Zosimus of Panopolis, a fourth-century A.D. apologist of alchemy, these angels gave to the daughters of men knowledge of the divine arts including that of alchemy, thus accounting for the origin of this occult science.[4] Francis V. O'Connor has confirmed that Pollock knew Seligmann, that he would have known of Seligmann's ideas, and that he probably read the article of 1945. Several issues of *View* from that year are in Pollock's library, though the December issue is not among them. A fire several years ago destroyed a large quantity of old magazines and clippings, and the December issue may well have been destroyed then.[5]

During the 1940s, alchemy appears to have been a subject of great interest to avant-garde circles in New York. In a previous article entitled "Magic Circles," also published in *View*, Seligmann states, "According to Jung the alchemic process is mainly of a psychic nature; and this makes it even more analogous to the artist's labor."[6] Seligmann proposes that occult forces are a part of the act of artistic creation and that the artist himself is subjected to them much as a medium experiences the trance. He goes on to say, "Only in the state of trance, in the moment when the World Soul has entered into the artist, will he be able to produce with impunity . . . those works which are in harmony with the universe and its secret laws."[7] Others besides Seligmann expressed awareness of and interest in alchemy. Breton, who emphasized that Rimbaud's phrase "the alchemy of the word" should be taken literally, stated that "surrealist research presents a remarkable similarity of aim with alchemic research. . . ."[8] Jung, most of whose writings on the subject of alchemy were available in New York prior to 1940, considered alchemy to be a projection of the psychology of man.[9] Finally, in addition to Pollock's use of the title *Alchemy*, Gottlieb titled two works of the mid '40s *Alchemy* and *The Alkahest of Paracelsus*.

In view of this evidence of a general interest in alchemy, Pollock's painting entitled *Alchemy* (Fig. 2), painted the year after *The White Angel*, is worth reexamining.[10] It must be mentioned from the start that Pollock may not have titled this painting himself. Nevertheless, since the subject of alchemy was in the air, and considering

2 Jackson Pollock, Alchemy, *1947. Mixed media
on canvas, 45⅛ x 87⅛". The Peggy Guggenheim
Collection, Venice; Solomon R. Guggenheim
Foundation, New York; Photo: Garmelo Guadagno*

the evidence from *The White Angel* that Pollock was aware of it, it
seems conceivable that ideas concerning alchemy may lie behind
not only this particular painting, but may even be seen as a factor in
Pollock's dramatic change of style in 1947. In her article "Jungian
Aspects of Jackson Pollock's Imagery," Judith Wolfe suggests that
the four main colors used in *Alchemy*—black, white, red, and
yellow—symbolize the four stages of transmutation in the alchemic
process.[11] Pollock also used aluminum paint; and though Wolfe
suggests only a visual but not a symbolic meaning for it, the silvery
colored paint may refer to quicksilver. Jung states in his essay, "The
Idea of Redemption in Alchemy," that quicksilver is analogous
to and sometimes identical with *materia prima*[12]; and as noted by
Wolfe in her discussion of the color symbolism of the alchemical
process, quicksilver is symbolically connected to the color of white
and the first transmutation.[13]

Wolfe also points out that in *Alchemy* there is an apparent star at
the left, a numeral "4" in the center, and a numeral "6" at the
right. She suggests that the "4" may symbolize the concept of com-
pleteness and the "6" may symbolize the fusion of male and
female.[14] Both ideas are of primary importance in alchemy, and

197

the second certainly suggests connections with *The White Angel*. The star, though not discussed by Wolfe, may also have a symbolic meaning. In *The Mirror of Magic*, Seligmann recalls that the agent used in the transmutation process is sometimes called the philosopher's stone or the quintessence.[15] Jung states in the essay quoted above that "astrum (star) is an alchemistic term that approximately means quintessence."[16] Quoting from Ruland's *Lexicon Alchemie* of 1612, he also states that "Imagination is the star in man. . . ."[17] Thus, depending upon whether Pollock's knowledge of alchemy derived directly from the literature and/or indirectly from friends such as Seligmann, the star in the painting may refer to the quintessence and /or to imagination.

While *The White Angel* and *Alchemy* seem related in subject, the manner of their execution differs vastly. The two works respectively typify the end of one style and the beginning of another. It is generally agreed that the change was a result of solutions to problems in painting faced by Pollock, or as he himself explained it in 1950, "new needs need new techniques."[18] The deep emotions suggested by the all-over energetic brushwork found in many of his figurative works, though less evident in *The White Angel*, perhaps called for a purer expression and form which were achieved by dripping rather than brushing the paint. Both the Surrealists and John Graham attached importance to automatism and are frequently considered as having provided Pollock with a means for expressing these emotions.[19] In her explanation of Pollock's stylistic change, Wolfe considers "the process of painting" as the primary cause but suggests that "it is entirely likely that Jung's concept of the process of psychic individuation provided important confirmation for the new style."[20]

Connections between Seligmann and Pollock which explain the subject of *The White Angel* further suggest new implications for Pollock's breakthrough. Not only may the more-than-passing interest in alchemy in avant-garde circles in the 1940s be noted, but the possibility should be considered as well that the analogy to be drawn between the alchemical process and the act of painting may have affected Pollock's approach to his medium.[21] Jung explains in his essay, with reference again to Ruland's text, that *meditatio*, a concept significant in alchemistic work, occurs when the alchemist "has an inner dialogue with someone who is invisible, as also with God, when he is invoked, or with oneself, or with one's good

angel."[22] This, according to Jung, is not a mere moment of cogitation but "a living relation to the answering voice of the 'other' in us," and represents a moment of contact with one's unconscious.[23] In addition, Jung states that through the act of imagining, signified by the alchemists' term *imaginatio*, "the alchemist related himself not only to the unconscious, but also directly to matter, in which he could hope to induce transformation through the power of imagination."[24]

Concepts of *meditatio* and *imaginatio* may explain some of the meaning behind Pollock's own statement about being "in" the painting and making "contact" with it.[25] In addition to acknowledging the obvious physical properties of paint and canvas, it may be that Pollock thought of these materials as having by analogy the latent spiritual and organic qualities attributed by alchemists to their materials, and which he, as a creator, could bring forth by relating himself to them and by elevating them through his imagination from a physical to a "spiritual" level, as the alchemists aspired to do with theirs.[26] Projecting his own unconscious as he perhaps believed alchemists had done, Pollock may have seen as an alchemical process his own creation of art, and its product, art, what gold was to the alchemists.

The possibility, suggested by Wolfe, that alchemical ideas and mythology contributed materially to Pollock's drip technique in general and specifically to *Alchemy* is reinforced and amplified with this new evidence of an alchemical theme in *The White Angel* of 1946. The earlier painting may now be seen as having historical significance in the stylistic as well as the iconographic evolution of Pollock's mature style.

Notes

This article is derived from an M.A. thesis (University of California, Santa Barbara, 1977). I would like to express my appreciation to Mr. and Mrs. Stanley K. Sheinbaum who made the painting available to me for study and to Dr. Beatrice Farwell who supervised my thesis and suggested the submission of its main conclusions for publication.

1. O'Connor dates this painting in the early part of 1946. Francis V. O'Connor, *Jackson Pollock*, New York, 1967, p. 38. *The White Angel* was first shown at Art of This Century, April 2-20, 1946.

2. Judith Wolfe, "Jungian Aspects of Jackson Pollock's Imagery," *Artforum*, XI, November 1972, pp. 65-73.

3. Kurt Seligmann, "Heritage of the Accursed," *View*, V, December 1945, p. 6.

4. Kurt Seligmann, *The Mirror of Magic* , New York, 1948, p. 120.

5. Personal communication, April 25, 1977.

6. Kurt Seligmann, "Magic Circles," *View*, I, February-March 1942, p. 3.

7. *Ibid*.

8. Michel Carrouges, *André Breton and the Basic Concepts of Surrealism*, University of Alabama Press, 1974, pp. 55-56.

9. Jung's literature on alchemy available in English translation in New York includes his foreword and commentary for *The Secret of the Golden Flower*, 1931; the Terry Lectures delivered at Yale University in 1937; and "The Idea of Redemption in Alchemy," in *The Integration of the Personality*, 1939. *Psychologie und Alchemie* was published in Zurich in 1944 and was referred to by Seligmann in *The Mirror of Magic*.

10. *Alchemy* was first shown at Betty Parsons Gallery, January 5-23, 1948. O'Connor, *Jackson Pollock*, p. 42.

11. Wolfe, "Jungian Aspects," p. 71.

12. C.G. Jung, *Integration of the Personality*, London, 1963, p. 209.

13. Wolfe, "Jungian Aspects," p. 71.

14. *Ibid*.

15. Seligmann, *Mirror*, p. 140.

16. Jung, *Integration*, p. 222.

17. *Ibid.*, p. 221.

18. O'Connor, *Jackson Pollock*, p. 79.

19. See Irving Sandler, *The Triumph of American Painting: A History of Abstract Expressionism*, New York, 1970, p. 23, or Barbara Rose, "Lee Krasner and the Origins of Abstract Expressionism," *Arts*, LI, February 1971, pp. 96-100.

20. Wolfe, "Jungian Aspects," p. 71.

21. In her analysis of *Alchemy*, Wolfe poses as a question whether "the fire colors and melting forms" of the painting suggested the title, or if the motto *solve et coagula*, a formula that epitomizes the alchemical evolution, guided Pollock in the making of the work. Wolfe, "Jungian Aspects," p. 71.

22. Jung, *Integration*, p. 220.

23. *Ibid*.

24. *Ibid.*, p. 222.

25. O'Connor, *Jackson Pollock*, p. 40.

26. The possibility that Pollock may have entertained ideas about "spiritual" forces in organic and inorganic matter recalls the fact that he expressed an interest in Theosophy during high school. O'Connor, *Jackson Pollock*, p. 15.

QUEST BOOKS
are published by
The Theosophical Society in America,
Wheaton, Illinois 60189-0270,
a branch of a world organization
dedicated to the promotion of brotherhood and
the encouragement of the study of religion,
philosophy, and science, to the end that man may
better understand himself and his place in
the universe. The Society stands for complete
freedom of individual search and belief.
In the Classics Series well-known
theosophical works are made
available in popular editions.

A Quest classic

The Beautiful Necessity

Seven essays on Theosophy and Architecture

by Claude Bragdon

Figure of Christ from the
East window, Poitiers

PLAN OF CATHEDRAL OF BEAUVAIS

A Gothic cathedral, the sym-
bol of the body of Jesus Christ

WITH 91 ILLUSTRATIONS

Architect Claude Bragdon was known as a man of extraordinary breadth
of mind and inner vision. In addition to his distinguished career in
this field, he was also a well-known Broadway stage designer and the
author of 16 books. Bragdon was keenly aware of the graceful co-evolution
of man's spirit and his earthbound accomplishments.

"It is doubtful if any other modern work shows such ingenious and
erudite study of exposition." —*The London Studio*

"Every page of it witnesses triumphantly to the grandeur of man."
—*Clifford Bax*